Memory Unearthed
The Lodz Ghetto Photographs of Henryk Ross

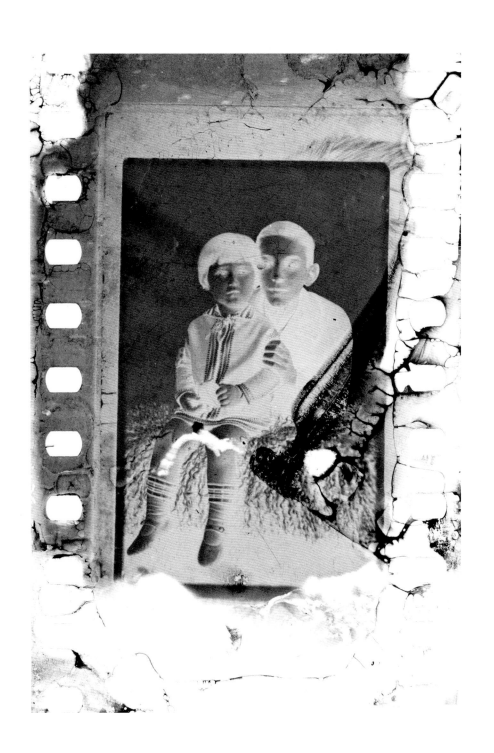

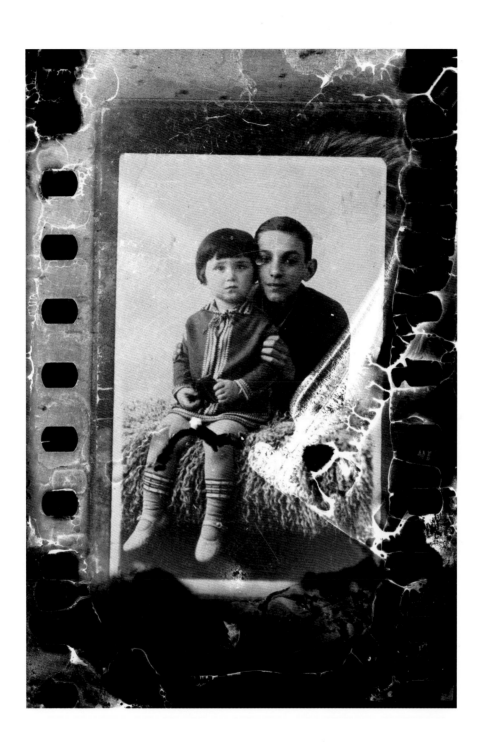

ABOVE AND OPPOSITE Young boy and girl, before 1942, 2007/2022.205.

Memory Unearthed
The Lodz Ghetto Photographs
of Henryk Ross

EDITED BY

Maia-Mari Sutnik

ART GALLERY OF ONTARIO

DISTRIBUTED BY YALE UNIVERSITY PRESS,
NEW HAVEN AND LONDON

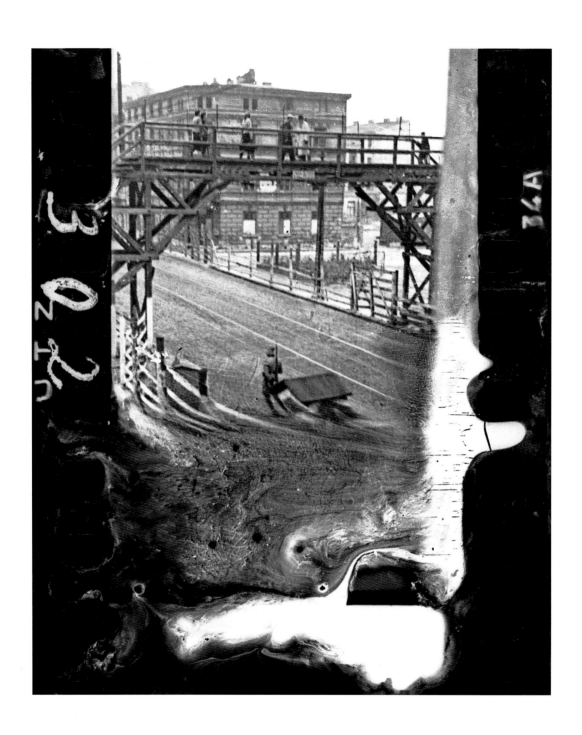

The bridge crossing Zigerska Street, the "Aryan" street
that divided the Lodz Ghetto into two areas, May 1, 1940, 2007/1964.27.

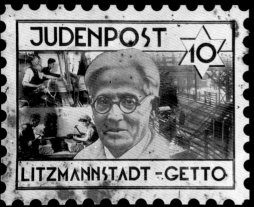

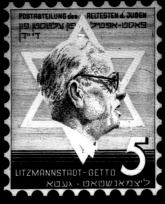

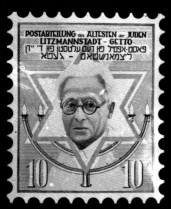

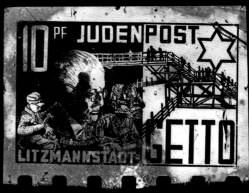

Some postage stamps issued during the occupation of Lodz, renamed Litzmannstadt by the Germans on April 11, 1940. Designs are by graphic artists of the ghetto's Statistics Department (Dr. Kowanic, Dr. Robicek, Gurenwicz and Henryk Ross). Ross's stamp (upper left) was confiscated for depicting a German guard sentry and a barbed fence. 2007/1956.9; 2007/1956.7; 2007/2459; 2007/1956.6.

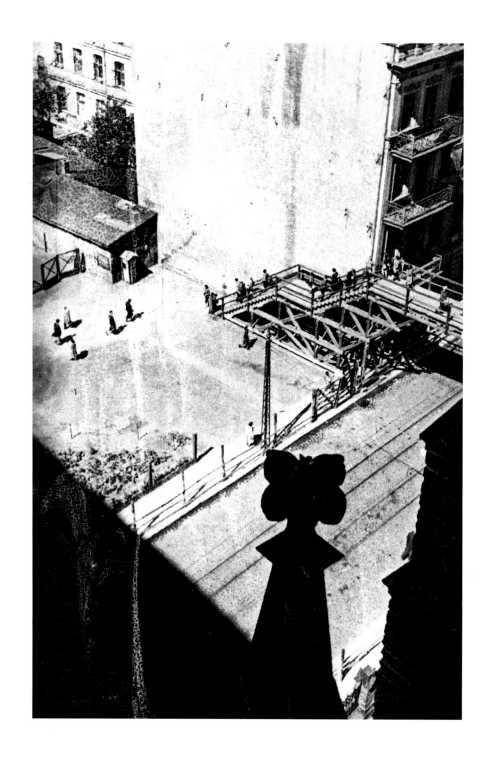

A view from above the Zigerska Street bridge showing a sentry booth
and the Lodz Ghetto gates, 1940–1941, 2007/2022.276.

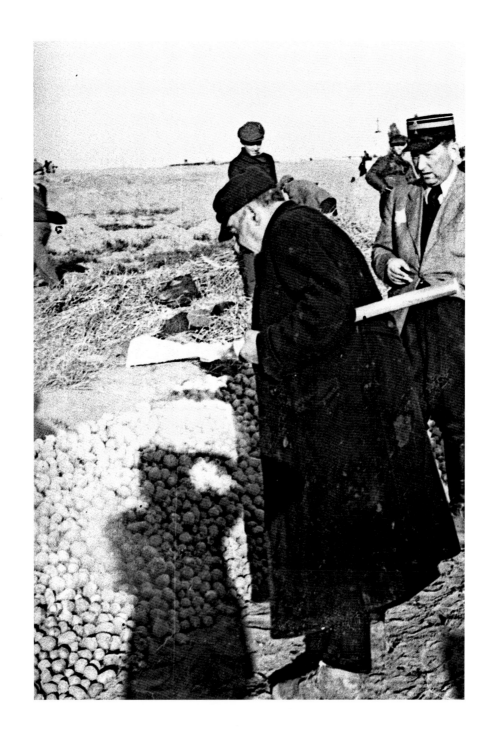

Shadow of Henryk Ross photographing in the Lodz Ghetto, 1940–1944, 2007/1973.10.

"I buried my negatives in the ground in order that there should be some record of our tragedy. . . . I was anticipating the total destruction of Polish Jewry. I wanted to leave a historical record of our martyrdom."

HENRYK ROSS

Italics in captions indicate statements written by Henryk Ross as part of
his "catalogue list" in Jaffa, Israel, dated 1987 (now at the Art Gallery of Ontario).

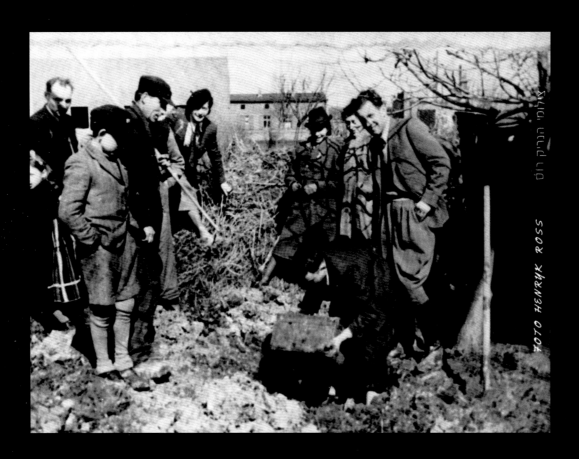

Excavating the box of negatives and documents Henryk Ross buried in the ghetto
at 12 Jagielonska Street, Lodz, March 1945, 2007/2644.2.

MEMORY UNEARTHED IS AN EXHIBITION, and a publication, of great impact and sustaining meaning. It is about memory and testimony, about art and artifact, about the individual and the collective. On view are a selection of images from the more than 3,000 photographs and negatives that constitute the life story of one man: Henryk Ross, active in the Lodz Ghetto in Poland as an official photographer from 1940 to 1945. His works were preserved through an act of will, not grand design. They are testimony to survival in the most dramatic sense, mirroring his own life: hiding, reforming, enduring scars and toil.

Simply told, during the final liquidation of the Lodz Ghetto, Ross buried his negatives with other artifacts in the barren ground, fearing that an imminent deportation would ensure the images were destroyed. Following the liberation of the ghetto by the Red Army in January 1945, Ross excavated the box of negatives. The images—and memories—were freed in parallel with the survivors in his community. It was the sum total of his life's work. His life's work in a box. His life's work in its entirety.

Ross's photographs vary widely in their composition and subject matter. Some are official portraits and propaganda pictures showing labour in the Lodz Ghetto. Others are horrific images depicting starving families and painful deportations. Still others portray ordinary, even joyful moments in the ghetto: smiling men and women, children's parties, various pastimes and celebrations. It is, in a deep and unsettling way, difficult to make sense of these images. We can see Ross struggling to come to terms with the events he witnessed in the disjointed folio of images he later assembled, which is presented in full here.

We should remember: though many of the negatives were severely damaged by water, nearly 3,000 survived, along with a small group of original prints, curfew notices and newspapers. We should know: Ross sent the negatives to Israel, where they remained in his personal collection. He published a book on the ghetto, and created a narrative from small contact sheets. His collection has come to the AGO as a gift from the Archive of Modern Conflict, for conservation and publication, to ensure it is shared broadly. We have preserved and digitized the negatives, which

were primarily produced on cellulose nitrate stock, and we are working to produce a public record of all of the images. We should acknowledge: to make them widely available is to insist on remembering.

Memory Unearthed is a testament to the AGO's wonderful Curator of Photography, Special Projects, Maia-Mari Sutnik, who has shepherded the Ross collection through the AGO, choreographed the exhibition and led the development of this important book. Maia assembled a diverse team of academics and artists to examine the Ross images from a variety of perspectives. Robert Jan van Pelt is one of the world's leading experts on the Holocaust, and his comprehensive historical overview of the establishment, operation and liquidation of the Lodz Ghetto explores this chapter in Holocaust history with newfound depth. Photographer and filmmaker Michael Mitchell looks at the negatives from a photographer's perspective, paying particular attention to Ross's enigmatic folio. Scholar Eric Beck Rubin reflects on the way Ross's photographs compel us to reconsider the history of the Holocaust, and writer and artist Bernice Eisenstein considers the enduring power of memory. Together, their generous offerings lead us to imagine the many multifaceted dimensions of Ross's body of work.

The project at the AGO would not be what it is—with such a consistent thoughtfulness—were it not for the excellent team that believed in *Memory Unearthed* from the beginning. This group includes Maia Sutnik; conservator Katharine Whitman, who has worked to prevent the further deterioration of the Ross negatives; researcher Sara Fruchtman and cataloguer Tracy Mallon-Jensen, who have organized and catalogued the collection; the image resources team at the AGO, who digitized the negatives; Tanya Zhilinsky, the project manager for the exhibition; and the publishing team led by Jim Shedden, along with the staff of Yale University Press, who guided the development of this publication.

In undertaking this unique project, the AGO has received an unprecedented and humbling outpouring of support. Early on, Joel and Jill Reitman expressed keen interest in helping us fully realize our ambitions. It is with deepest gratitude that we acknowledge The Cyril & Dorothy, Joel & Jill Reitman Family Foundation as lead supporter; their passionate involvement is a testament to their commitment, and a special legacy for the late Cyril Reitman. We are indebted to the exceptional generosity of a community of supporters for whom this project has profound resonance—some of whom are the children of Lodz survivors. A full list of these remarkable donors appears on page 19. I wish to extend heartfelt thanks to three individuals who championed this project in the community: Earl Rotman, Maxine Granovsky Gluskin and Honey Sherman. Earl's father is a survivor of the Lodz Ghetto, and *Memory Unearthed* struck a deep and personal chord. Of key importance to this family of supporters and to the AGO is the establishment of a far-reaching and long-lasting archive of Henryk Ross's photographs and the narrative they reveal. The AGO is developing this legacy project and we are grateful to an anonymous supporter in Ottawa for contributing to the initiative.

In light of Ross's experiences and the extraordinary chronicle that reflects them, we might ask: is there a position of neutrality, in Ross's time, or in ours? What does such evidence lead us to conclude? We are, I believe, moved to judgment. While Ross documented the reality of everyday life in the Lodz Ghetto, as both horrific and routine, his photographs seem not to judge or interpret these historical events, except in the following way: they convey discrete moments of lives lived in the brief existence of the Lodz Ghetto: no roads lead elsewhere; no light shines through windows; walls, fences and closed doors separate but do not join. We honour his vision and his extraordinary perseverance, and we take from him the mantle of remembrance.

MATTHEW TEITELBAUM
Michael and Sonja Koerner Director, and CEO, Art Gallery of Ontario

LEAD SUPPORTER
The Cyril & Dorothy, Joel & Jill Reitman Family Foundation

GENEROUSLY SUPPORTED BY
A friend in Ottawa, in memory of the perished

Jack Weinbaum Family Foundation
Gerald Sheff & Shanitha Kachan
MDC Partners—Miles S. Nadal
Gerald Schwartz & Heather Reisman
Marion & Gerald Soloway
Ed & Fran Sonshine
Larry & Judy Tanenbaum & family

Apotex Foundation—Honey & Barry Sherman
Daniel Bjarnason & Nance Gelber
D. H. Gales Family Foundation
Wendy & Elliott Eisen
Saul & Toby Feldberg
Beatrice Fischer
Joe & Budgie Frieberg
Lillian & Norman Glowinsky
Maxine Granovsky Gluskin & Ira Gluskin
Mary Golfman & Fred Litwin
The Jay and Barbara Hennick Family Foundation
Warren & Debbie Kimel
The Koschitzky Family
Steven & Lynda Latner
In memory of Miriam Lindenberg by her children,
Nathan Lindenberg and Brunia Cooperman and families
Faye Minuk
Earl Rotman & Ariella Rohringer
Penny Rubinoff
Samuel & Esther Sarick
Dorothy Cohen Shoichet
Fred and Linda Waks, Jay and Deborah Waks

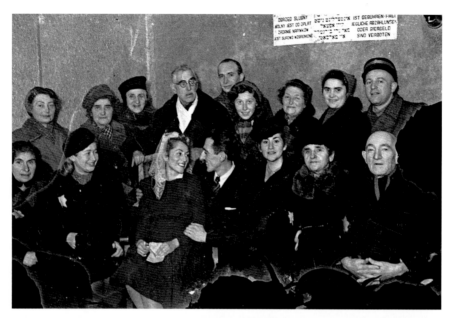

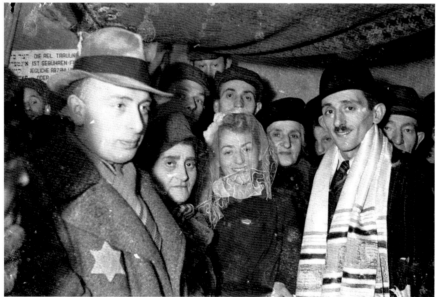

The marriage of Henryk Ross and Stefania Schoenberg, 1941, 2007/1957.1; 2007/1957.3.

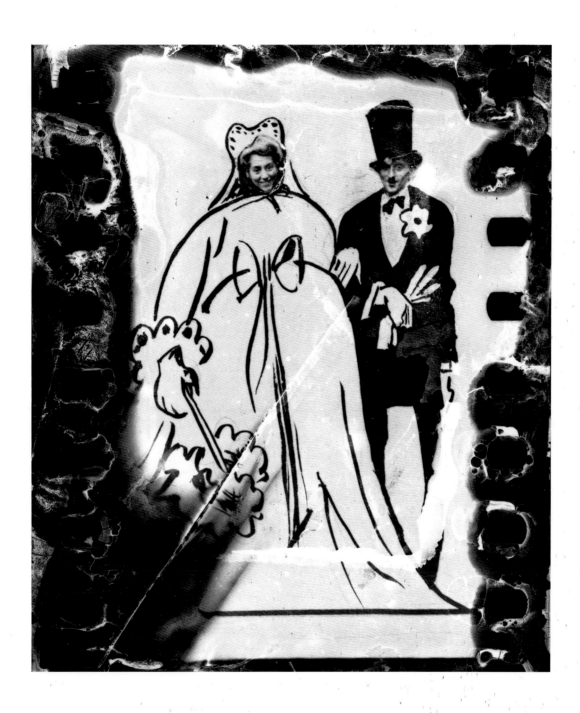

A Henryk Ross cartoon of Stefania Schoenberg and Ross as a bride and groom in *"formal attire,"* 1941, 2007/2022.18.

Cruel Tragedies, Consoling Pleasures

Maia-Mari Sutnik

AMONG THE HANDFUL OF PRINTS AND 3,000 SURVIVING NEGATIVES produced by the attentive eye and determined mind of Henryk Rozencwaijg-Ross in the Lodz Ghetto from 1940 to 1945, there are images that are hard to blot out once seen. In their expressiveness, heightened by blights and swirls on the surfaces of the degrading film emulsions, these once-buried images evoke a palpable sense of reality. Each is more than an isolated frame: even if marked with trace damages, it is a moment in history—and all of these images belong somewhere in our collective consciousness. In Ross's images, which transcribe a chain of events in the ghetto, one sees grace and anguish, hope and suffering, productivity and devastation. Looking at these photographs leads to a subjective "reading," not simply because we are familiar with other photographic documentation of grievous world events, but because the indelible scenes Ross captured evoke visual and emotional responses. Their immediacy—a connecting experience—urges us to respond, inciting an outcry over the cruel tragedy inflicted on the Jewish community, with so few consoling moments.

A photograph's affiliation to the real world is demanding: it asks the viewer to locate its full meaning in reality. Its key connection is its reflection of the world—a vital point of view, whether objective or subjective. A photograph forms traces of the world, delineating and pausing that reality. Critics have questioned the integrity of social documentary photographs, condemning them as unreliable objects that espouse social and political values and despairing the lack of aesthetic originality that stems from photography's "mechanization." But this is a polemical debate rather than an illuminating or progressive perspective.[1] Such critiques overlook the value of the photographer's inspiration—the careful effort taken to capture a well-defined moment—and one can only attribute this antipathy to the extraordinary power photographs actually possess. Of the many ways to read a photograph—to catalogue, to identify, to interpret—it is perhaps subjectivity that is its most potent quality. And its most oddly feared: photographs are "biased" and therefore considered unreliable witnesses.

A photograph *is* a point of view. The distinct freedom of the medium suggests that photography's role may be not to reproduce unbiased, unvarnished reality, but rather to provide viewpoints that form layers in our consciousness, imaginations and memories. For some, a photograph is the only thing—a surrogate—left over from a once-felt reality. In that light, it cannot be anything but subjective. Photographs are very fragile objects, in both their analytical capacity and material source—a certain fact of Ross's negatives. His images, we discover, are as complex as they are persuasive. Their survival foregrounds Ross's original intent: to reveal a remarkable narrative, and to ensure that the tragic reality of the Jews in Lodz is never forgotten. This was his endeavour.

Looking at two scenes from Ross's photography, we see how unyielding images can be in specifics, and yet how their focus propels us to probe. A photograph of a group of shabbily clothed children, twenty or more, crammed into the kind of dilapidated wooden wagon used by poor farmers in hayfields (p. 124), is pervaded by an unsettling atmosphere. The sun casts a strong light on the huddled children, most of whom have their backs turned or are peering over the sides of the wagon. Only one young boy, wearing a threadbare sweater marked with a tattered Star of David, fully faces Ross's camera: his squint and apprehensive smile do not fail to connect with the viewer. He may be seeking acknowledgement from Ross, he may be bewildered and afraid, he may have been told to be courageous, but clearly he is without parents and very much on his own. Pulling this heavy load through an empty stone street, the horse appears bedraggled—too many loads already? Ahead, a similar wagon is disappearing into the late-afternoon shadow. To the right, a neatly dressed figure, perhaps a strapping youth, appears to have just stepped into the picture, wearing the mandatory Star of David on his right shoulder: he is a Jew who, like the children, must wonder about the wagon's destination. Where is it going?

The photograph never tells, but its thought-provoking substance leads to discovery and consideration. Ross was engaged in capturing the consequences of the *Gehsperre* (deportation) announced by the German administration officials. On

September 4, 1942, Mordechai Chaim Rumkowski, Elder of the Jewish Council in the Lodz Ghetto, called on ghetto parents to give up their children under the age of ten for "resettlement."[2] Nearly 17,000 young, sick and elderly Lodz residents were removed from the ghetto and murdered in the gas vans of Chełmno nad Nerem (which had been renamed Kulmhof). Ross's photograph does not show their deaths, but it communicates the ordeal experienced by innocent Jewish children at the hands of the Nazi perpetrators. Years later, Ross included this image in a series of "The most tragic victims…"[3] but said no more about it, implicitly connecting the photograph to an abhorrent reality: the Nazi regime's agenda of extermination.

Ross was open-eyed to life and events in the ghetto. At about the same time he witnessed the evacuation of the children, he photographed a "family portrait" series that elicits a starkly different awareness (pp. 56–57). These images reveal Ross's photographic versatility: the sequence of husband, wife and infant is emphatically composed to reveal tenderness and loving interaction. Taken outdoors, presumably in a back garden, all four images centre on a cherished, well-bundled child, but this emotional series also conveys a haunting aura. Photographs remind us to ask questions. What is revealed by this family union? Or, alternatively, how can one extrapolate from existing knowledge to cast this moment in a different moral light? Does the fact that thousands of children were torn from their homes call into question the conscience of this family, still united within the context of these harrowing events?

On the other hand, the scene may hold another revelation: the family could be struck by fearful anticipation. As few parents volunteered their offspring to the Jewish police, the German Gestapo stepped in to fulfil the quota for children. Ross may have captured this family in a moment of consolation, not adoration. The husband seems to be a member of the *Judenrat* (Jewish Council)'s empowered police force, yet we are not certain he is protected. The man lovingly touches his infant's chin; his policeman's hat obscures his face and expression, and also hides his wife, who may be whispering into his ear. This is an affectionate emotional moment, but

the series also shows the mother clutching the child—fiercely—and placing an adoring kiss on the infant, who seems singularly still. Ultimately, this scene may be a drama of loss—or impending loss. The ghetto's Nazi administration was determined to implement these quotas for "resettlement" to the fullest. In the face of their relentless numbers, deportation to the death camp was a threat for everyone, regardless of social strata.

Photographs are ambiguous; these 1942 images depict experiences that only Ross can claim. They may not tell the viewer a full story, but they are nevertheless potent documents that convey extraordinary pathos, and, significantly, emotional veracity: the anxieties are palpable. Social documentary photography is often an expression of both the intellectual and the sensory. It rarely strays far from the real world, tugging at one's conscience where social and political struggles persist. Less than two years after Ross took these photographs, on August 2, 1944, a new order to all Lodz residents announced the final liquidation of the ghetto. Tens of thousands of people boarded trains to Auschwitz-Birkenau. If any "protected" families survived to experience tender moments like the ones Ross captured in 1942, these were merciful exceptions.

In his introduction to *The Art of Social Conscience*, Peter Selz discusses the value of art as an expression of morality, stating that humanity must essentially be learned and fought for, and that it is "often the artist [who] becomes the individual in whom the struggle manifests itself, the man in revolt against accepted values, and the guardian of nonconformity."[4] Selz suggests that works of art can help alleviate humankind's alienation, and act as instruments to achieve greater freedom and dignity. Historically, we are aware, many artists have expressed empathy by depicting expressions of inhumanity in imagery critical of social and political affairs; long before Francisco José de Goya y Lucientes's etchings of *The Disasters of War*, the biting social satire and graphics of Honoré Daumier and George Grosz, and John Heartfield's satirical anti-fascist collages, pictorial responses condemned adverse social injustices perpetrated on the disadvantaged. This too was Ross's mission.

Photography, more than any other form of visual expression, has facilitated candid points of view on ideological and cultural values, which allow the probing of social ideals. Photographs inform meaningful perspectives, often revealing a magnitude of evidence and critically accounting for the extraordinary by way of prolonged observation and participation. Images of wars, disasters and other horrors have the capacity to bring to our attention content that could only be experienced via these startling surrogates. A photograph is never *the* ultimate experienced reality, but rather a temporal transcription in which to place some trust—"a pause in the clock," as expressed by Michel Lambeth, a photographer whose social conscience had equal empathy with Ross's depictions of daily struggles in the ghetto.[5]

And as much as Ross, who referred to himself humorously as "sometimes hiding from the Germans and, if necessary, at the top of a ladder" (fig. 1),[6] witnessed with his camera, he also responded creatively to his situation as a professional photographer and a graphic artist. Though his surviving images were transformed by the ground, they are still laudable touchstones of inspiration, complexity and authenticity. Ross intuitively reveals the spectrum of life in the ghetto, documenting the complex contingencies of daily existence and using his direct experience to increase our understanding. Goya, on one of his war depictions, adds the caption *"Yo lo vi"*— "I saw this"—to evoke a sense of reality. Just as earnestly, Ross's photographs provide us with visual observations that reveal the reality of his experience.

Henryk Ross's photography clearly represents his "I saw this" point of view of incarceration in Lodz. The work is a testament to what Paul von Blum, in an essay on concentration camp art, refers to as "the resiliency of the human spirit." Von Blum sees this work as both complex and bewildering, in that the most adverse conditions somehow provoke extraordinary intellectual artistic responses.[7] Forty-two years after his precarious existence in the ghetto, Ross said he felt the need to preserve "some record of our tragedy, namely the total elimination of the Jews from Lodz by the Nazi executioners. I was anticipating the total destruction of Polish Jewry. . . . I did it knowing that if I were caught my family and I would be tortured and killed."[8]

The images Ross captured with his camera delineate the grim conditions in the ghetto: we see stricken faces awaiting "resettlement," not knowing or perhaps fully aware of their fate. We see blurred people, like walking shadows on the street— ill, hungry, falling, hopeless. We see the catastrophe of the everyday everywhere. These images are often at odds with Ross's professional standard, but responding spontaneously to moments was more meaningful to him than camera control.

Of course, Ross saw much more than tragedy; having worked for picture agencies, he sought out other stories, "happier moments" for his camera to capture. He found such moments in the outlying area of Marysin, where one might not feel the heavy weight of daily ordeals, assaults and devastation. Here, he photographed children, women, men and families. It is evident Ross worked closely with his subjects, developing playful sequences, employing stylistic innovations and posing subjects among greenery, not only to make these photographic moments pleasurable, but also to imbue them with grace, dignity and a sense of self-worth. Ross's subjects must have consented to this exercise of his auteur skills, as some of these compositions would have required great patience. Ross's wife, Stefania, clearly his constant muse, is seen in more than forty studies.

In this process of aspiring to create a comprehensive visual account, Ross captured the fuller arc of survival in the ghetto. Working against extraordinary odds, he photographed what he knew and the places he could access. Simultaneously, he performed the tasks required of an official photographer; along with Mendel Grossman and Lejb Maliniak,[9] Ross worked for the Jewish administration's Statistics Department, which was officially controlled by the ghetto's German authority, Hans Biebow. Ross's earliest task was to take identification photographs for work permits (fig. 2). Anticipating the need to stockpile film, he devised a clever technique: he would record several subjects in the same image, then crop to individual faces. He also systematically documented the industrial productivity of the Jewish labour force: the successful textile workshops, the production of shoes from raw leather, and the process of assembling mattresses by filling them with wood shaved

FIG. 1

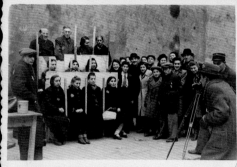

FIG. 2

FIG. 3

FIG. 4

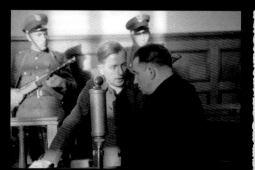

FIG. 5

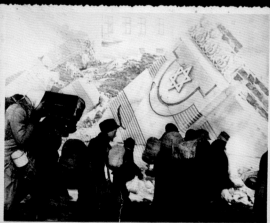

FIG. 6

as fine as wool. Rumkowski had essentially transformed the ghetto into a slave labour camp, exploiting Jewish workers to carry out his "survival of the fittest" plan in an abysmally crumbling ghetto, yet he wanted to portray the labouring populace with a gloss of "normalcy" to please the ruling Nazi management officials. For these "official" documentary assignments, Ross used his training as a photojournalist to tell compelling stories: he carefully composed frames featuring engaged workers in various stages of production to support Rumkowski's peremptory motto, "Unser Weg ist Arbeit!" ("Our way is work!").[10]

Even under the siege of strict regulations and posted demands (fig. 3), Ross and his colleagues managed to document the ghetto's daily unfolding. Ross photographed relentlessly on rolls of 35mm film, mixing his range of subjects: alongside the official documentation, he also recorded overcrowding, dismal living conditions, disease, empty soup kitchens, starvation and death. Remarkably, Ross and his fellow photographers, along with scholars, artists, writers and poets living in the ghetto, managed to produce the Lodz Ghetto *Chronicle*, which now serves as a historical record of official data, correspondences, news, graphics and photographs.[11] Postal worker Nachman Zonabend played a significant role in preserving many of these documents and images after the ghetto's liberation in 1945.[12]

On December 8, 1941, anticipating that photographs would no longer show the ghetto in an ideal light, Rumkowski curtailed photography, except to document "official" occasions. The distinction between official, private and personal was malleable, however, and both Ross and Grossman kept taking satisfying "show" pictures for Rumkowski. One series shows Grossman posing with a portrait of a German officer (fig. 4)—a perfect foil to veil the photographers' prohibited recording of ghetto-life miseries. Grossman photographed until the 1944 mass deportations, often using his camera in the open, without any interference from the Jewish police. Ross similarly documented many deportations, even taking photographs at the Radogoszcz (renamed Radegast) station—Lodz residents' gateway to the Chełmno

death factory—which was off-limits.[13] Ross and Grossman both risked their lives many times by using their cameras when the Gestapo or German guards were patrolling.

To ensure the visual memory of the Lodz was retained, both photographers gave prints to Zonabend for archiving and preservation. Grossman hid his negatives in his house; they later made their way to a kibbutz in Israel but were lost during the 1948 Arab-Israeli War, and Grossman himself died on way to the Königs Wusterhausen concentration camp in 1944.[14] When the final liquidation of the ghetto was announced, Ross was selected to be part of the "clean-up crew" that emptied buildings and brought valuables to Biebow. (Ross later photographed Biebow's trial, at which the former ghetto authority was found guilty and sentenced to death, fig. 5.) To preserve his photographic legacy, Ross packed his film rolls in a canister and buried the box in the ground at 12 Jagielonska Street.

In March 1945, following the ghetto's liberation by the Red Army, Ross excavated his collection. Nearly half of the 6,000 negatives were blackened by moisture, and those with emulsions still intact were in various states of deterioration. This must have been a devastating moment for Ross, but, miraculously, many negatives were saved, and these are now preserved at the AGO. It is a challenge to reconstruct the surviving images, as Ross eliminated many degraded negatives and did not date rolls or provide descriptions of events or the names of his subjects; seeing himself as an employee, he was not diligent in attributing authorship to his prints.[15] The lack of identification on Ross's prints meant that when he provided them to the *Chronicle* and to Zonabend, his work and Grossman's was often confused, and incorrectly attributed in subsequent reproductions.

When Ross immigrated with Stefania to Israel in 1956, he focused on rebuilding their lives and building a family. In 1961, he testified at the trial of Adolf Eichmann.[16] This spurred him to disseminate his Lodz Ghetto documentation more widely; following the trial, he printed up some of his negatives, took hold of his copyright and worked to produce the book *The Last Journey of the Jews of Lodz*.[17] In 1987, more than

four decades after the war, he organized contact prints selected from the surviving negatives into a remarkable "folio" (pp. 184–201). One would hope this assemblage would provide a lucid timeline of events, but Ross tells *his* narrative by renumbering frames and repositioning images, so the document is not particularly yielding. His "catalogue list," also assembled at this time, features only a few specific captions, which often conflict with earlier comments appearing in *The Last Journey of the Jews of Lodz*. Ultimately, Ross did not restore the chronology of his collection. The creation of a purposeful archive would have required a great deal of time and energy, and it seems Ross believed his recollection of ghetto life was complete.

Negatives have material authority, and recent examination of Ross's collection has revealed further information about his photographic practice. Had the whole body of negatives survived, it would have been easier to reconstruct the chronology of events based on film frame numbers, film brands, emulsion matches and the telltale marks of film processing, but of course much of Ross's work was lost to the elements. Lindsay Bolanos has undertaken an in-depth study of the surviving Ross negatives, considering each negative as a primary document with "untapped capacity as a historical object."[18] She discovered that Ross used eleven different 35mm film stocks (ten cellulose nitrate film bases and one safety film), indicating that it was a challenge for him to acquire film consistently. By examining similar emulsion bases, Bolanos was able to unify certain sequences of subjects and their subsequent uses by Ross. This study has revealed significant information about Ross's methodology, and made it possible to match negatives to unfolding events in the ghetto. Based on this evidence, one begins to discern that most of Ross's documentation of the ghetto's various services and administrative departments took place from 1940 to December of 1941. This period was no doubt traumatic for the Jews, who had to abandon their homes and occupy a zone hermetically sealed from the wider world, but there are also images of optimism and social celebration, as residents gather together for group portraits, willingly strike dignified poses and partake in Ross's

stylistic pictorial modes. Ross's image content changes radically after 1941, when the deportations to Chełmno were accelerated.

A question about Ross's work remains: why has this extensive collection received so little attention for so many years? Of the many images of the Holocaust released immediately after the war, the majority show the magnitude of the atrocities perpetrated by the Nazis. Liberation images taken at camps such as Auschwitz by Allied military observers and established photojournalists (including Margaret Bourke-White and Lee Miller) show heaps of bodies, starved and sick prisoners, and the stark brutality perpetrated by the concentration camp authorities. These unsettling photographs served the news media effectively and took official status as memorable markers, becoming the "iconic" images of the Holocaust. There is something definite about pictures of death—a concluding statement. Horror is so evident in such images that they appear to speak for all the crimes of the Holocaust. At the time, there seemed to be no need to level further verdicts of guilt by also depicting the suffering in the ghettos; for the Allies rebuilding postwar Germany, it was politically problematic to mix national guilt with atonement, as many Germans were still in shock about the extent of the devastation.

Sadly, therefore, the prolonged suffering in the ghettos—and the images of it—did not garner immediate attention. The ghettos were places of despair and humiliation, and their story was depressing. The media were not eager to take up issues of poverty, hunger and disease, which had been played out in the Depression-era photographs of the 1930s and seemed oddly familiar. Atrocity was more flagrant. For the general public, photographs of ghetto life held little sway (with the exception of the Warsaw Uprising), while testimonials and personal narratives more empathically reflected the shared emotional torment and memories of survivors. Having once worked for the ghetto's Statistics Department, Ross would have been sensitive to the many emerging issues surrounding survival. His background would have made it difficult for some members of the survivor community to embrace his role as a

documentarian, regardless of the significant risks he took to act as a conscientious photographer. Only when his photographs of the victims of the Lodz Ghetto helped in the prosecution of Eichmann—the Nazi instigator of the worst evil perpetrated on Jews and their communities—did Ross gain the confidence to assemble his memories, reconstructing those that were the most meaningful to him.

At first glance, many of Ross's images have the look of a settled existence, an air of normalcy. Looking closely, however, one notices the veiled theatrics of hope. For ghetto residents, the act of being photographed was a consoling experience amid the many degrading uncertainties: one could present a spirit—whatever one wanted to reveal—and there would be a record of one's dignified existence. This relationship with the camera is evident even in the many workplace images, in which different individuals sit behind the same sparse work desk or in the same office with looks of self-importance. Surrounded by the bleakness of reality, ghetto residents desired to believe they had meaning and value; this turmoil is instilled in the photographic moments that Ross so successfully captured.

Photographs have the freedom of selectivity, but the fact that they are often mediated does not mean they fail to reveal a truth—and there is often more than one to discern in every moment. The Ross negatives authenticate many deep revelations, which seem to have been challenging for the photographer himself, who must have been searching among his memories for the heart of *his* story: one of resilience and commitment to remembering the Lodz Ghetto and its people. His courageous endeavour now offers future generations the chance to research a vital historical record and to locate valuable truths—the many truths that Ross's negatives will unearth.

1 As photography in the 1970s was garnering unprecedented success in the art world, a number of influential critics contended that photographs—and specifically practices of documentary photojournalism—were deceptive. This discourse encompassed many critical positions, most a postmodern criticism of formalism that took issue with the medium's reproducibility, lack of objectivity and originality, and ties to capitalist ideology. Roland Barthes, John Berger, Victor Burgin, Allan Sekula and Susan Sontag, among others, offered critical weight and fostered intellectual discourse on the theory and practice of documentary photography.

2 "Resettlement" was the word authorities used when moving Jews out of the ghetto—in theory, sending them to German labour camps, but in practice condemning them to extermination.

3 Henryk Ross, *The Last Journey of the Jews of Lodz* (Tel Aviv: S. Kibel Publishing, 1962), 47–53.

4 Peter Selz ,*The Art of Social Conscience* (New York: Universe Books, 1976), ix.

5 Michel Lambeth in *Michel Lambeth, Photographer* (Toronto: Art Gallery of Ontario, 1998), 16; "The Pause in the Clock," *Exile* (Toronto: York University, 1974), vol. 1, no. 4.

6 From a statement by Henryk Ross, written as part of his "catalogue list" in Jaffa, Israel, dated 1987 (now at the Art Gallery of Ontario).

7 Paul von Blum, *The Art of Social Conscience* (New York: Universe Book, 1976), 165–184.

8 From a statement by Henrk Ross, written in Jaffa, Israel, dated 1987 (now at the Art Gallery of Ontario); translated in *Łódź Ghetto Album: Photographs by Henryk Ross* (London: Archive of Modern Conflict, 2004), 27.

9 Ross and Grossman are usually noted as the two official photographers of the Lodz Ghetto. Maliniak was brought to attention in research by Ingo Loose in *The Face of the Ghetto: Pictures Taken by Jewish Photographers in the Litzmannstadt Ghetto, 1940–1944* (Berlin: Stiftung Topographie des Terrors, 2010), 28–30. Nachman Zonabend also notes the names of Borkowski and Rubiczek as colleagues in the Nachman Zonabend Collection, 1939–1944, RG 241, New York: YIVO Institute for Jewish Research.

10 Rumkowski instilled conflicting structures of favouritism in the Lodz Ghetto, and ultimately gambled on the worth of Jewish labour to the Germans authorities, believing he had the persuasive power to save Jews from deportation and certain death. He remains one of the most controversial figures to emerge in the history of the Holocaust.

11 The Lodz Ghetto *Chronicle* is preserved in the Lodz State Archive.

12 Along with Ross, Zonabend was chosen to be part of the ghetto "clean-up crew" that stayed behind after the final liquidation. His collection is now housed at the YIVO Institute for Jewish Research in New York City.

13 In *Łódź Ghetto Album*, Ross recounts taking photographs at the Radogoszcz station, situated outside the ghetto boundaries, from which the Lodz Ghetto Jews were transported to Chełmno. Only workers for the station were allowed to enter; with their help, Ross locked himself in a store. From there, he was able to photograph deportation loadings through a hole, at great risk of being discovered. See p. 87.

14 For a fuller discussion of Grossman, see Janina Struk, *Photographing the Holocaust: Interpretations of the Evidence* (London: I.B. Tauris, European Jewish Publication Society, 2004).

15 During the halcyon days of photojournalism, in the interwar years in Europe, few photographers took matters of attribution seriously. As photojournalists were seen primarily as suppliers to press agencies, individual credits were not always recognized.

16 *Memories of the Eichmann Trial*, directed by David Perlov (Jerusalem: Israeli Broadcasting Authority, Channel 1, 1979). The transcript is published in *Łódź Ghetto Album*, 150–156.

17 At this time, Ross stamped his prints with "Copyright/Foto Henryk Ross/Tel-Aviv-Jaffo, 40276/Copyright Reserved . . ." and began to make designs for publications, many based on a deportation image of a young boy in a cap with a satchel (fig. 6).

18 Ross's negatives, their dissemination and his practice are discussed in greater detail in Lindsay M. Bolanos, *The Photographic Negative as a Historical Record: An Analysis of the Henryk Ross Lodz Collection at the Art Gallery of Ontario* (Toronto: Ryerson University and Art Gallery of Ontario, 2010).

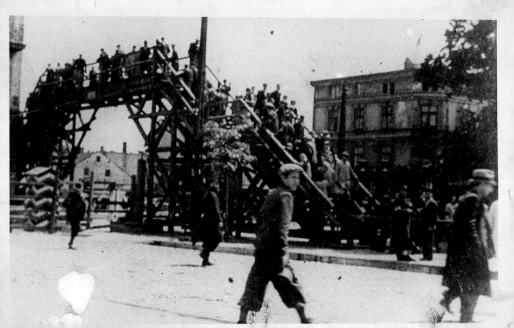

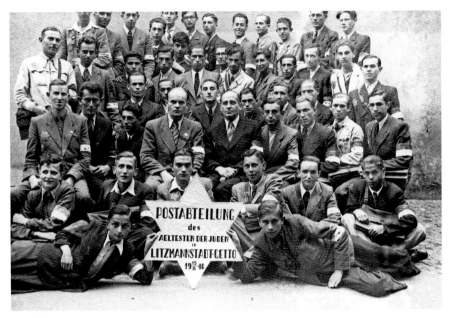

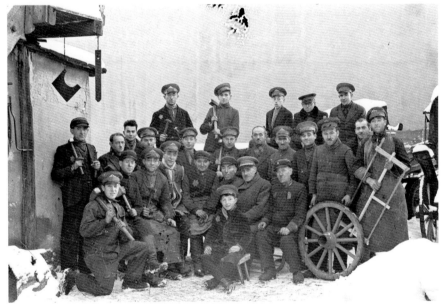

Litzmannstadt (Lodz) postal office administration and workers, March 15, 1940, 2007/1999.12.
Transport Department managers, tram drivers and workers, 1940–1941, 2007/1995.7.

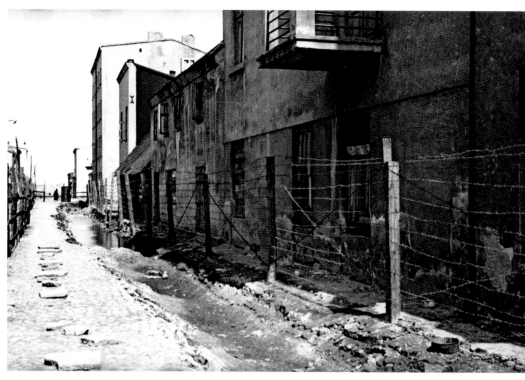

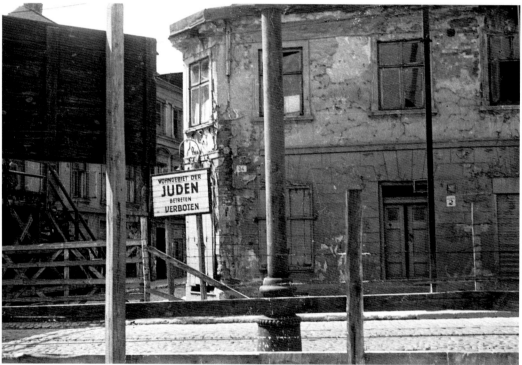

Street view of buildings with barbed-wire fencing in the Bałuty area, 1940–1944, 2007/2022.141.
A sign for Jewish residential area restriction, 1940–1944, 2007/2022.15.

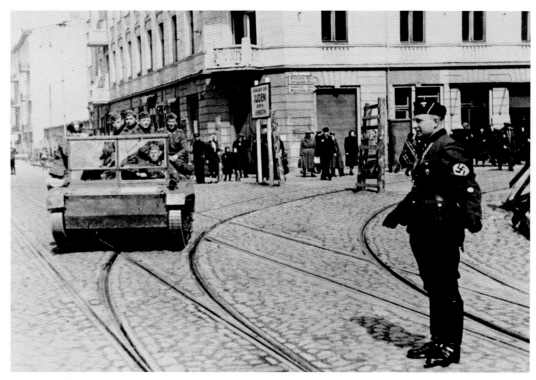

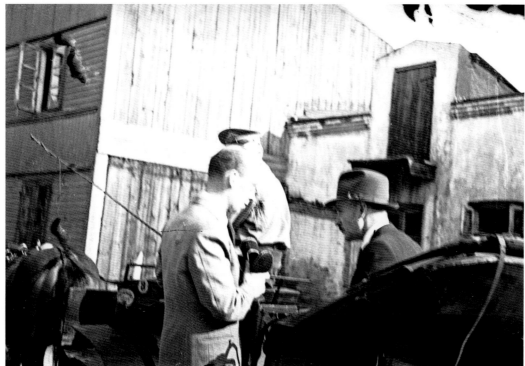

German military personnel in vehicle in Lodz, 1940–1944, 2007/2428.
Inspection of the ghetto by a German official, 1940–1944, 2007/1997.12.

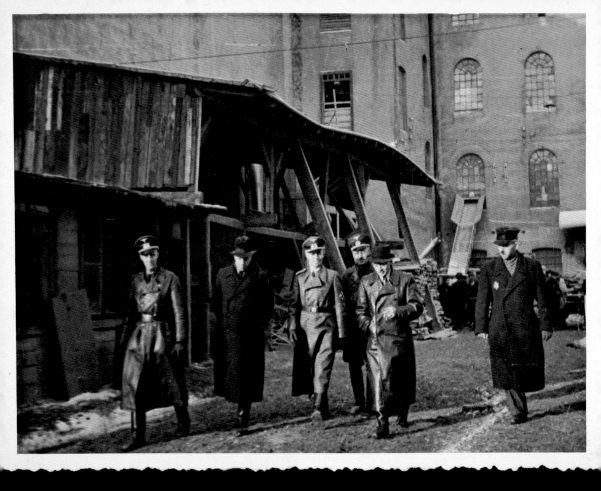

German inspectors of production and factories, 1940–1944. 2007/2287

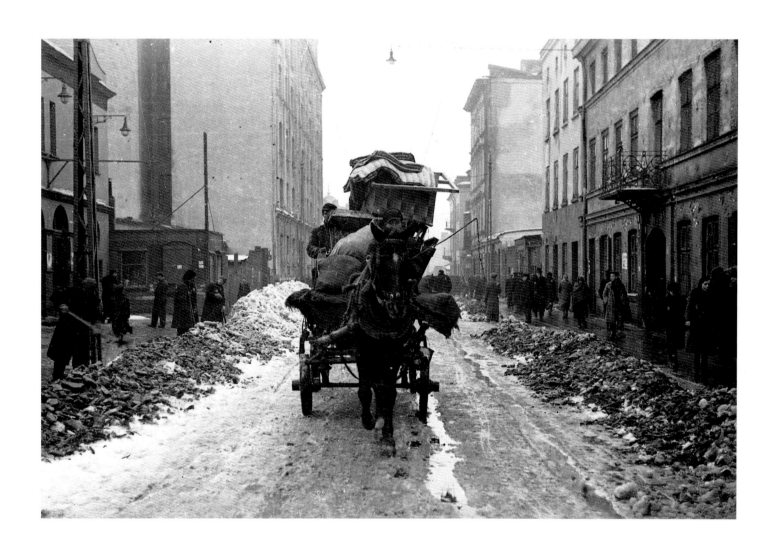

Resettlement in the Lodz Ghetto, 1941–1942, 2007/2022.22.

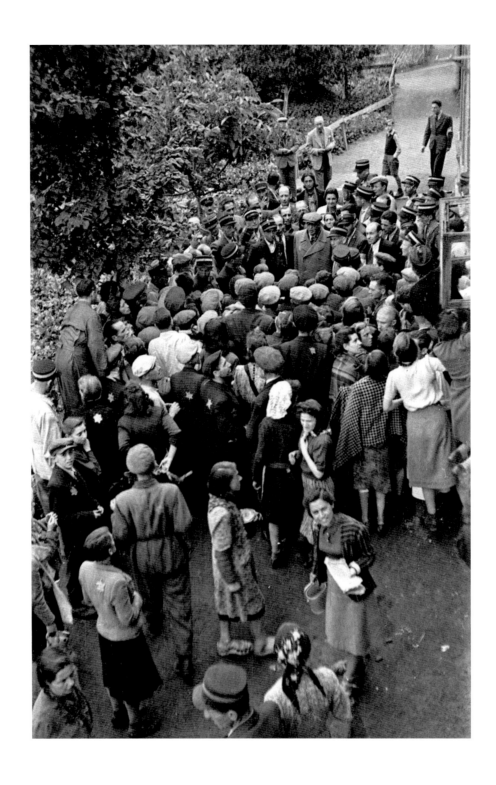

Mordechai Chaim Rumkowski, "Elder of the Jews" and chairman of the *Judenrat*,
speaks to a crowd, surrounded by ghetto police, 1940–1944, 2007/1957.11.

Postcard with portrait painting of Mordechai Chaim Rumkowski by Obraz Leizerowitza, 1940–1944, 3907/2281

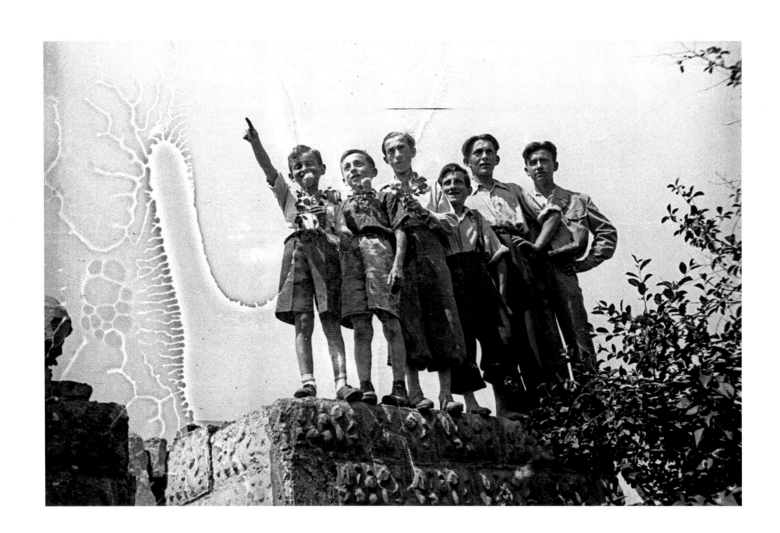

Ajzemann, Mordechai Chaim Rumkowski's personal guard, with children, 1941–1942, 2007/1979.1.

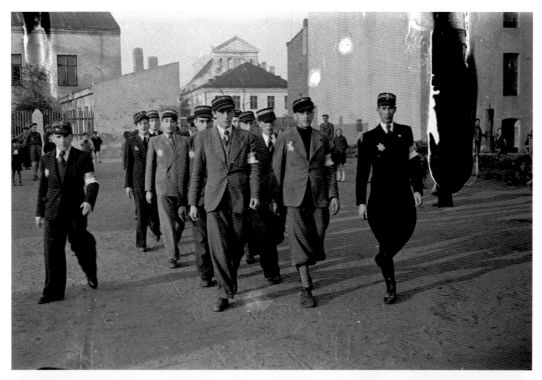

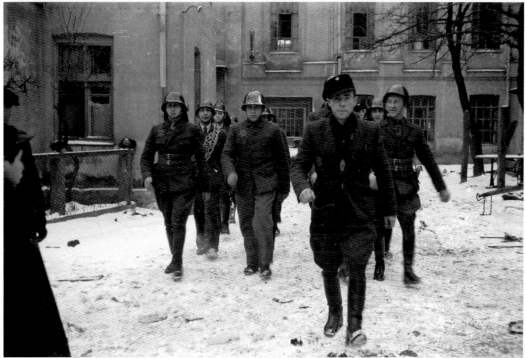

Jewish police in the Lodz Ghetto, 1940–1944, 2007/1970.27.
Fire brigade in the Lodz Ghetto, 1940–1944, 2007/2290.

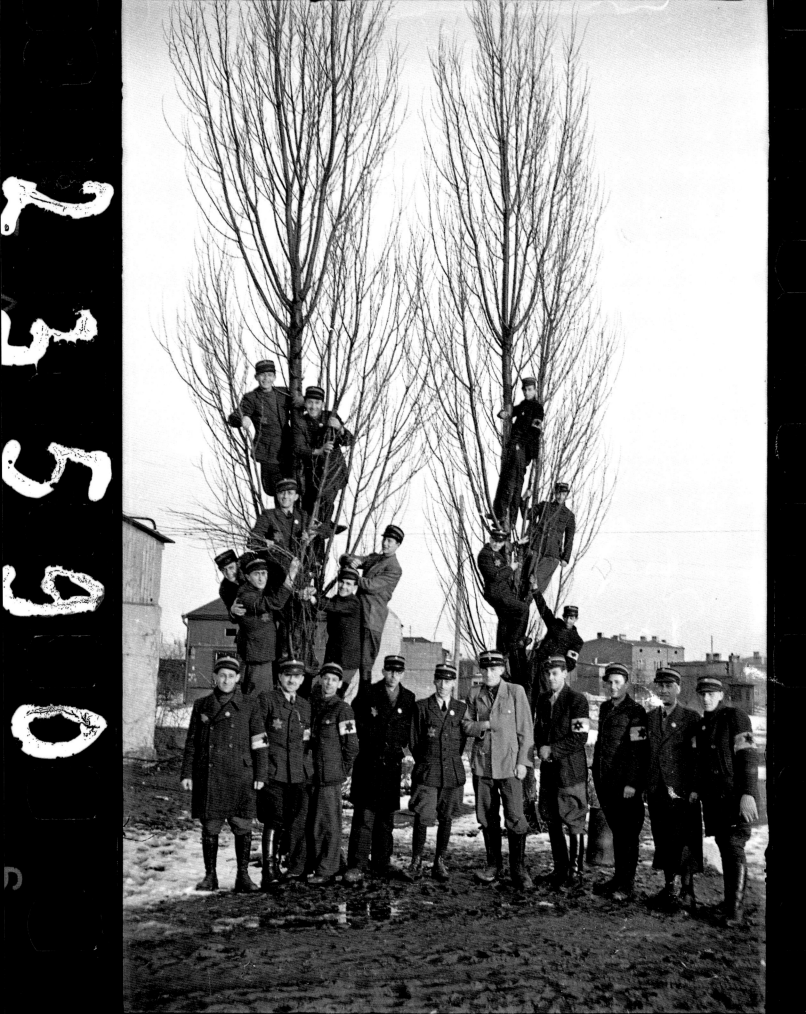

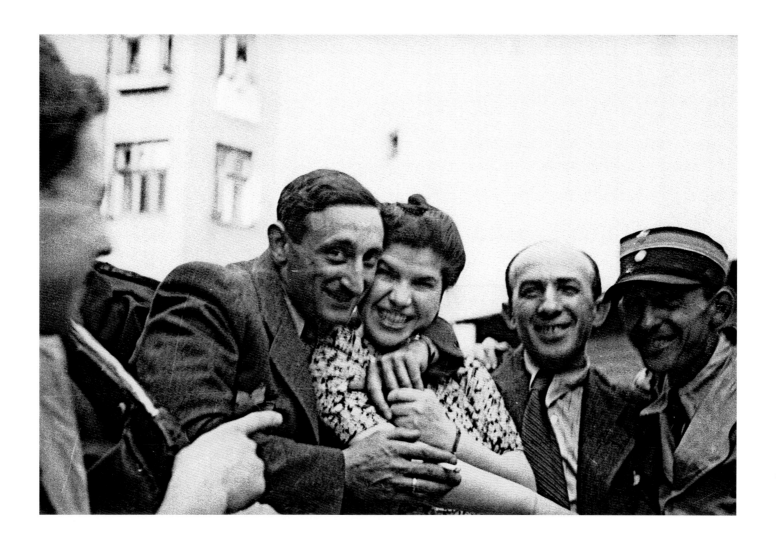

OPPOSITE Members of the Jewish police force performing for the camera, 1941–1942, 2007/2006.15.
A Lodz couple on a carriage ride, 1941–1942, 2007/1957.32.

49

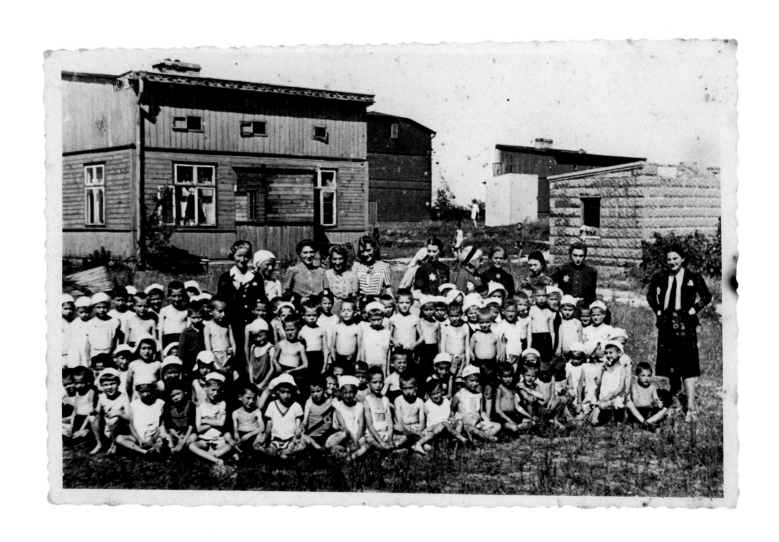

ABOVE AND OPPOSITE Children's orphanage, Marysin district, 1940, 2007/2040; 2007/1973.14.

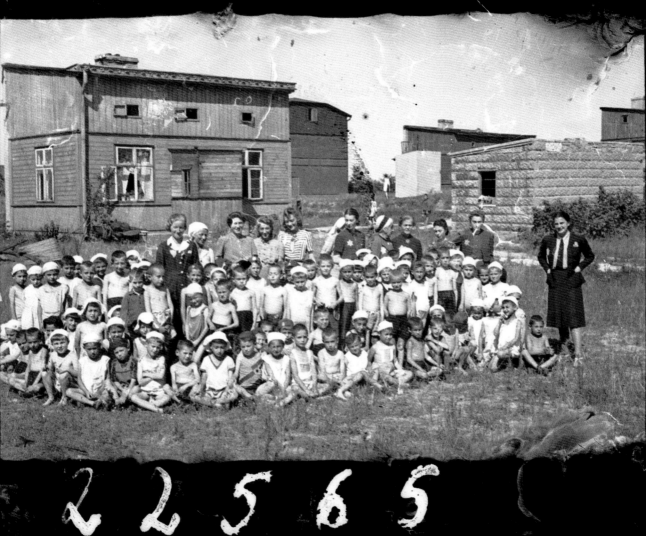

22565

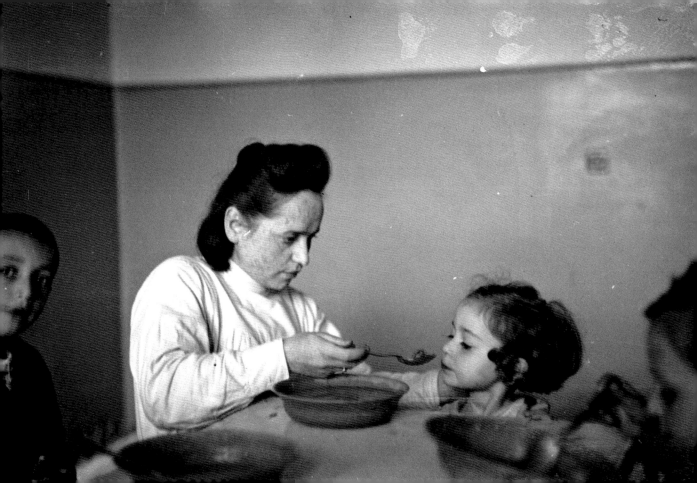

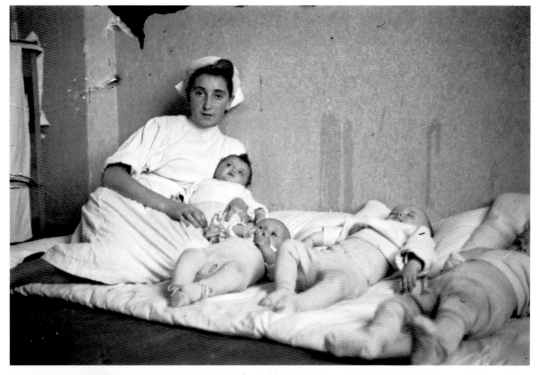

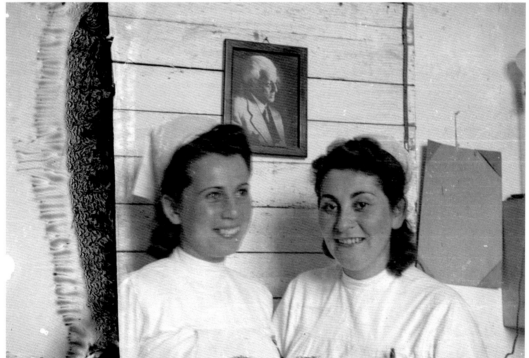

In the hospital nursery, 1942, 2007/1961.2.
Nursing staff with portrait of Mordechai Chaim Rumkowski, in the hospital, 1940–1942, 2007/1969.9.

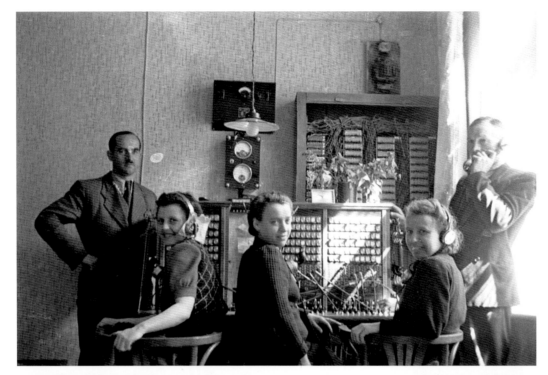

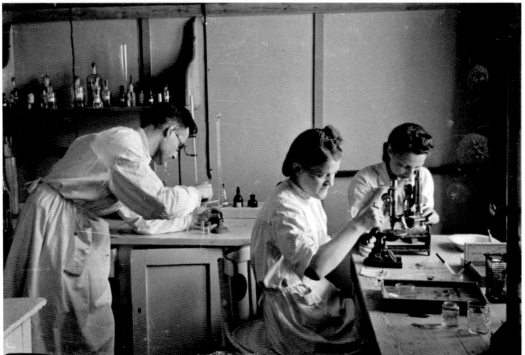

Telephone exchange workers, 1940–1942, 2007/1983.8.
In the hospital laboratory, 1940–1942, 2007/2013.1.

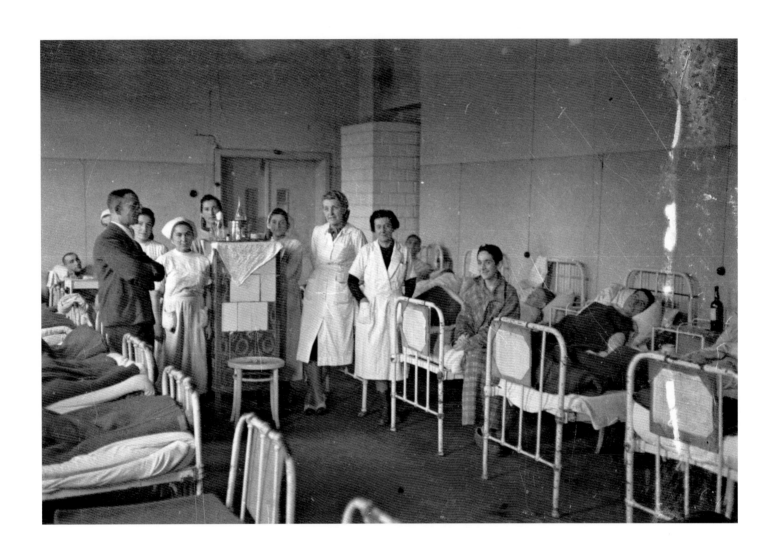

Hospital staff with doctor, possibly Dr. Dribin, 1940–1942, 2007/1987.10.

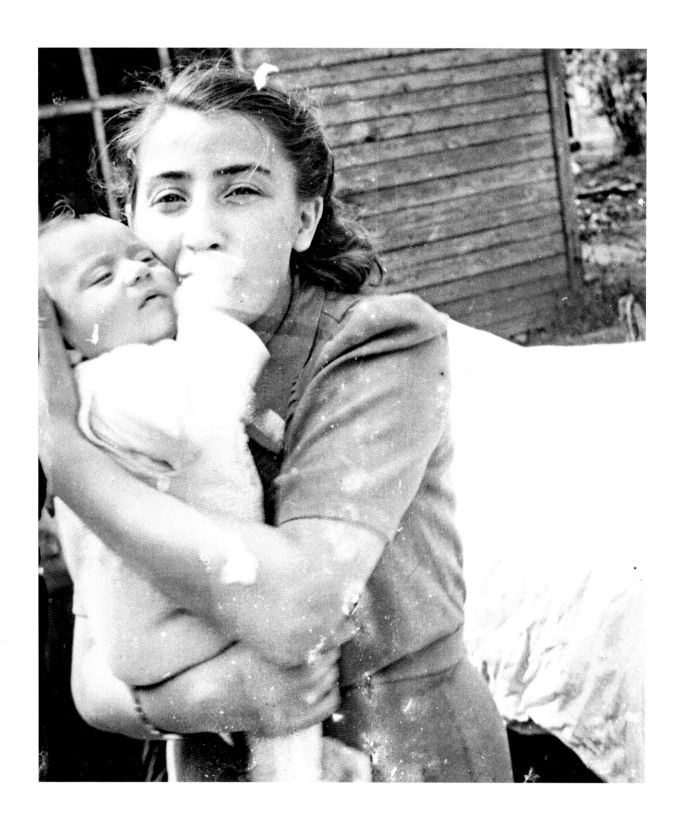

ABOVE AND OPPOSITE Ghetto policeman's family, 1940–1942,
2007/1988.14; 2007/1988.15; 2007/1988.16; 2007/1988.13.

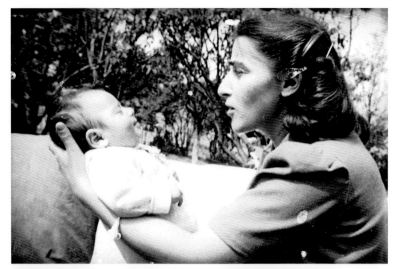

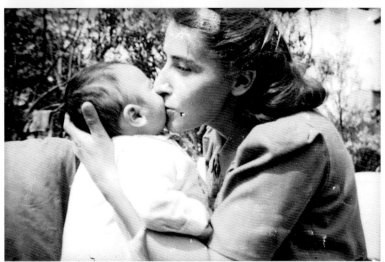

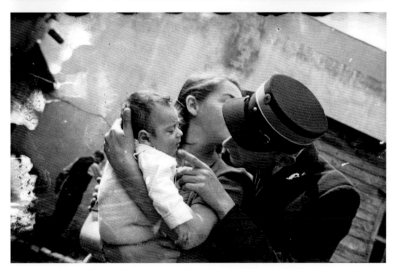

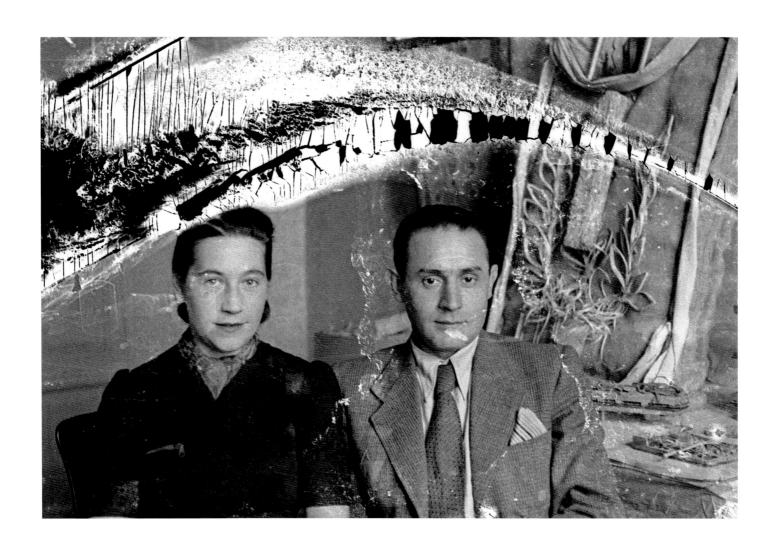

M. Rosen, manager of the Holzwollefabrik workshop, with his wife, 1942, 2007/1974.9.

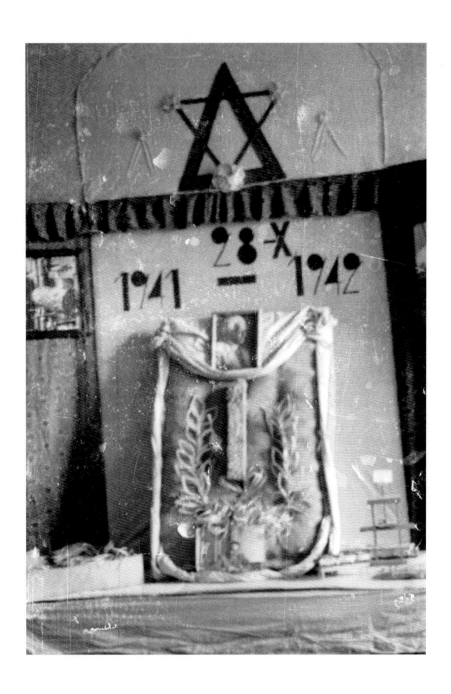

A plaque commemorating the Holzwollefabrik workshop,
with a portrait of Mordechai Chaim Rumkowski, 1942, 2007/1974.11.

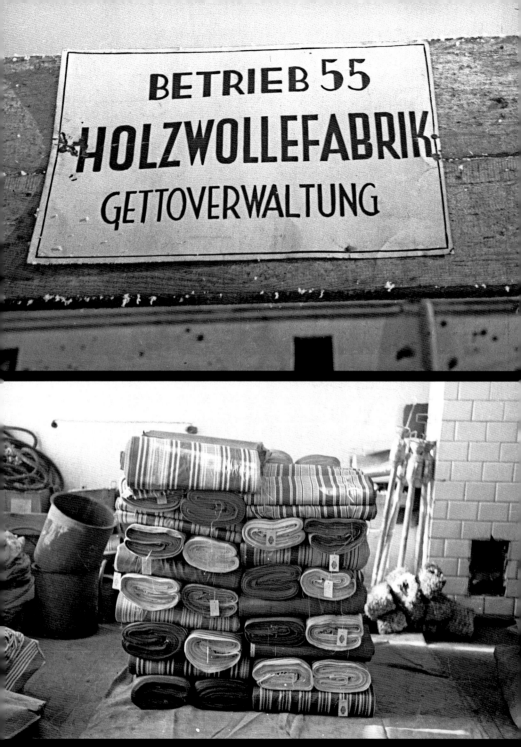

PAGES 60–63 Mattress and wood shavings production at the Holzwollefabrik workshop, 1942,
2007/1964.23; 2007/1965.3; 2007/1965.5; 2007/1965.6; 2007/1965.20; 2007/1965.1;
2007/1964.33; 2007/1964.14; 2007/1964.16; 2007/1964.19

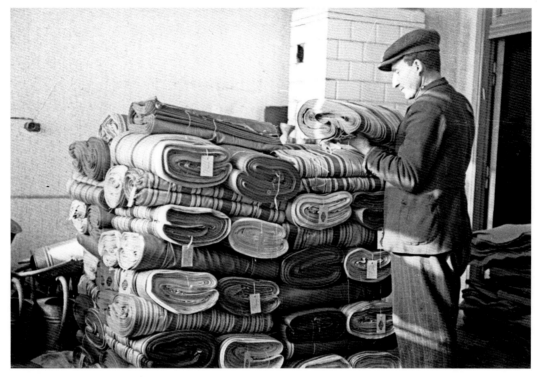

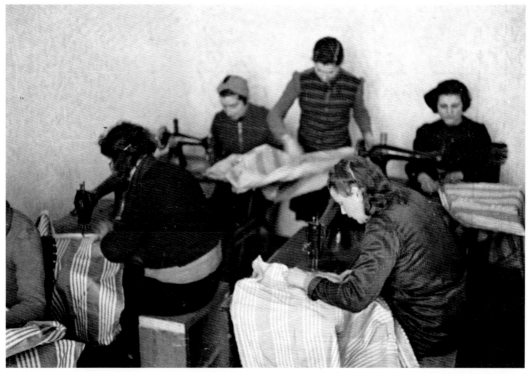

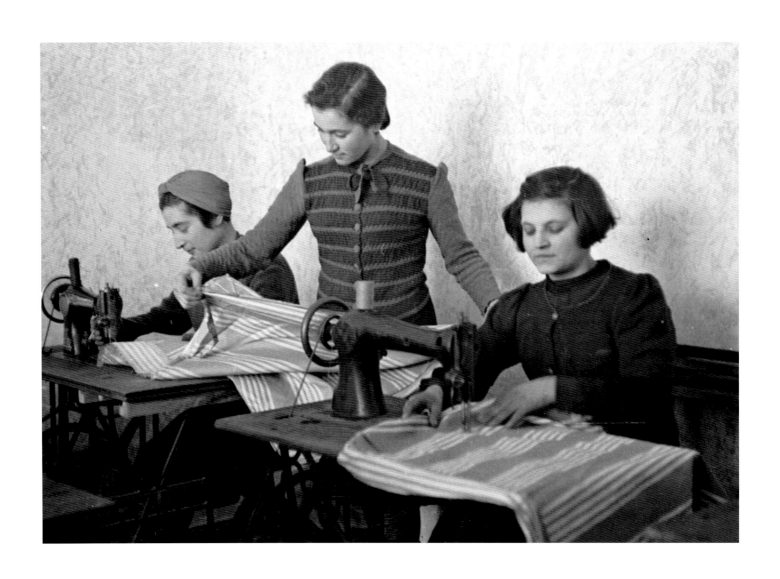

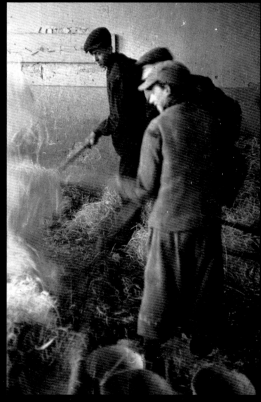

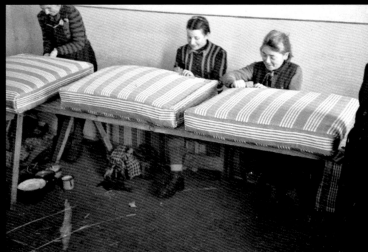

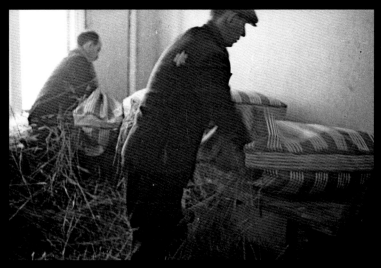

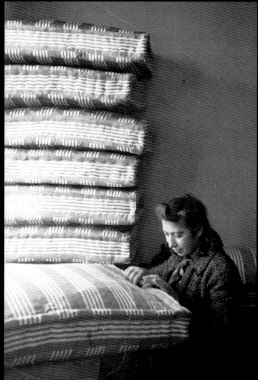

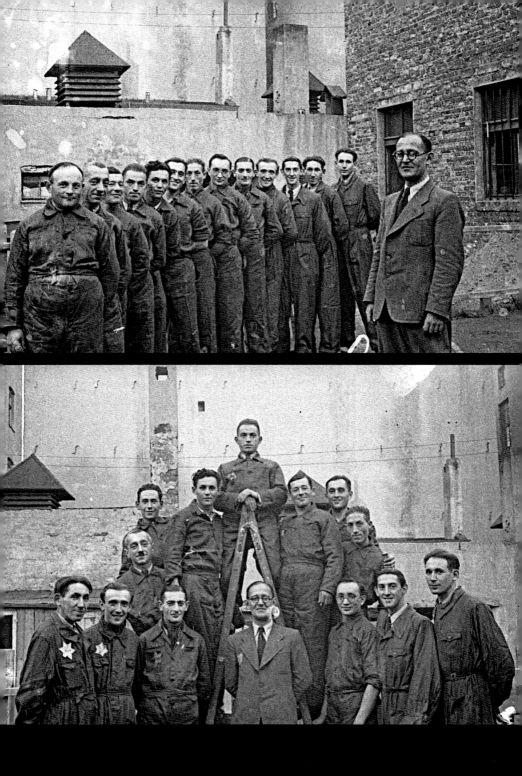

Ghetto hospital labourers with manager Kagan, 1940–1944, 2007/1975.23; 2007/1975.24

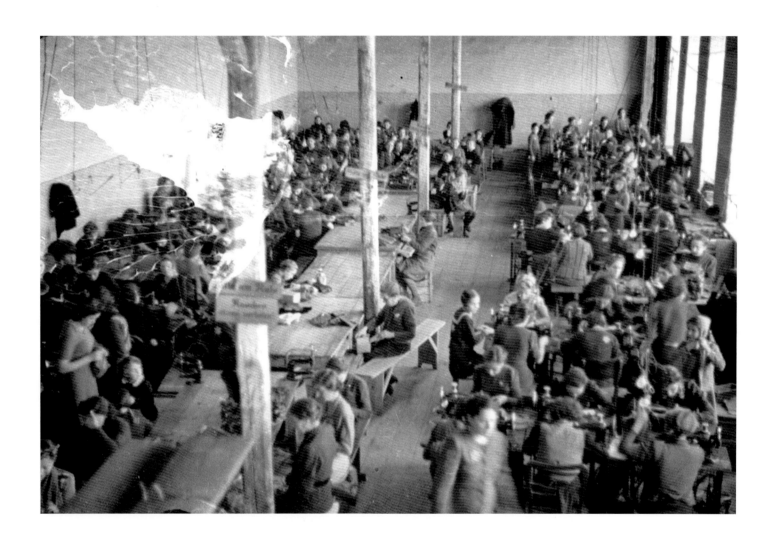

Advanced training of youth workers, Labour Department, 1940–1942, 2007/1965.13.

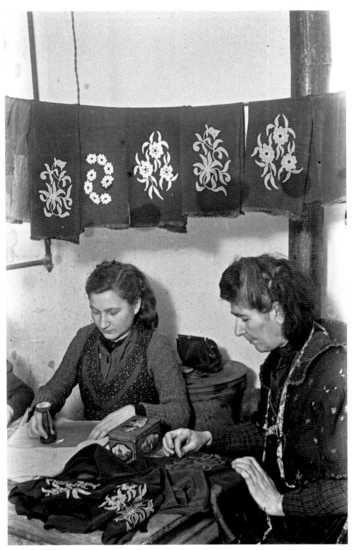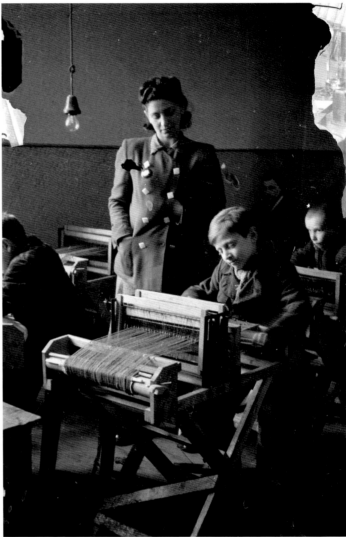

"Women embroidering goods for German shops" in the Textile Department, 1940–1944, 2007/1970.2.
Children learning to weave with Mrs. M. Bronowska, 1940–1942, 2007/1999.20.

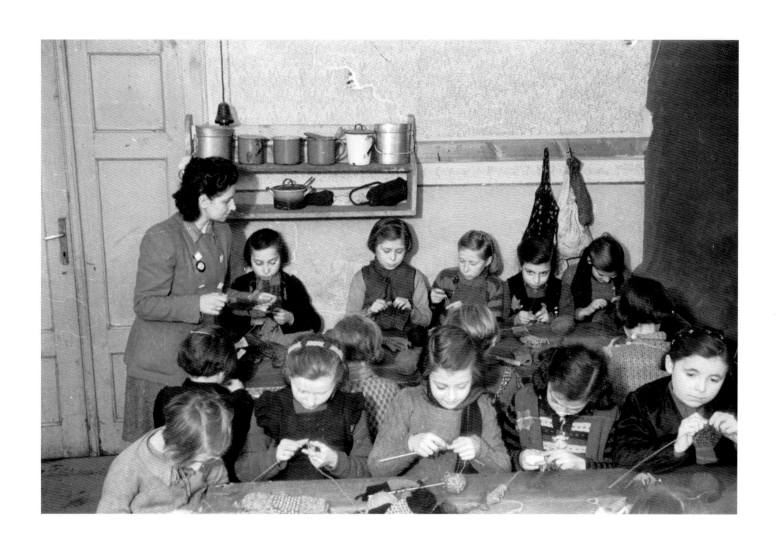

Children learning to knit with Mrs. M. Bronowska, 1940–1942, 2007/1999.23.

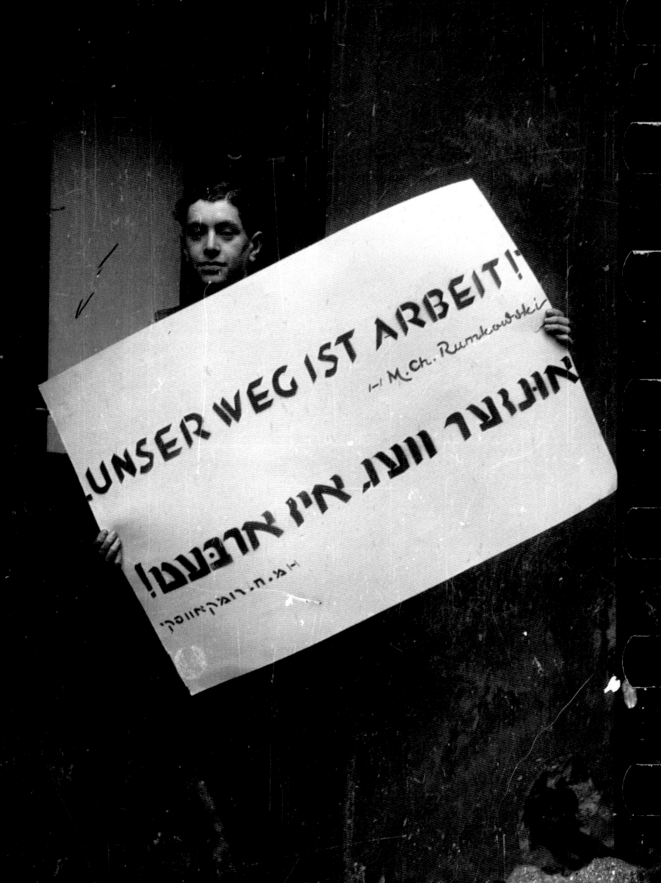

OPPOSITE Mordechai Chaim Rumkowski's motto, "Unser weg ist arbeit!" ("Our way is work!"), 1940–1944, 2007/1968.16.
A young girl working in the laundry room, 1940–1944, 2007/2133.

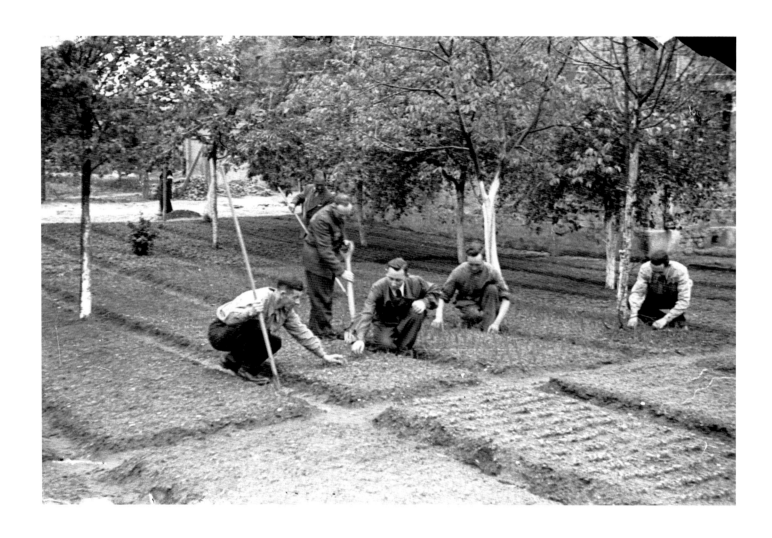

Young Zionist agricultural workers in the early days of the ghetto, 1940–1941, 2007/1957.20.

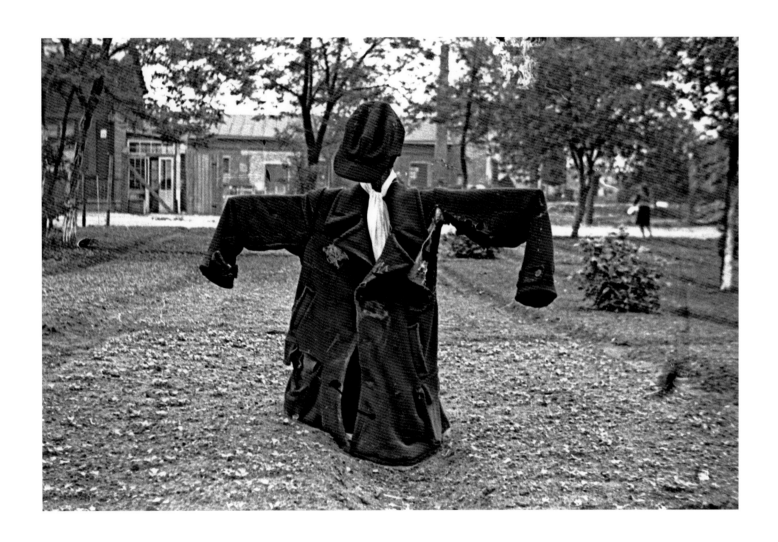

A scarecrow with a yellow *Jude* star, 1940–1941, 2007/1957.21.

An elderly resident of the ghetto, 1940–1944, 2007/1996.11.
Superintendent of ghetto departments, B. Praskier, 1940–1944, 2007/1991.9.

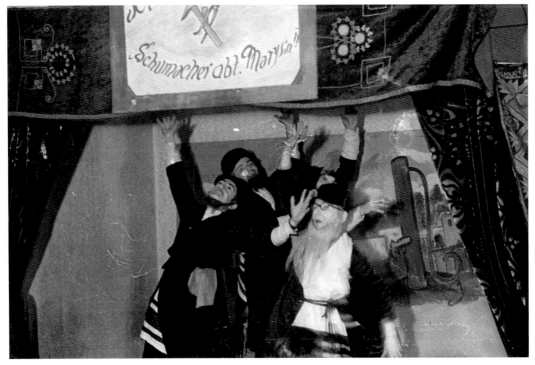

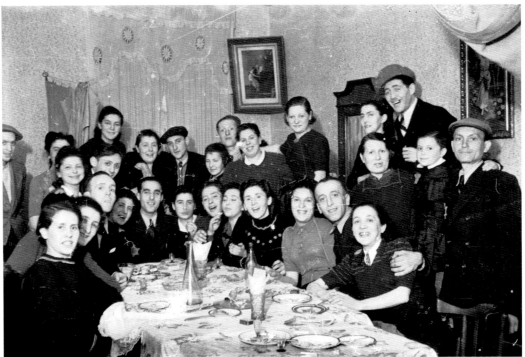

A performance of *Shoemaker of Marysin* in the factory, 1940–1944, 2007/1985.26.
A festive occasion, 1940–1944, 2007/2015.12.

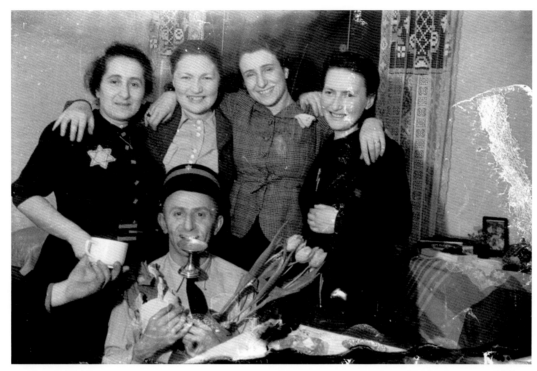

A ghetto policeman celebrating with friends, 1940–1944, 2007/1971.19.
Ghetto men posing, 1940–1942, 2007/2001.17.

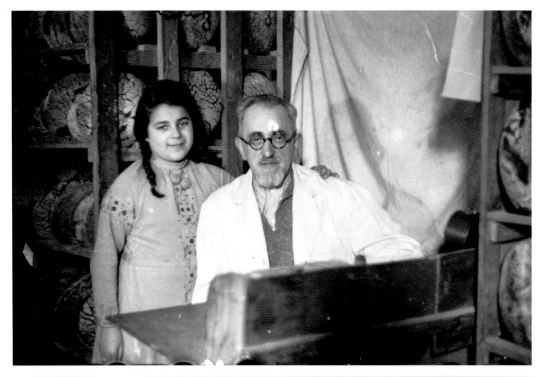

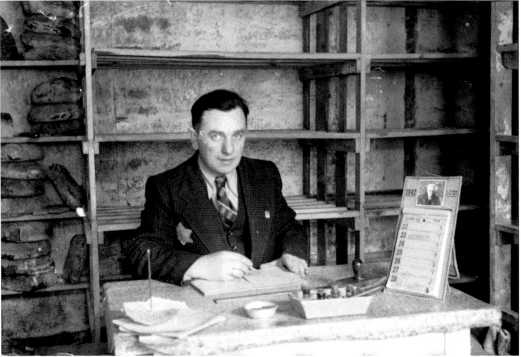

Manager with his daughter in the bakery, 1942, 2007/1989.11.
Administrator at his desk in the bakery, 1942, 2007/1989.21.

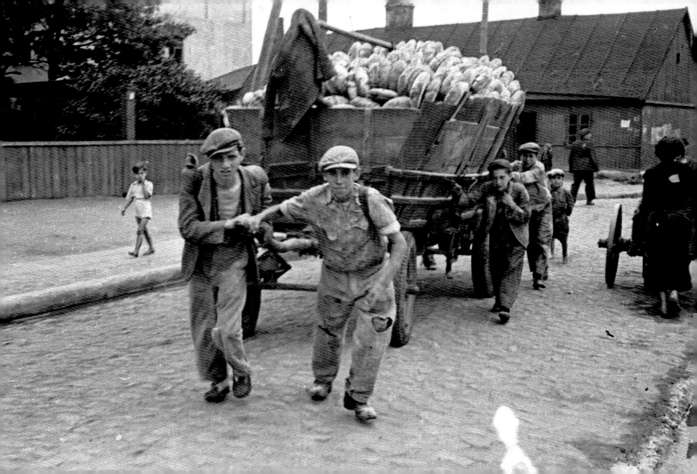

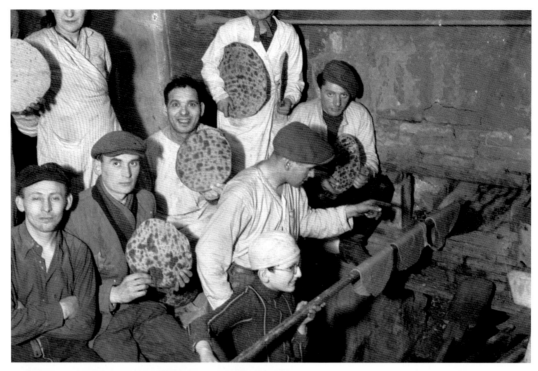

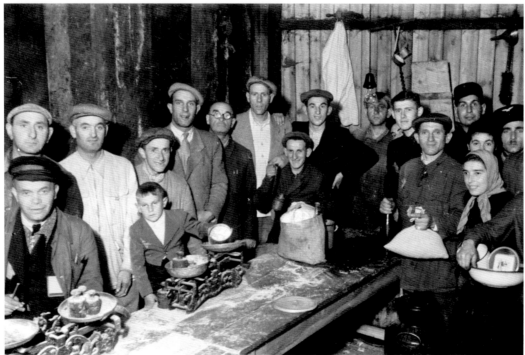

"In the ghetto's first year, the bakery of matzos was permitted." 1940, 2007/1965.9.
Food distribution, ration centre, 1940–1944, 2007/1963.3.
OPPOSITE Attendants in charge of food and provisions stored in the Lodz Ghetto church, 1940–1944, 2007/2006.2.

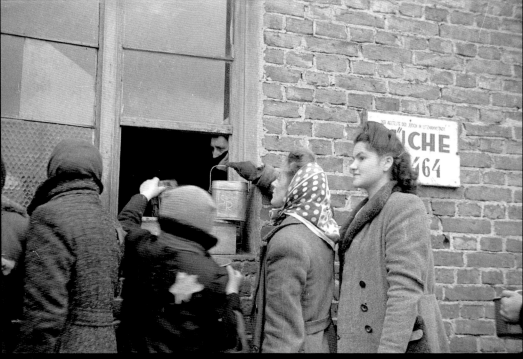
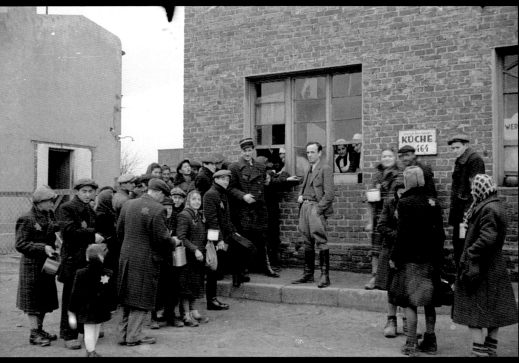

Line-up at the soup kitchen, 1942, 2007/2021.12.
Group waiting at the soup kitchen, 1942, 2007/1958.12.

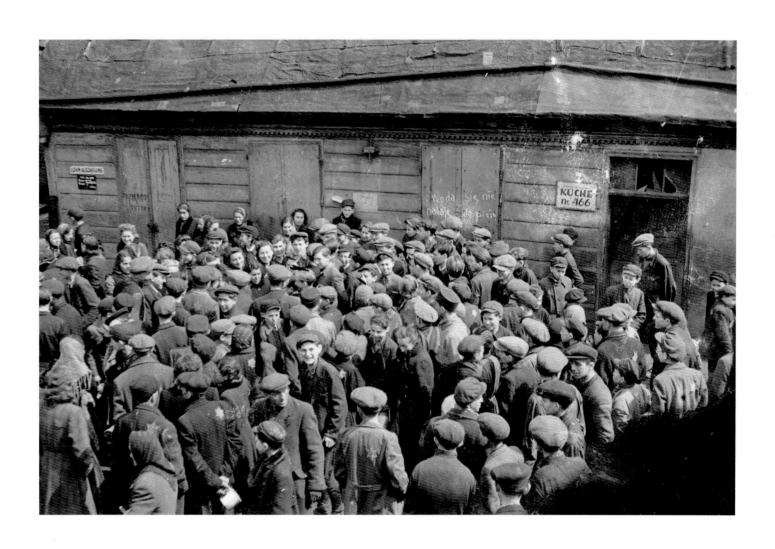

"People protesting in front of kitchen against food which contained 98 percent water." 1943–1944, 2007/1961.21.

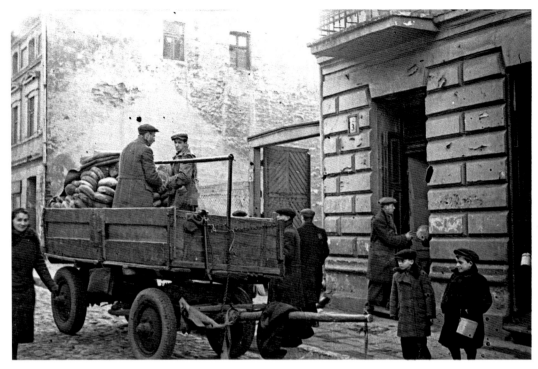

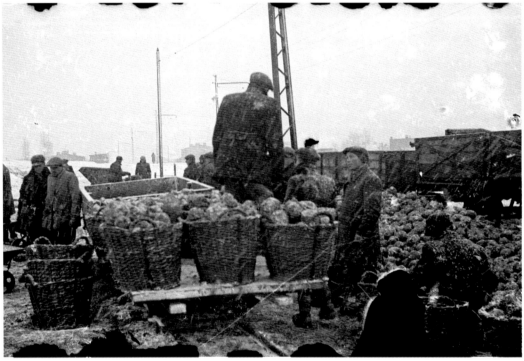

"Bread for the people of the ghetto. It was brought to distribution shops.
Children look on yearningly. How to get a little of it." 1940–1944, 2007/1956.24.

"Delivery of food to the ghetto, the lion's share not fit for human
consumption. It [cabbage] was rotten and frozen." 1940–1944, 2007/1968.7.

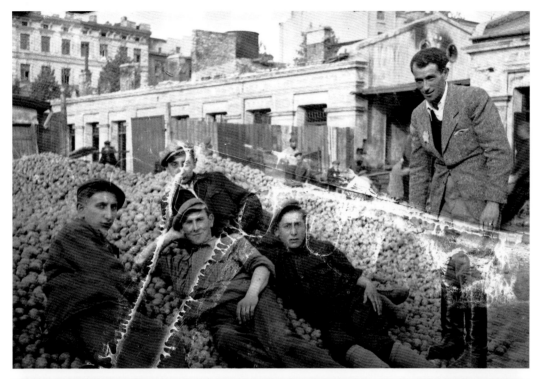

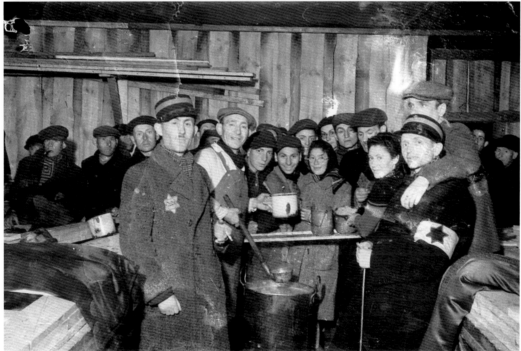

Delivery of potatoes to the ghetto, 1940–1944, 2007/2016.25.
"Distribution of soup in the workplace." 1940–1944, 2007/1963.12.

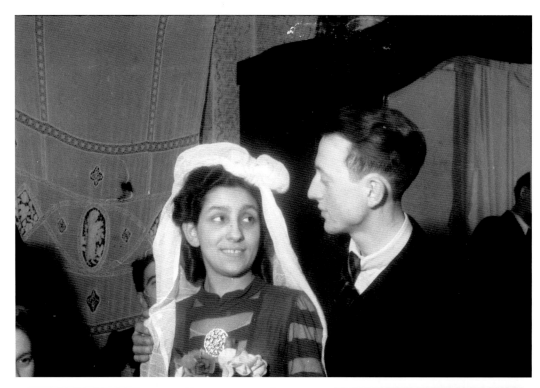

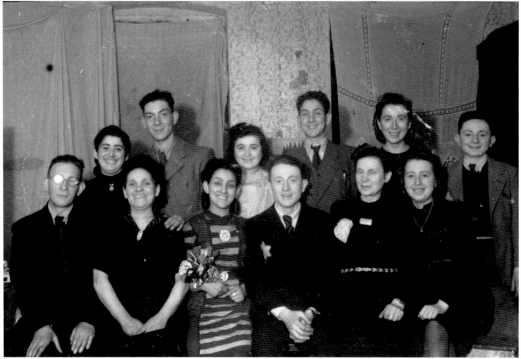

A wedding in the ghetto, 1940–1944, 2007/1986.19; 2007/1986.22.

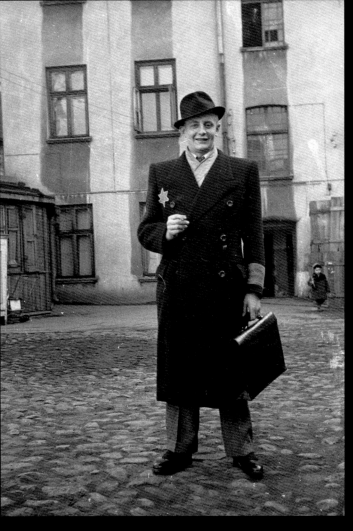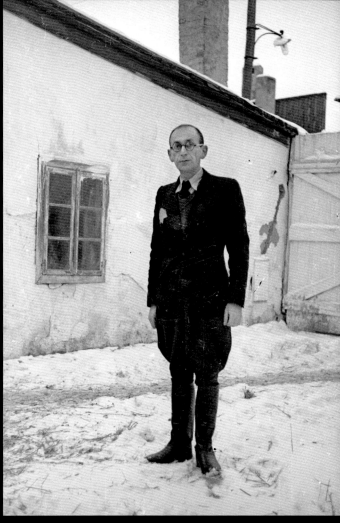

A well-dressed ghetto official, 1940–1944, 2007/1996.12.
Transport Department administrator Mr. Elefant, 1940–1944, 2007/1995.21.

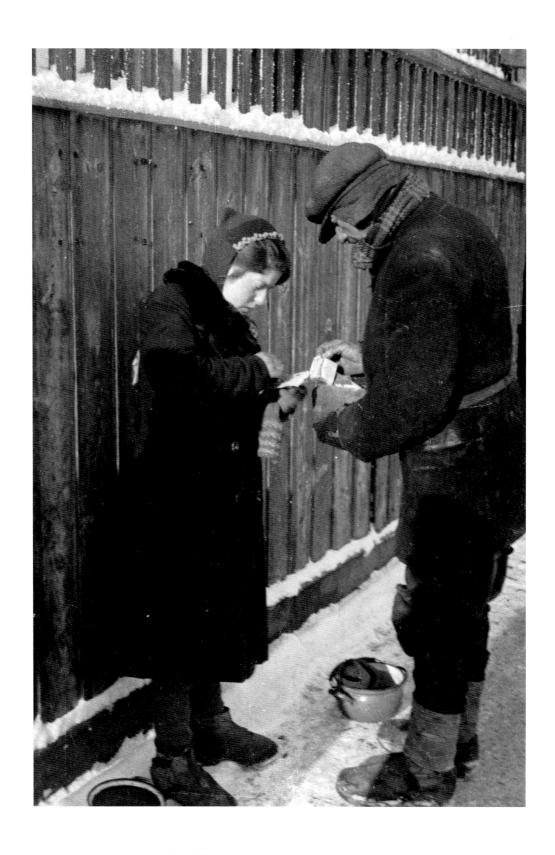

Street life in the ghetto, 1940–1942, 2007/2022.67.

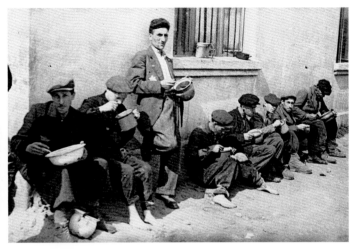
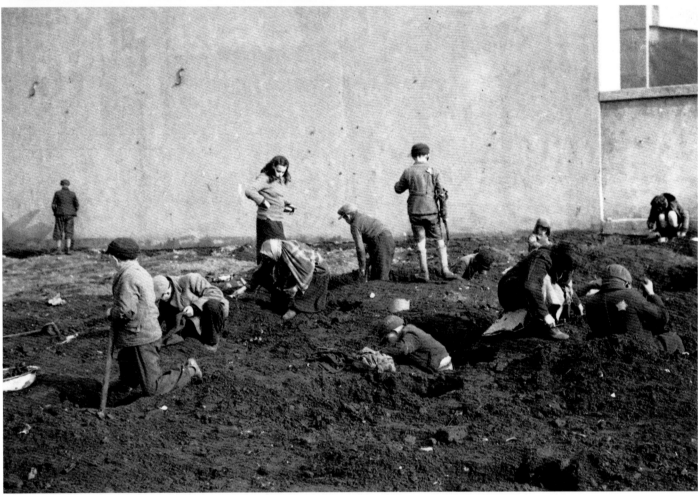

A woman trading *Jude* stars in the ghetto, 1940–1942, 2007/1972.6.
"Soup for lunch." 1940–1944, 2007/1967.3.
"Children searching in the ground for waste food, coal, wood." 1940–1944, 2007/1999.11.

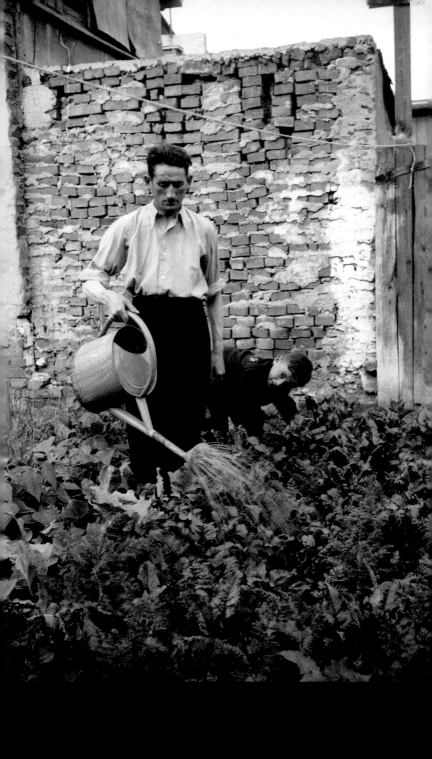

A ghetto resident tending to a garden in hope of food, 1940–1944. 2007/1992.25

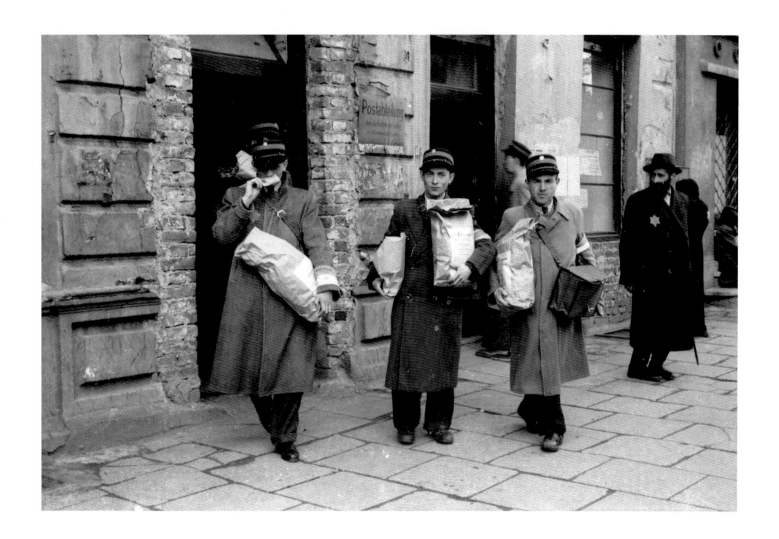

Ghetto police with bags of bread and provisions, 1940–1944, 2007/2022.167.

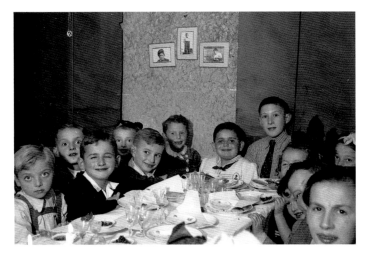

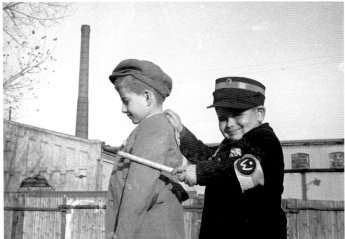

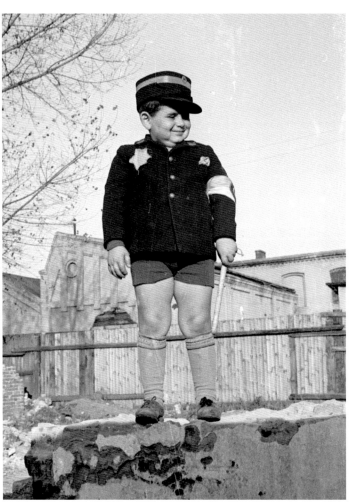

A children's party, with guests who had *"more money,"* after 1942, 2007/2016.10.
Playing policeman, after 1942, 2007/1976.24; 2007/1976.21.

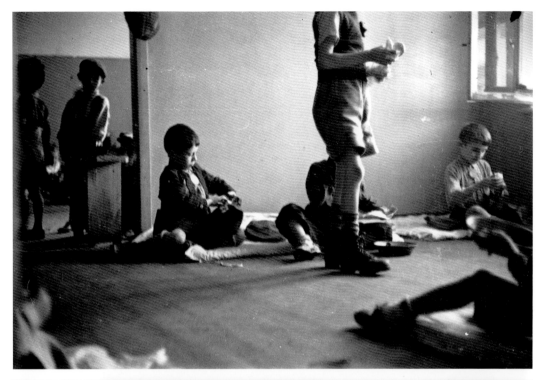

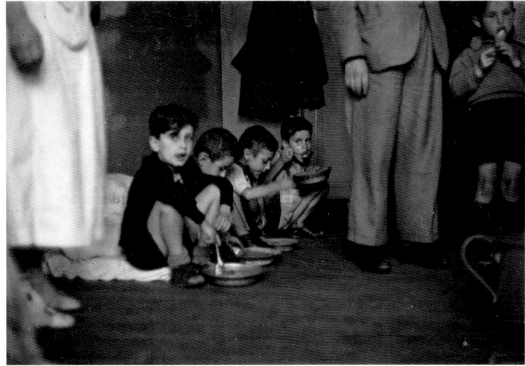

Care and provisions in the children's colony, Marysin, 1940–1942, 2007/1961.5; 2007/1960.29.

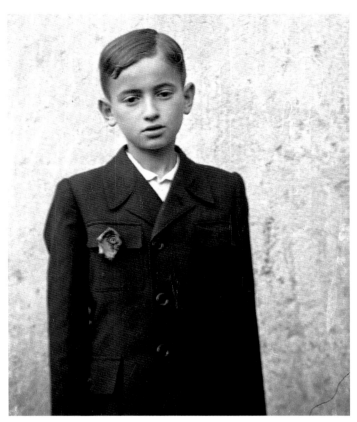 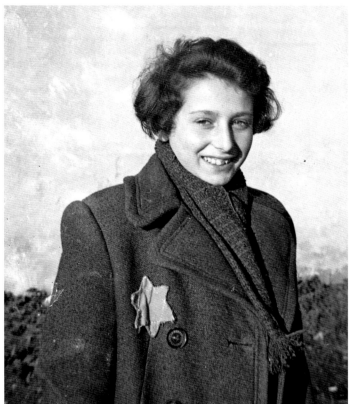

A young boy in the ghetto, 1940–1944, 2007/1992.18.
A young girl in the ghetto, 1940–1944, 2007/2017.16.

A grandmother and grandson in the ghetto, 1940–1944, 2007/1086.1

"In the beginning burials in the ghetto were made individually.
Later the collection of bodies was on a massive scale." 1940–1944, 2007/1955.14.

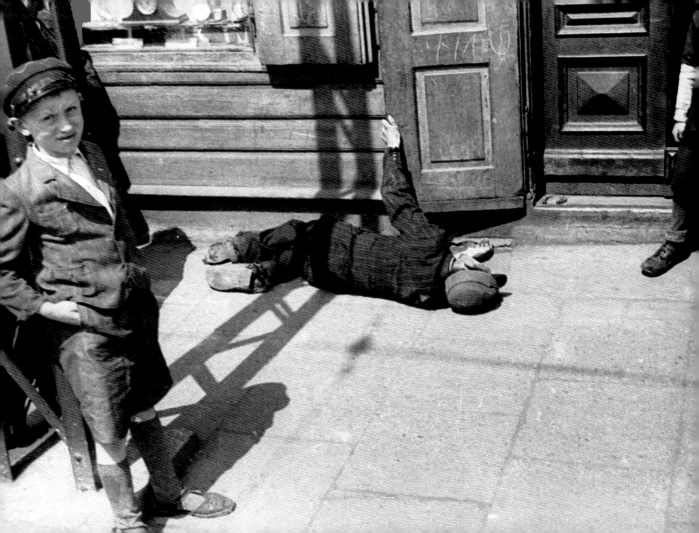

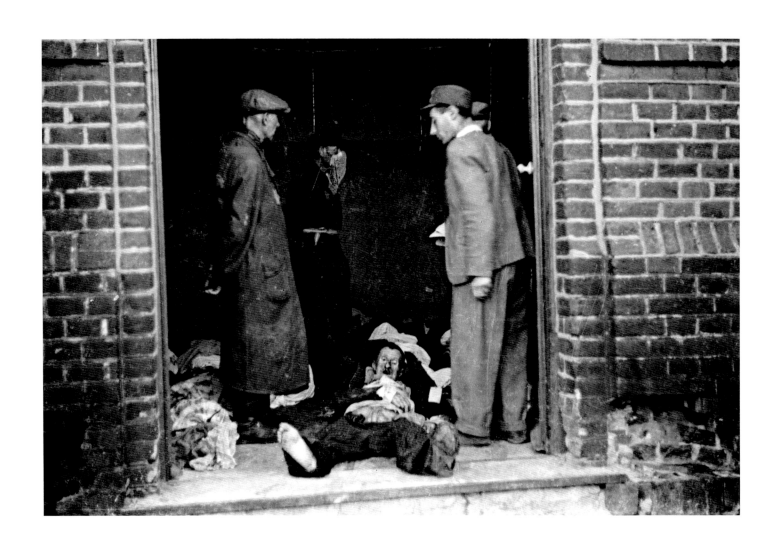

The ghetto morgue, 1940–1944, 2007/2022.151.

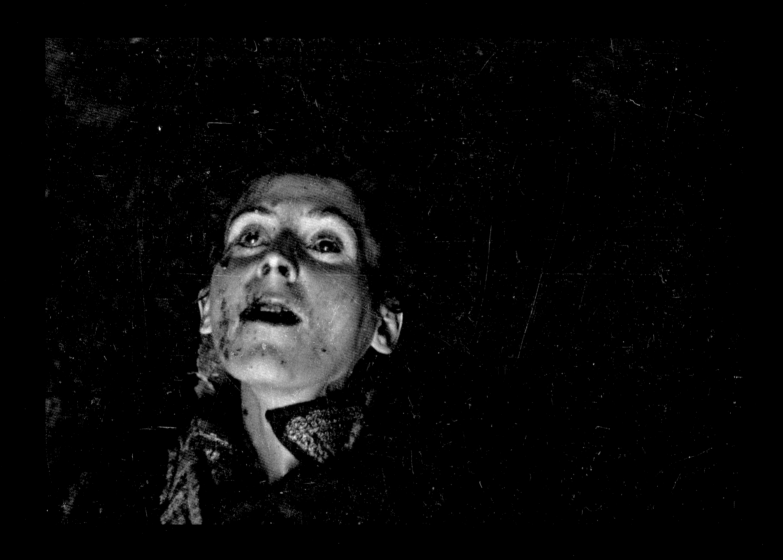

A young ghetto victim in the morgue, 1940–1944, 2007/2021.11.

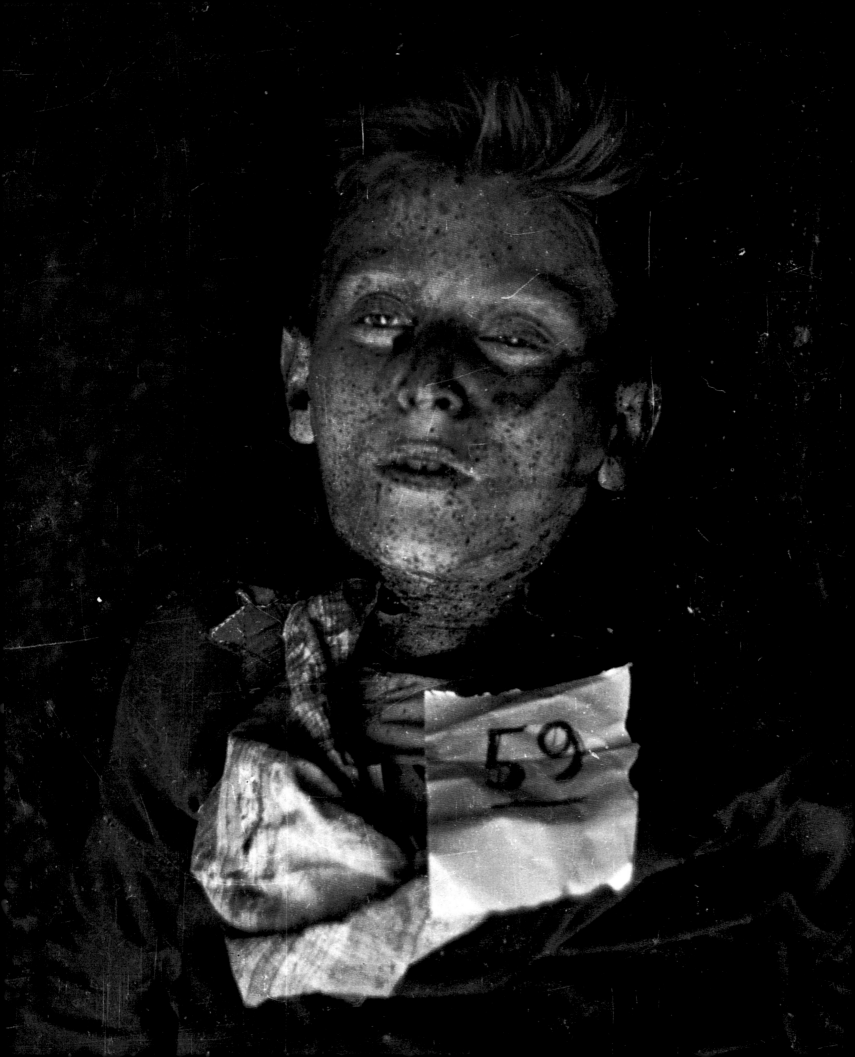

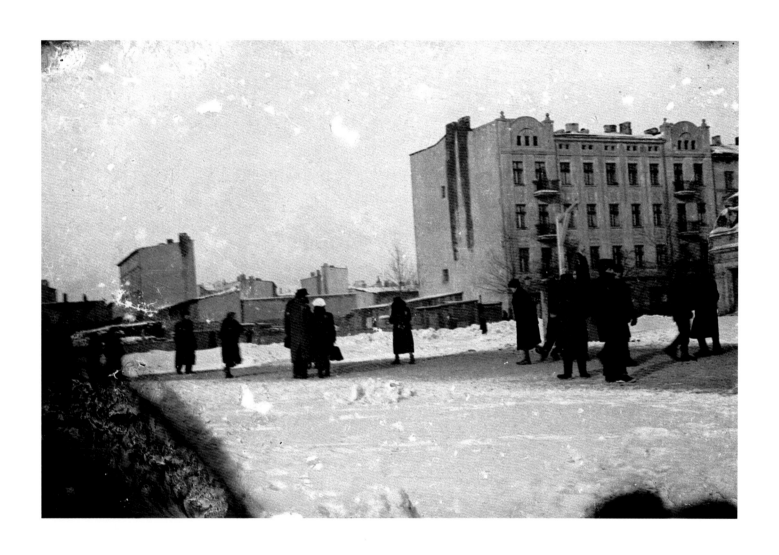

OPPOSITE A young ghetto victim in the morgue, 1940–1944, 2007/2021.10.
"Executions. The gallows in operation." 1940–1944. 2007/1967.13.

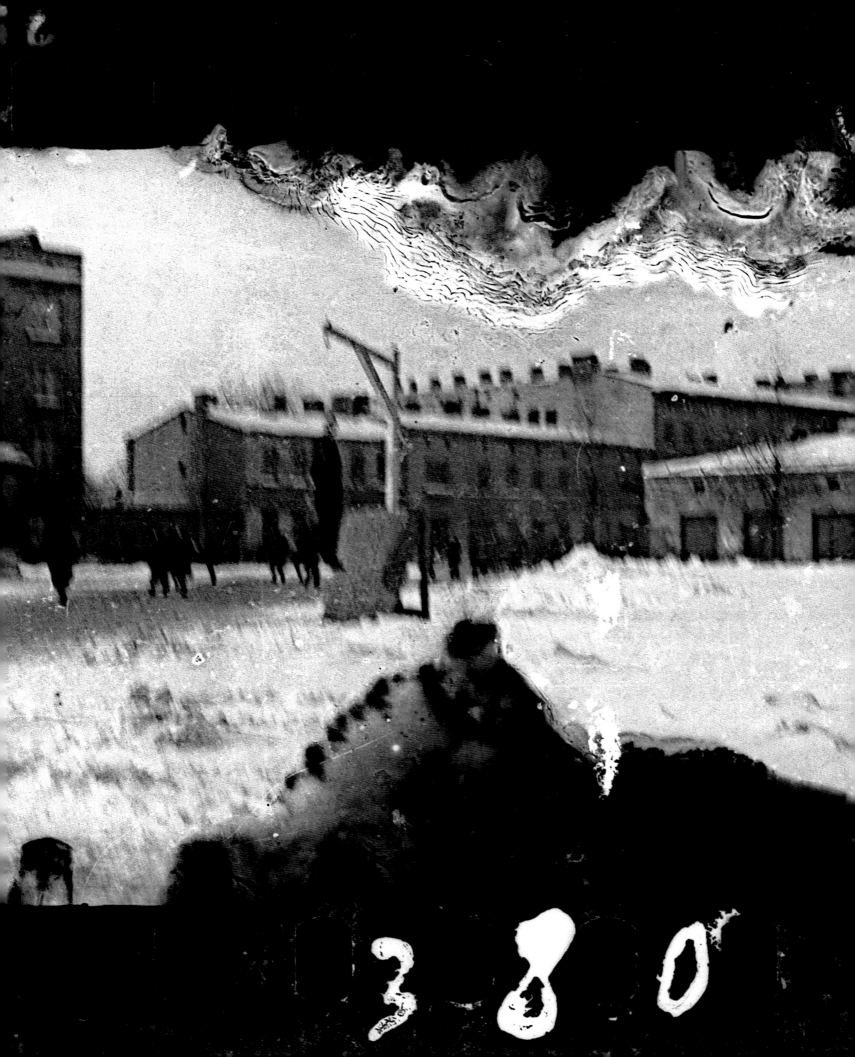

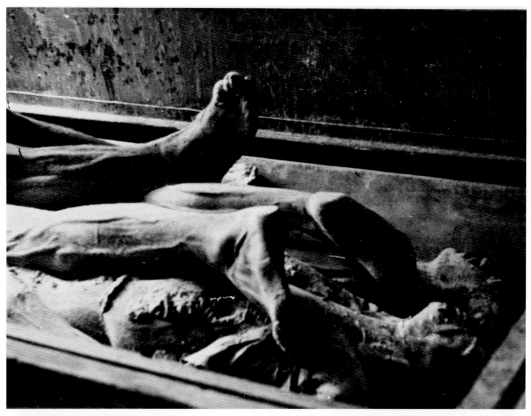

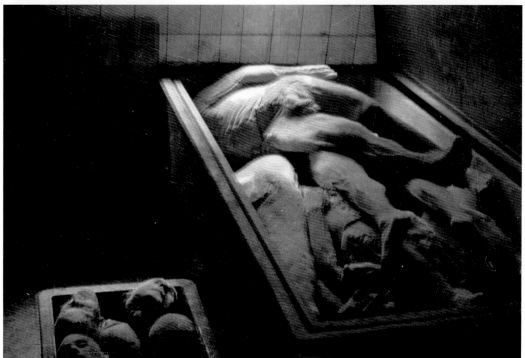

OPPOSITE *"The gallows in operation."* 1940–1944, 2007/1967.10.
Corpses and body parts in the morgue, 1940–1944, 2007/2304; 2007/2022.102.

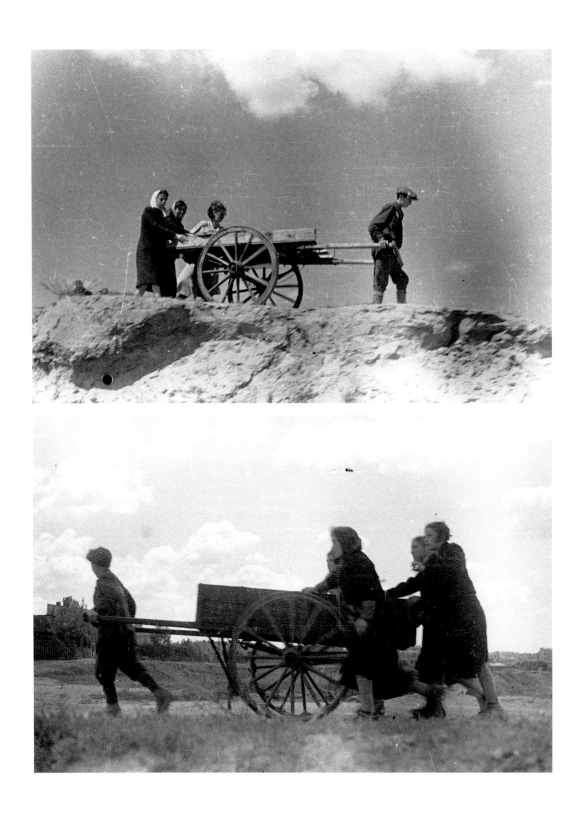

A young boy pulling a hearse to the burial ground, 1940–1944, 2007/2022.38; 2007/2002.36.

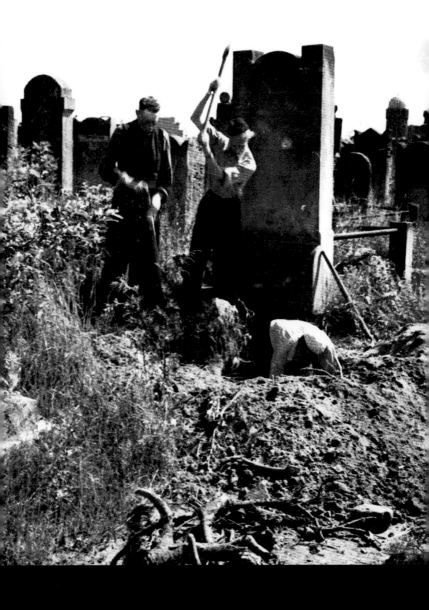

Digging a grave at the ghetto cemetery, 1940–1944. 2007/2022.308

Mordechai Chaim Rumkowski talking to attentive youth, 1940–1944, 2007/2022.211.
Henryk Ross photomontage promoting work in the ghetto to the Germans, 1940–1944, 2007/1962.26.

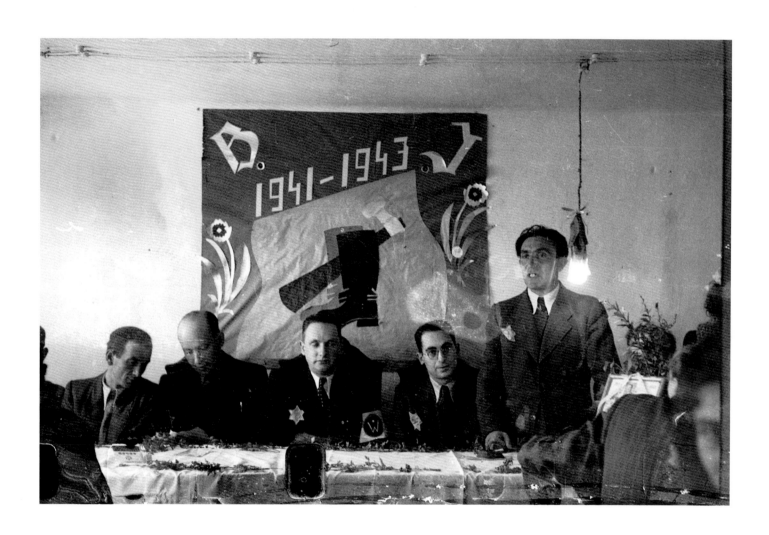

Administration of the leather factory, 1943, 2007/1985.17.

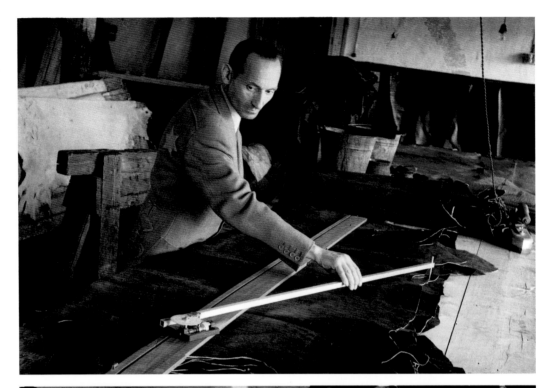

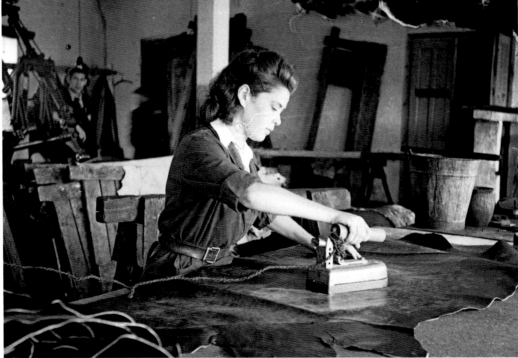

Production in the leather factory, 1943, 2007/2003.3; 2007/2000.27.

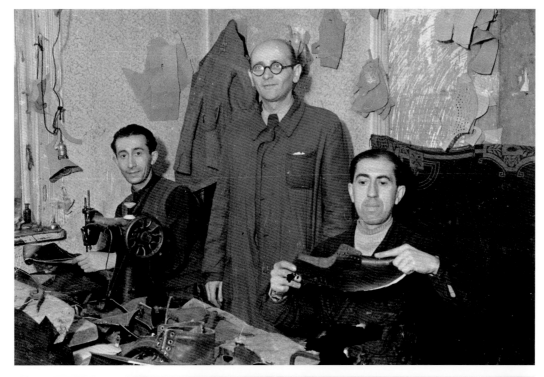

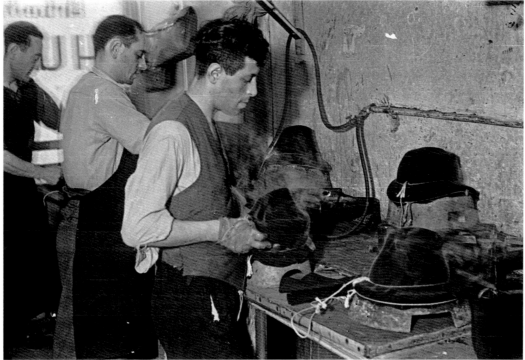

Production in the leather factory, 1943, 2007/1996.1.
Workers in the hat workshop, 1942–1944, 2007/1968.25.

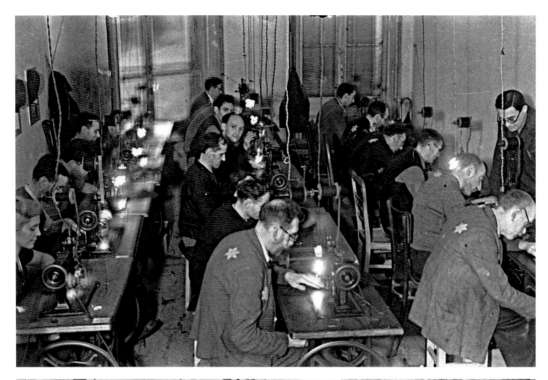

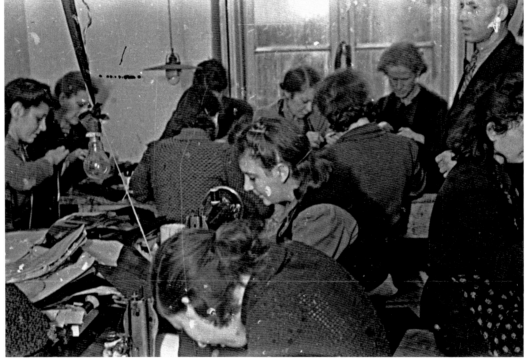

Workers in the Textile Department, 1942–1944, 2007/2134.
Workers in the Textile Department sewing, 1940–1944, 2007/1967.34.

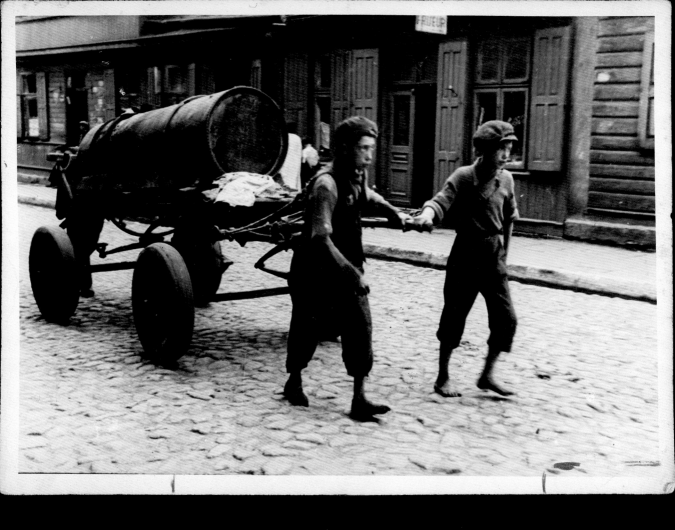

Young boys hauling a cart in the ghetto, 1940–1944, 2007/2086.

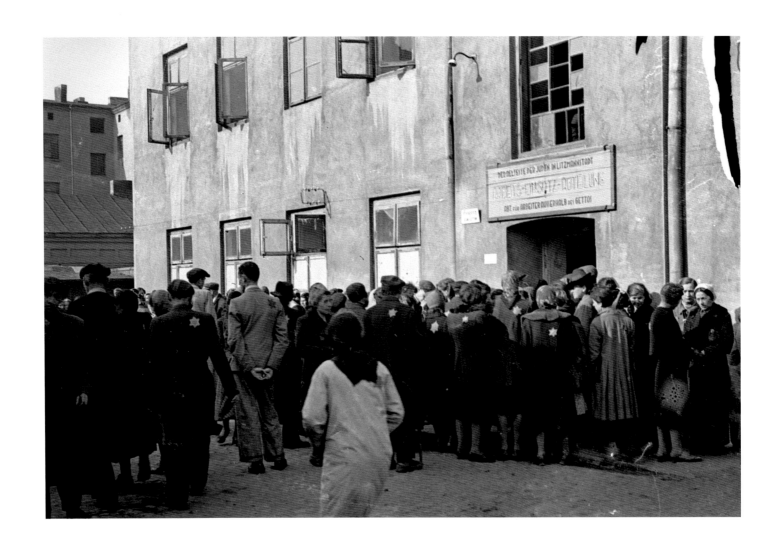

Ghetto residents seeking work at an employment office, 1940–1944, 2007/1967.25.

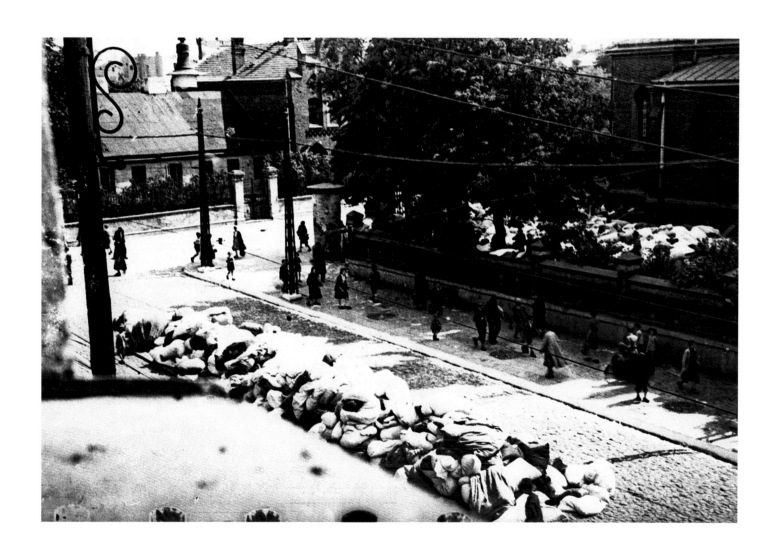

"The Catholic Church in Kosielny Square, in which the Nazis collected down and feathers [in bags] taken from Jews, for transport to Germany." 1943, 2007/1955.26.

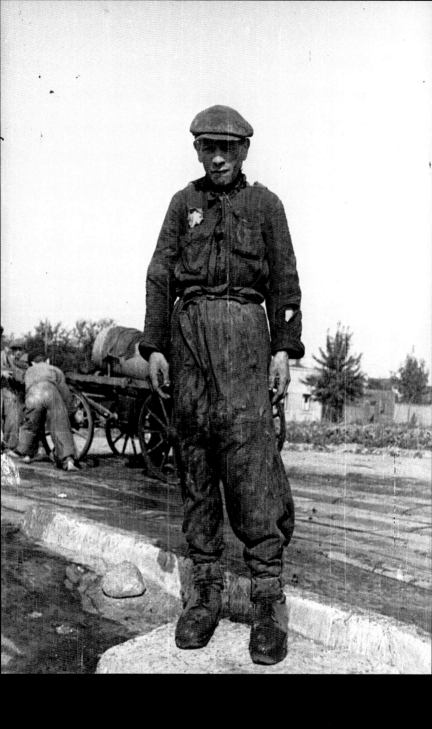

A fecal worker in the ghetto, 1943–1944, 2007/1966.16.

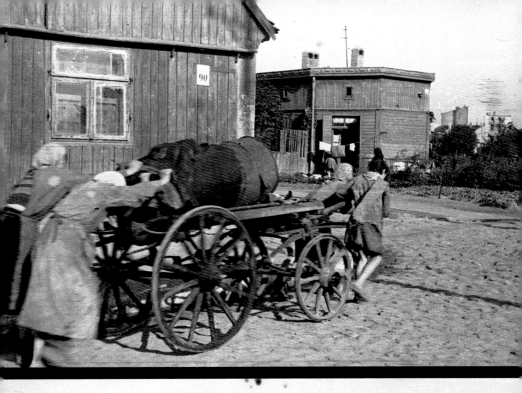

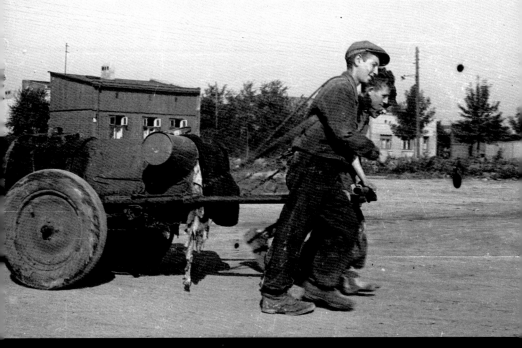

PAGES 113–117 The removal of feces in the ghetto by men and women workers, 1943–1944, 2007/1966.1; 2007/1966.3; 2007/1966.4; 2007/1966.5; 2007/1966.6; 2007/1966.7; 2007/1966.8; 2007/1966.10; 2007/1966.18; 2007/1966.19; 2007/1966.20; 2007/1966.21; 2007/1966.22; 2007/1966.23; 2007/1966.29; 2007/1966.30; 2007/1966.31; 2007/1966.15; 2007/1966.26; 2007/1966.11; 2007/1966.12; 2007/1966.13; 2007/1966.14

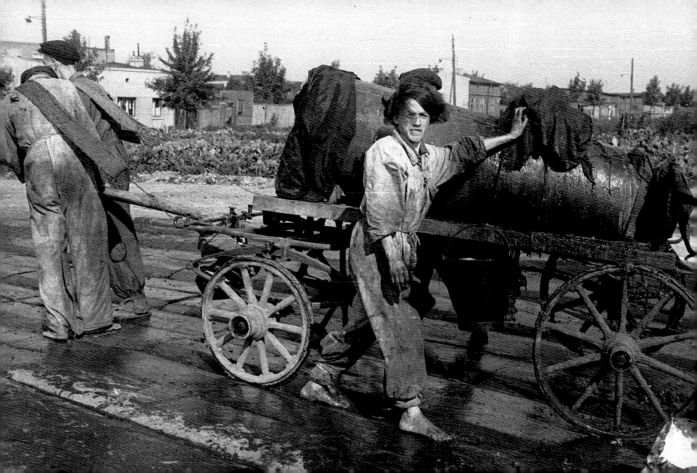

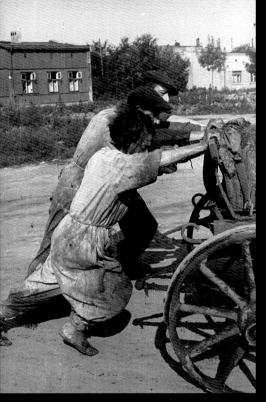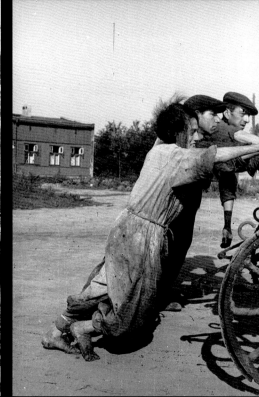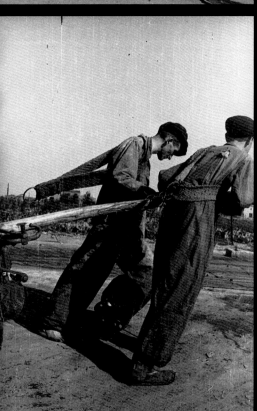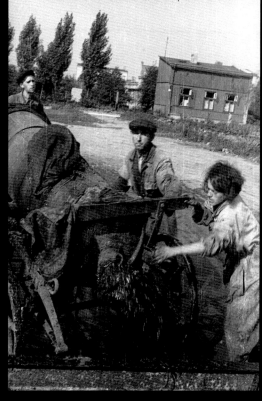

"Great distress, deportation from hospital." 1942, 2007/1961.6.

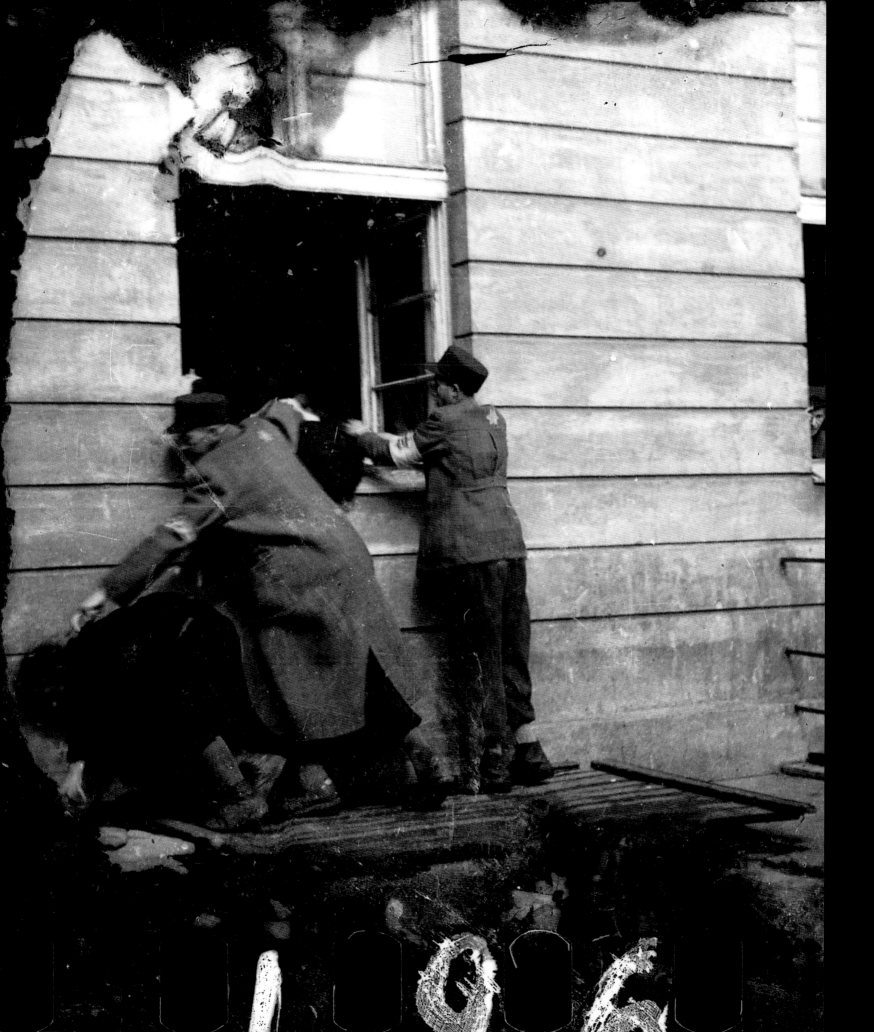

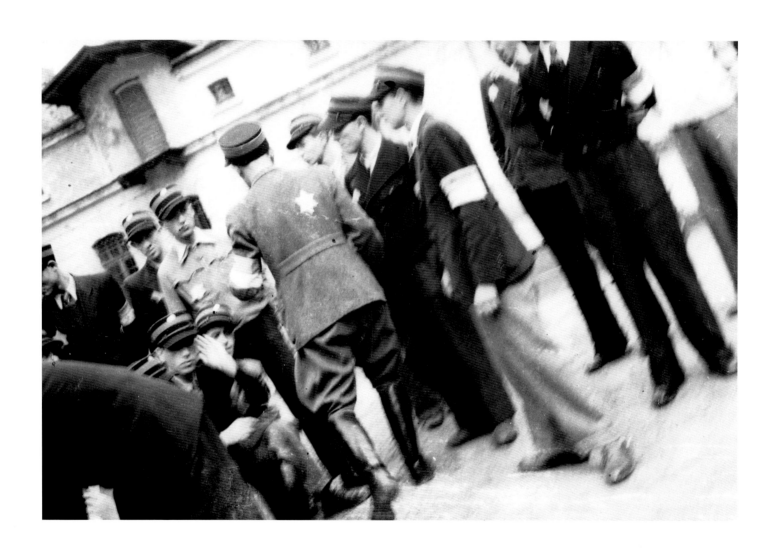

Assembly of ghetto police preparing to deport residents, 1942–1944, 2007/2015.7.

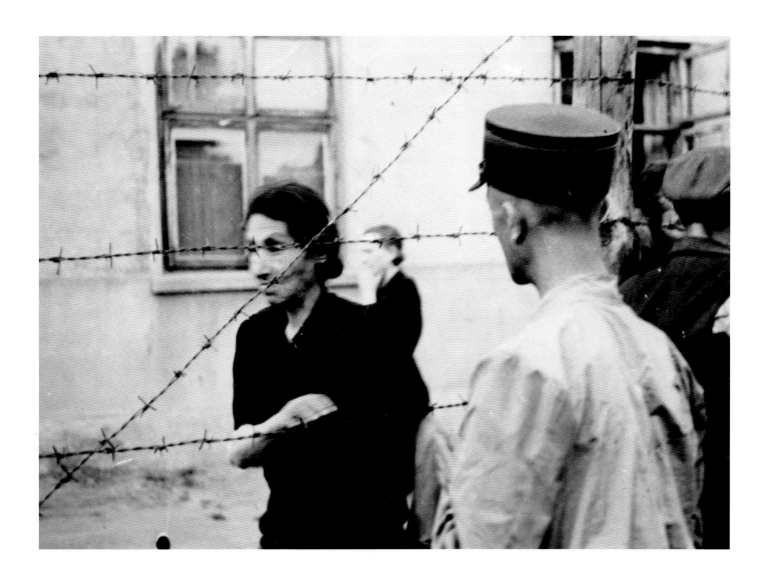

Ghetto police with woman behind barbed wire, 1940–1944, 2007/2185.

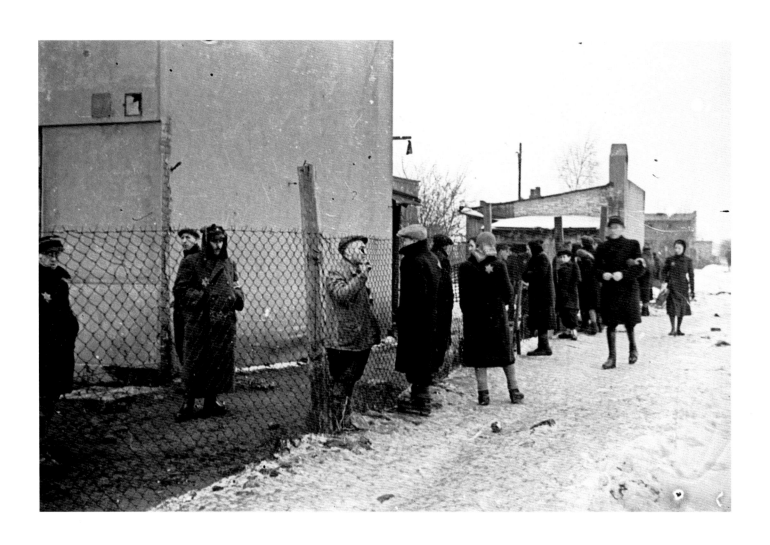

Ghetto residents held for deportation, 1942, 2007/1963.29.

OPPOSITE *"Opposite the prison at Czarnecki Street, which was a rallying point before deportation."* 1940–1942, 2007/2066.

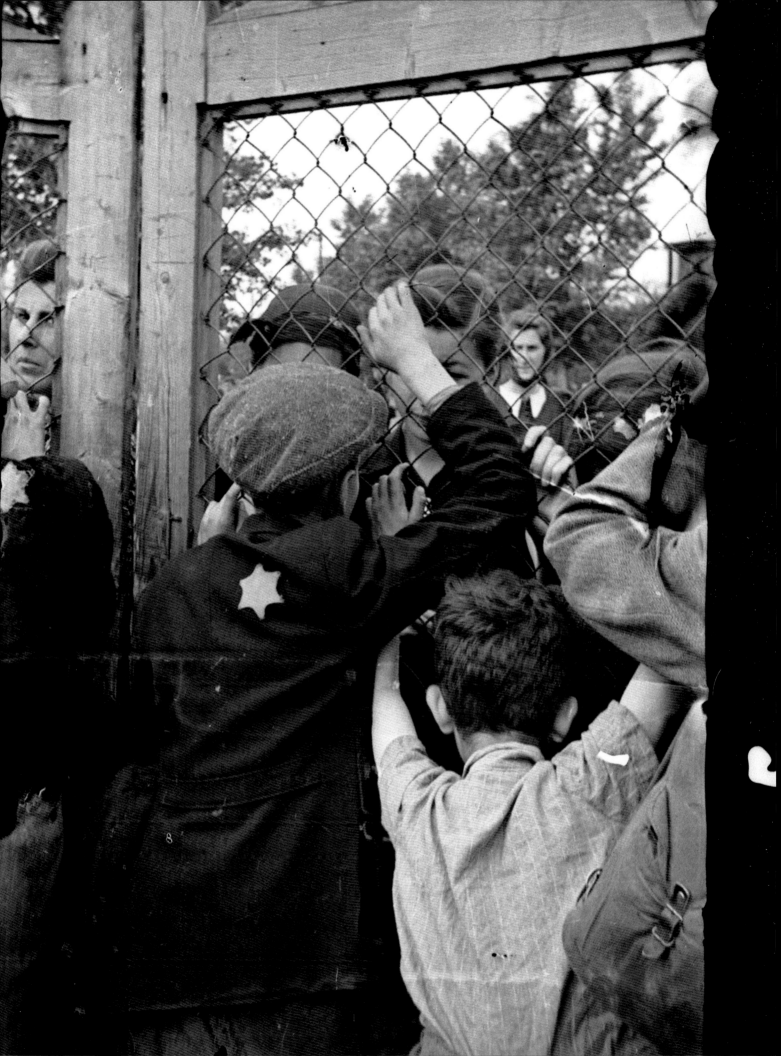

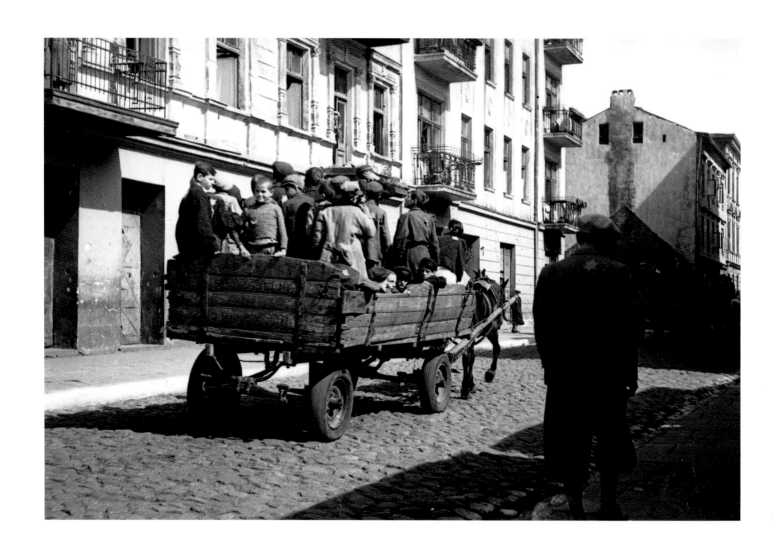

Children being deported to the Chełmno nad Nerem (renamed Kulmhof) death camp, 1942, 2007/1961.13.

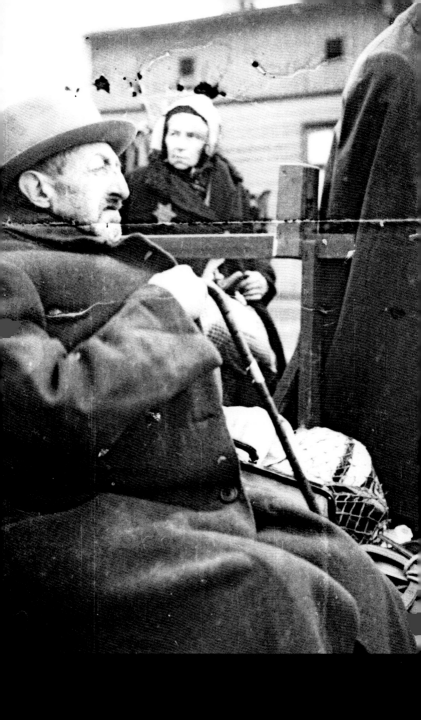

An elderly ghetto resident being deported to the Chełmno death camp, 1942. 2007/1959.8

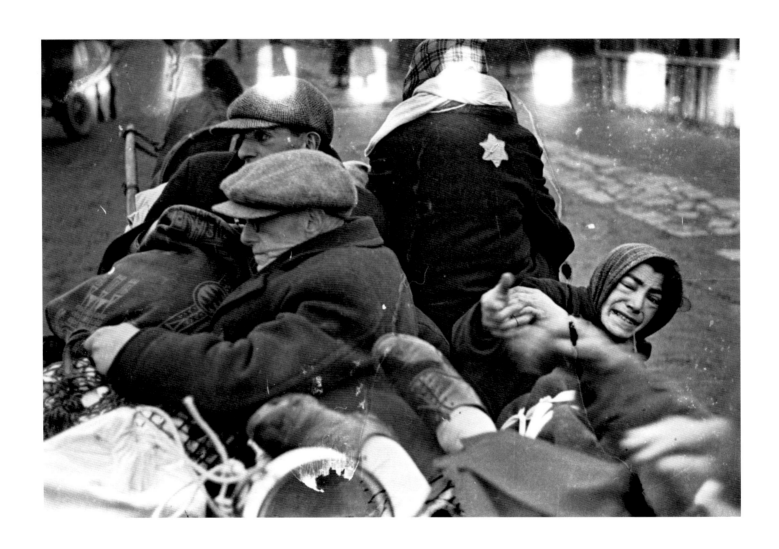

"Evacuation of the sick [and aged, by horse-drawn cart]." 1942, 2007/1959.6.

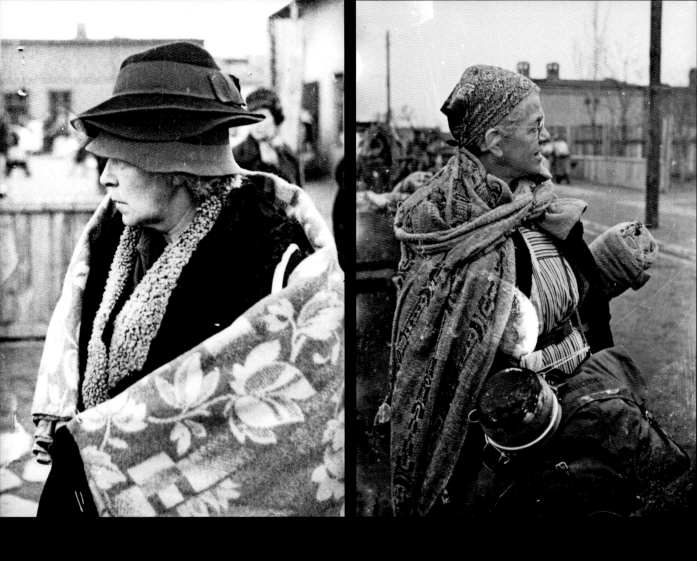

Ghetto residents being deported to the Chełmno death camp, 1942–1944, 2007/1959.9; 2007/1959.4.

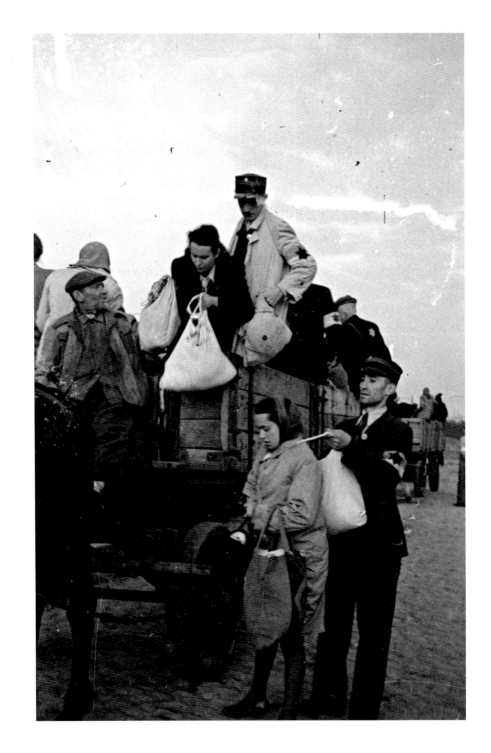

Ghetto police assisting with deportation, 1942–1944, 2007/1959.16.
OPPOSITE Ghetto police escorting residents for deportation, 1942–1944, 2007/1960.21.

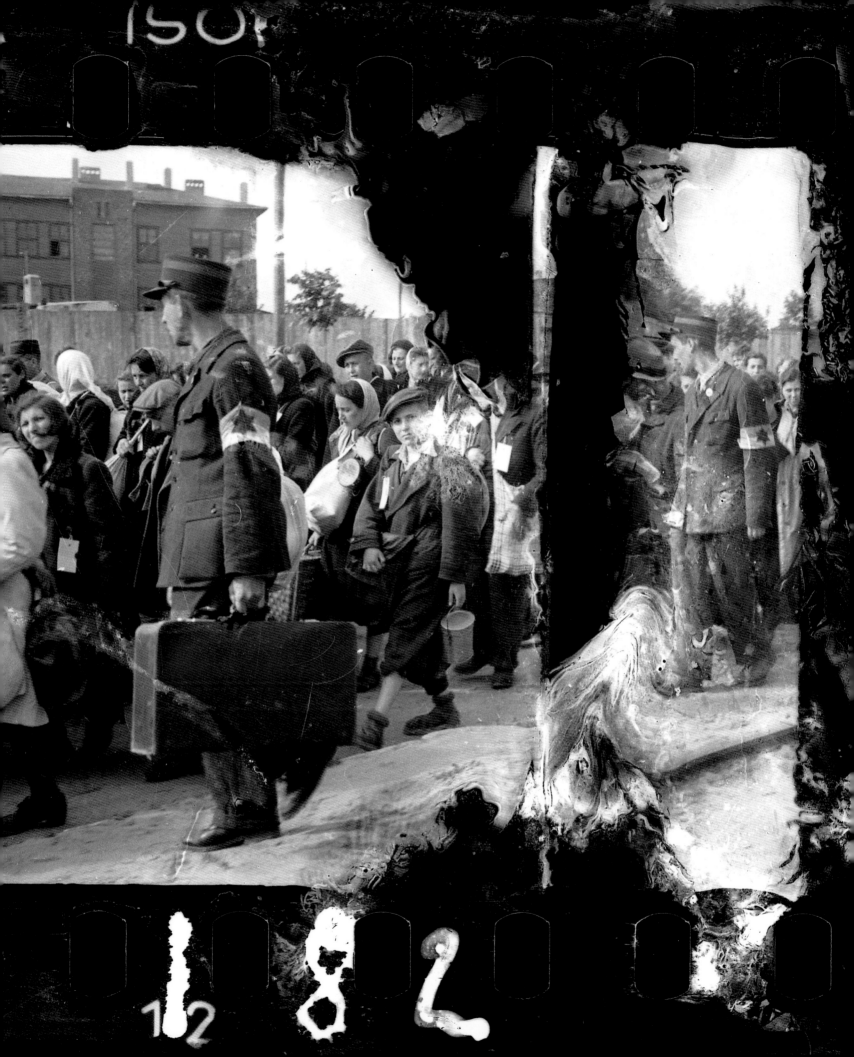

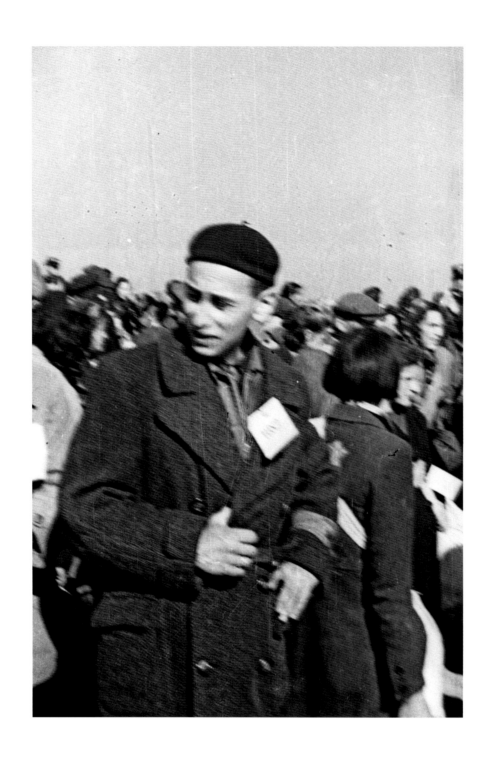

Ghetto residents tagged for deportation, 1942–1944, 2007/1960.5.

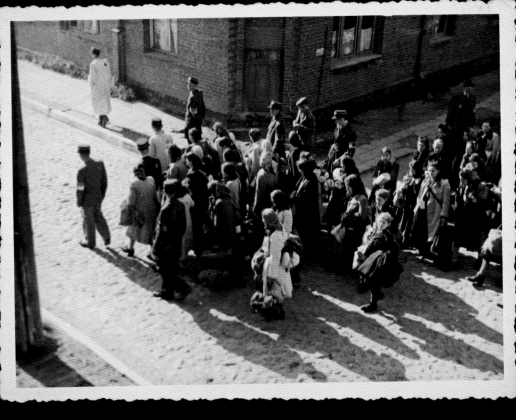

Massive deportation of ghetto residents, 1944, 2007/2197.

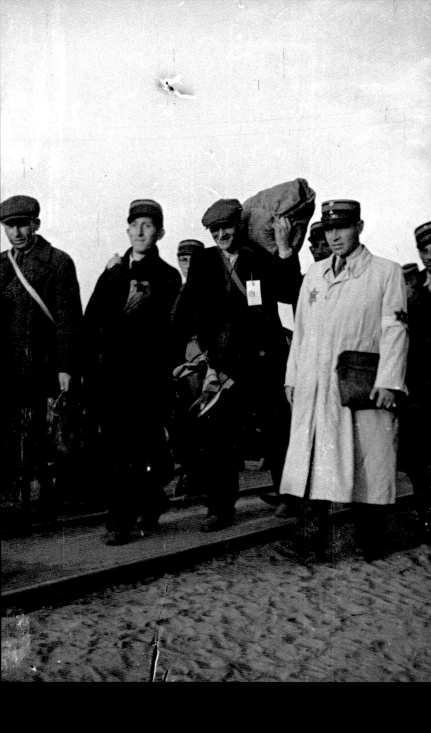

ABOVE AND OPPOSITE Massive deportation of ghetto residents, 1944, 2007/1959.18; 2007/1959.30

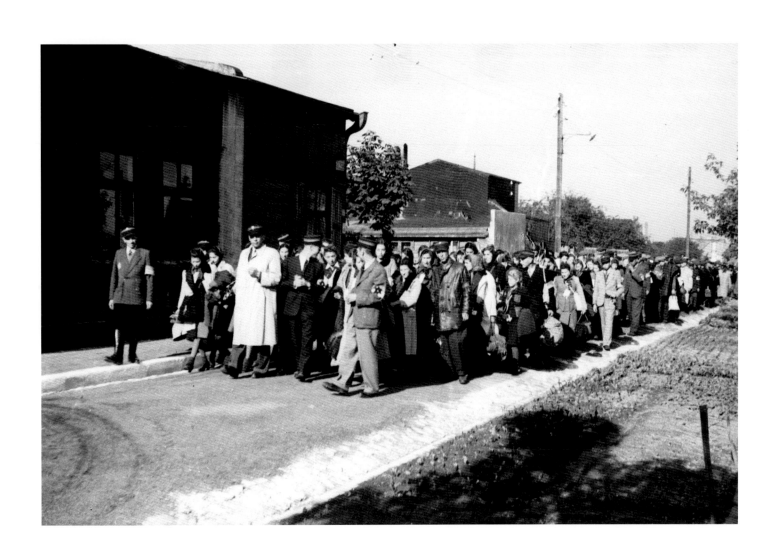

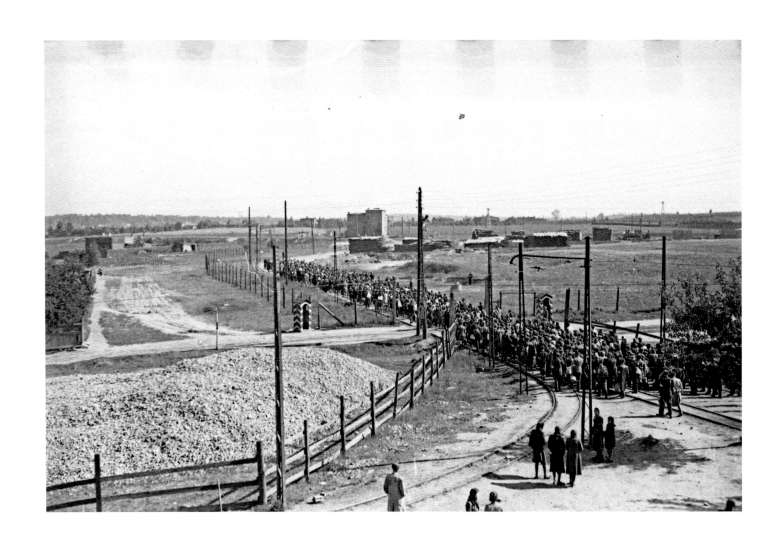

Liquidation of the ghetto, 1944, 2007/1960.12.
OPPOSITE *"…more deportations."* 1944, 2007/1959.34.

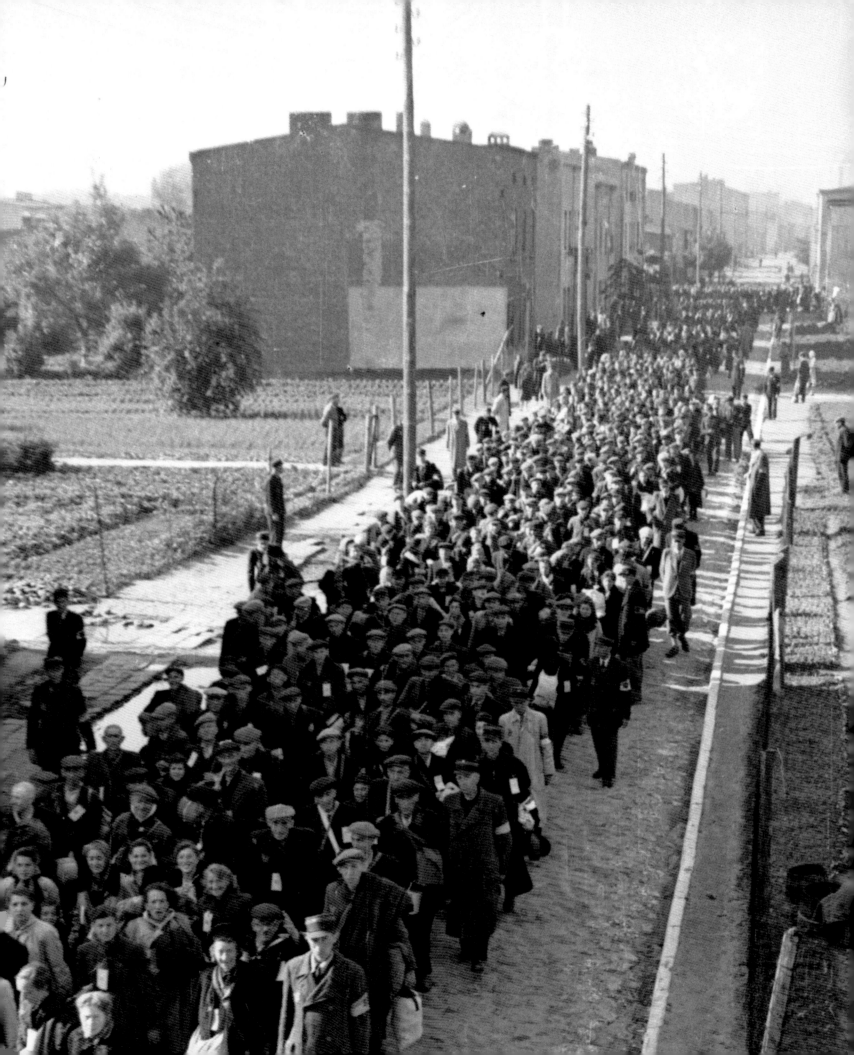

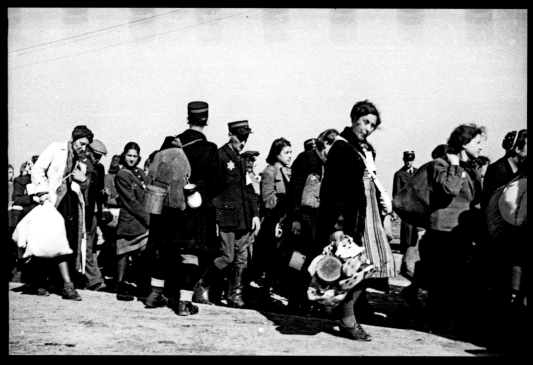
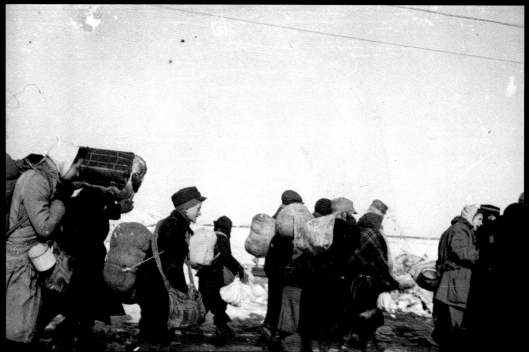

"... more deportations." 1944, 2007/1956.20; 2007/1960.4.

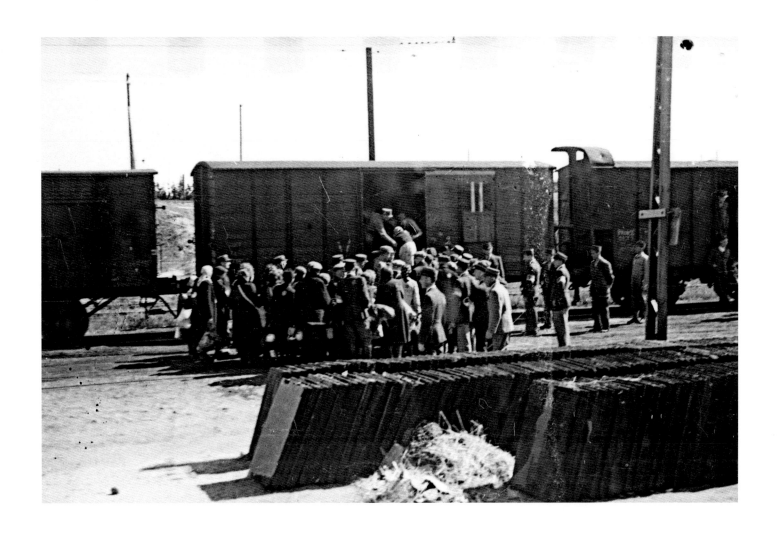

"Radogoszcz station from which ghetto Jews were transported to concentration camps, was situated outside the boundaries of the Lodz Ghetto. The right of entry was only for workers at the station. I stole into the station with a group of railway workers. I was locked in a store from where I was able to, through a hole in the wood, photograph this deportation." 1944, 2007/1960.14.

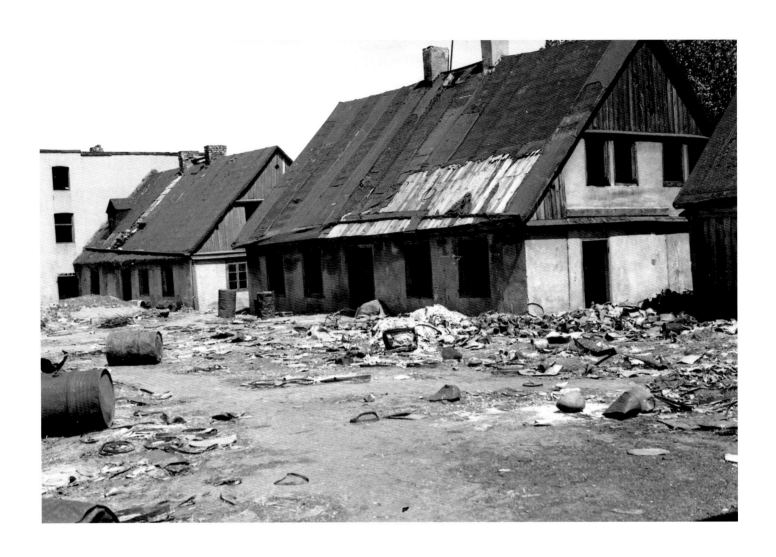

The ghetto after the massive deportation, 1944, 2007/2022.335.

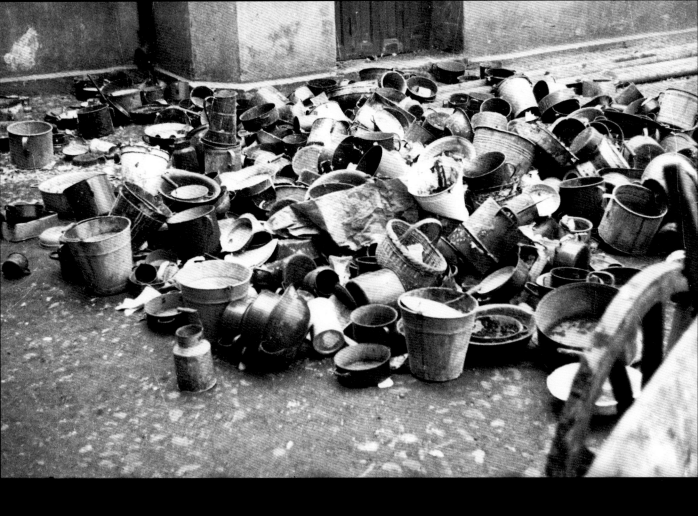

Food pails and dishes left behind by deported ghetto residents, 1944, 2007/2022.285.

PAGES 140–141 Crowd leaving Lodz for the Radogoszcz station, February 1942, 2007/1958.1.

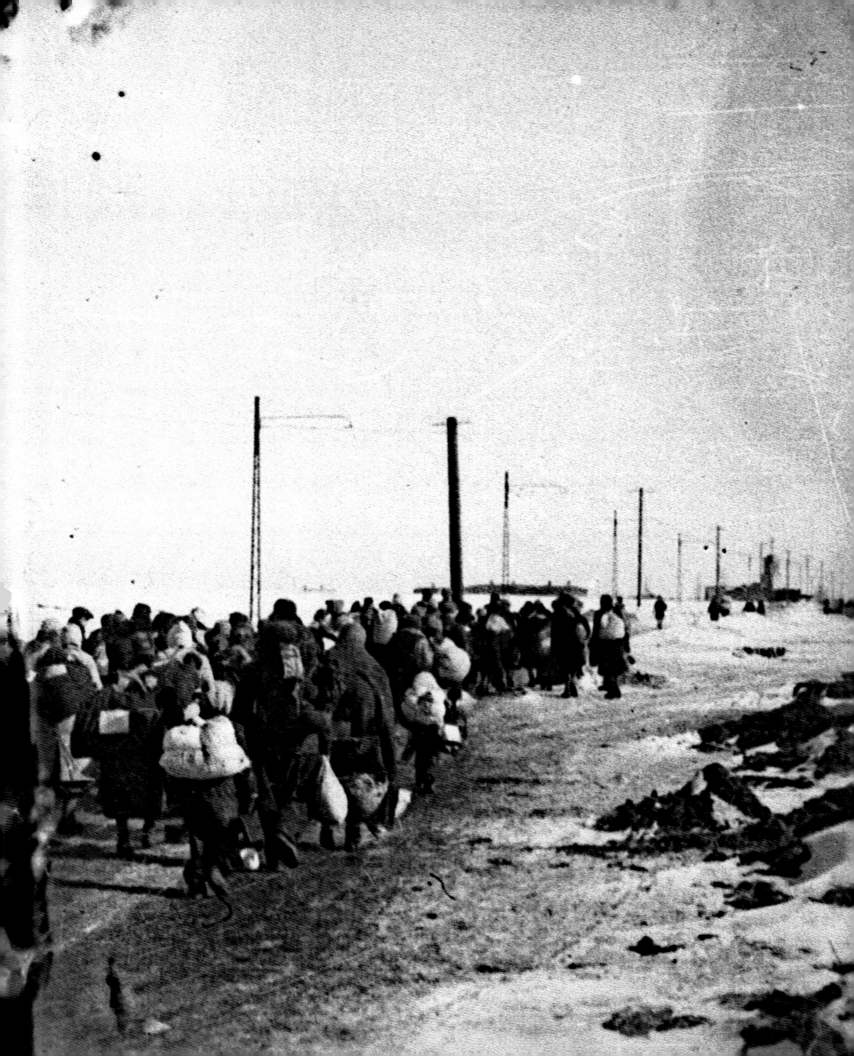

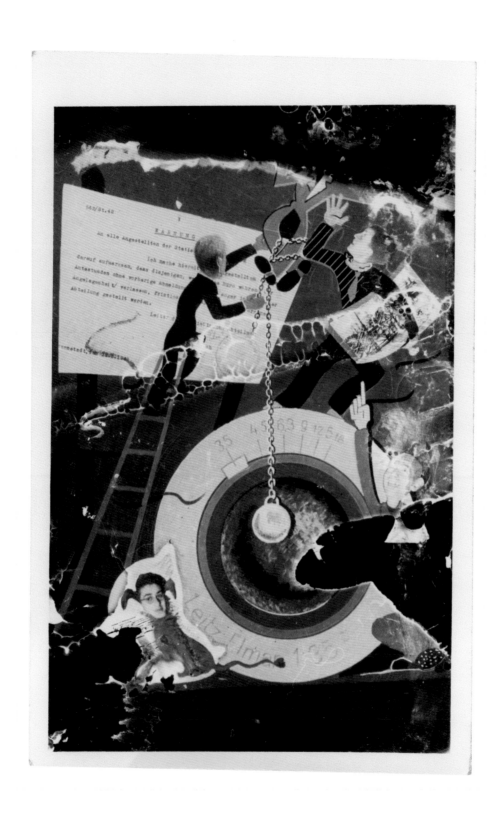

Henryk Ross photomontage of the photographic members of the ghetto's Statistics Department, 1940–1944, 2007/2406.

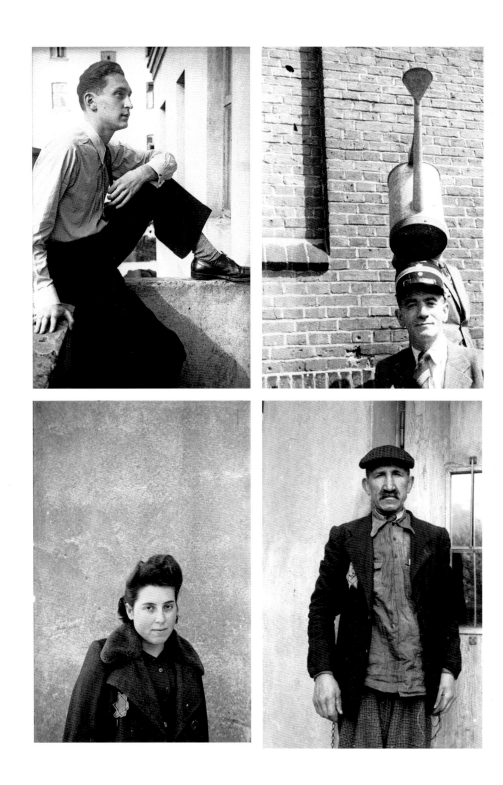

Portrait studies of photographer Mendel Grossman; a ghetto policeman; a woman resident;
a male resident, 1940–1944, 2007/1978.17; 2007/2008.17; 2007/2006.10; 2007/2022.147.

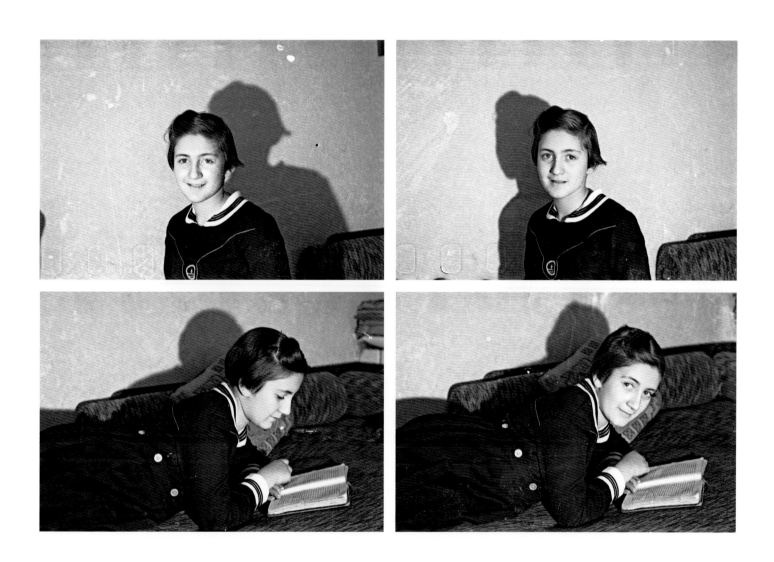

Portrait studies of N. Kleinmann, 1940–1944, 2007/2009.22; 2007/2009.21; 2007/2009.24; 2007/2009.23.

Ghetto policemen posing for the camera, 1940–1944, 2007/1974.30.
Ghetto residents happily strolling, 1940–1944, 2007/1982.3.

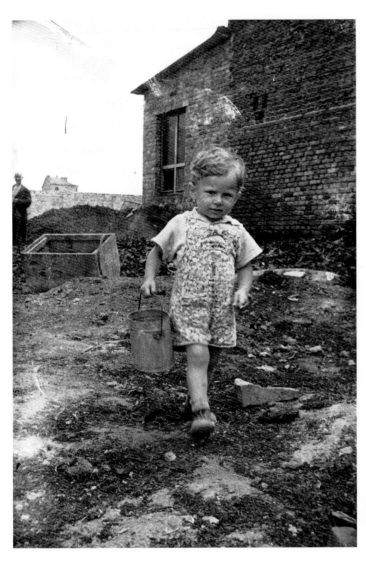
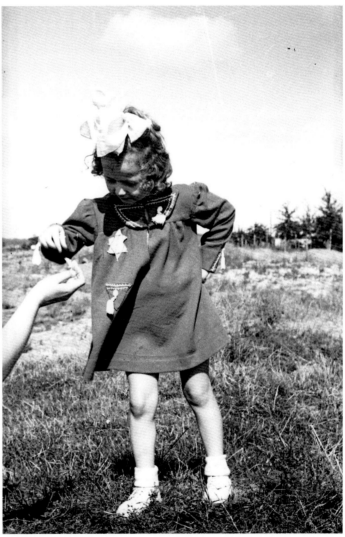

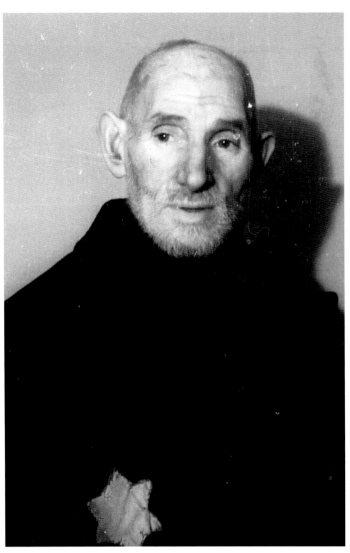

Portrait studies of male ghetto residents, 1940–1944, 2007/1975.16; 2007/1975.15.

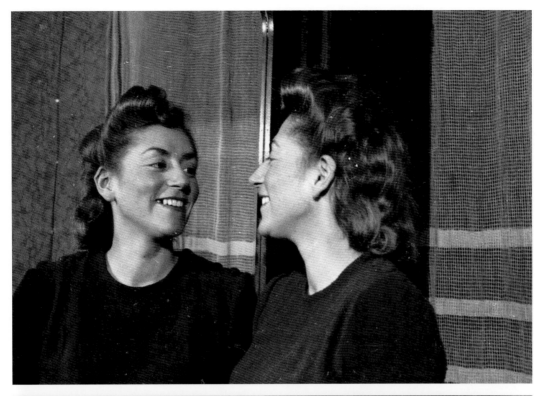

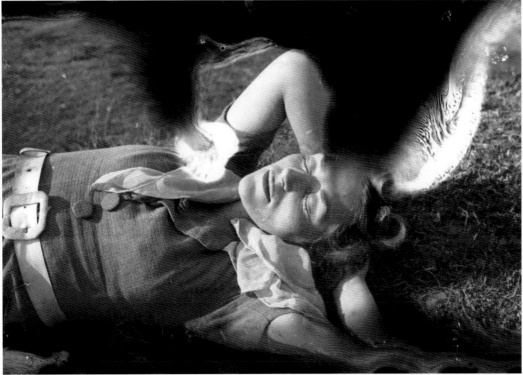

Portrait studies of Stefania Ross, 1940–1944, 2007/1972.25; 2007/2022.122.

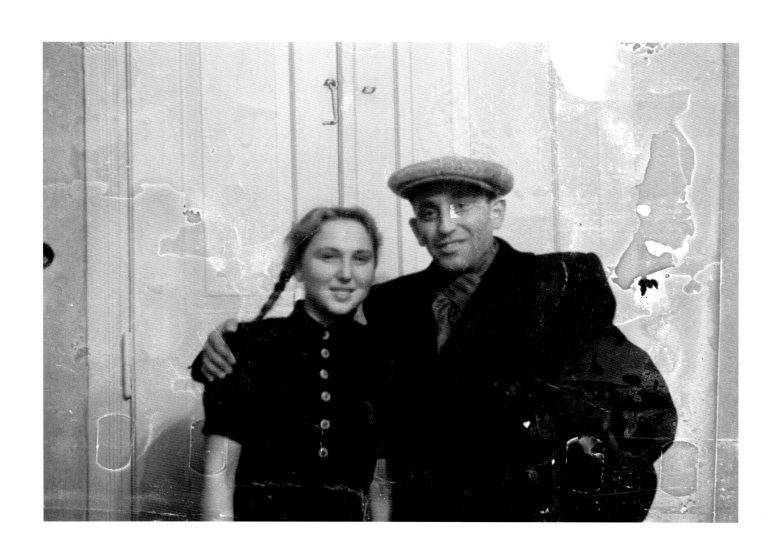

Father and daughter, 1940–1944, 2007.1984.5.

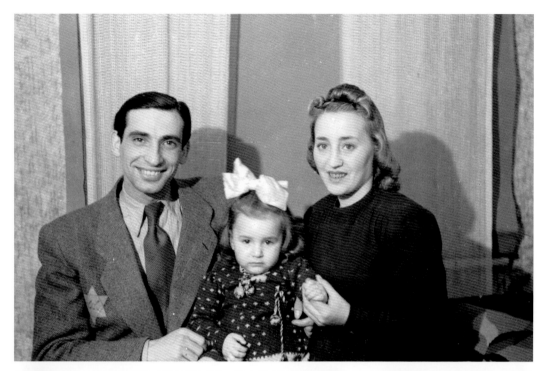

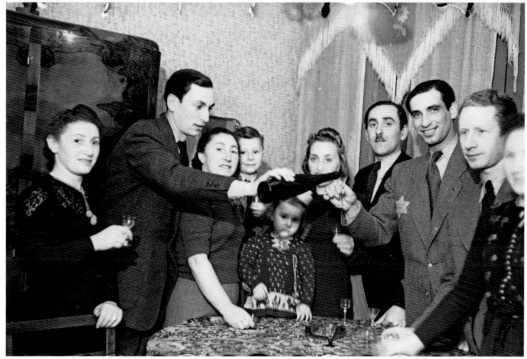

A ghetto family, 1940–1944, 2007/1988.25.
A family gathering, 1940–1944, 2007/1988.29.

153

Mother and child, 1940–1944, 2007/1986.3.

Father and his children, 1940–1944, 2007/1991.14.

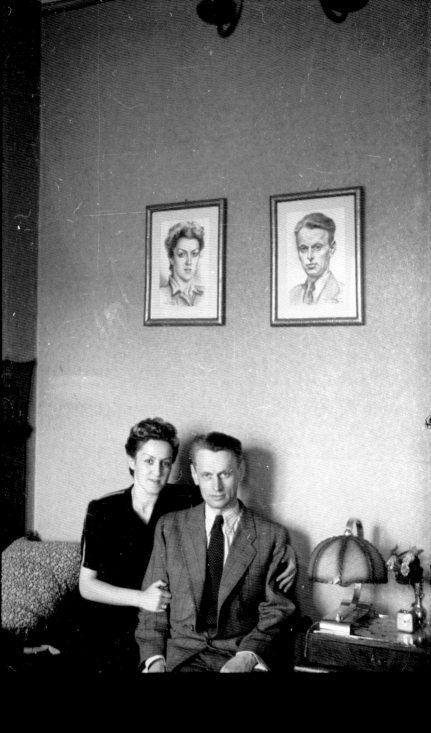

A ghetto couple with their portraits, 1940–1944, 2007/2013.20.

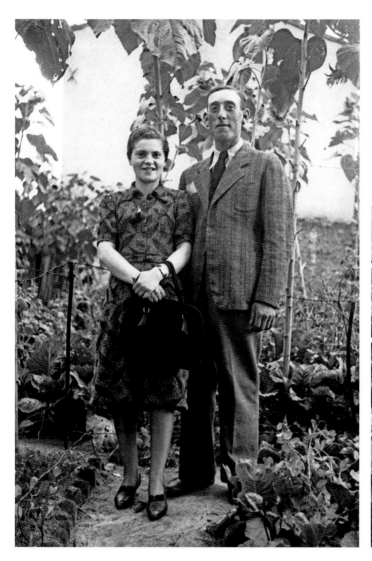 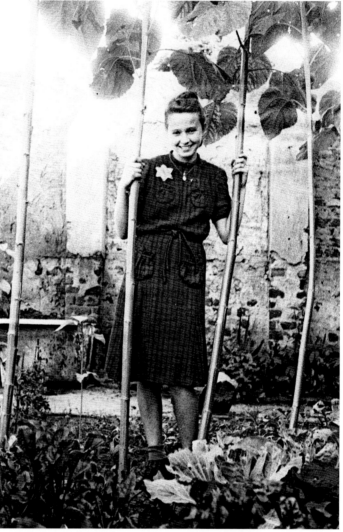

A couple in a garden, before 1942, 2007/1978.28.
A young woman in a garden, 1942, 2007/1977.11.

157

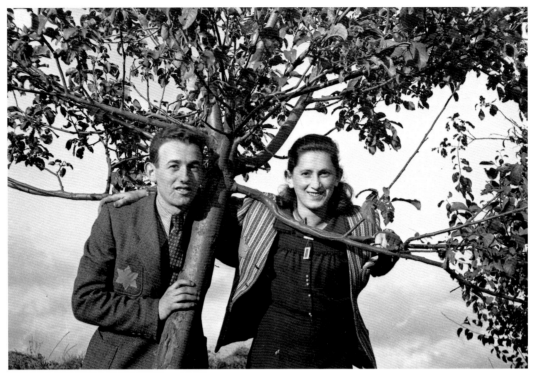

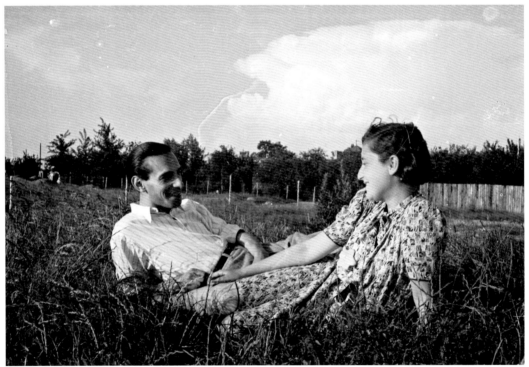

A couple posing in a tree, before 1942, 2007/2003.22.
A couple in a meadow, before 1942, 2007/2014.3.
OPPOSITE A seated young woman, 1940–1944, 2007/1994.17.

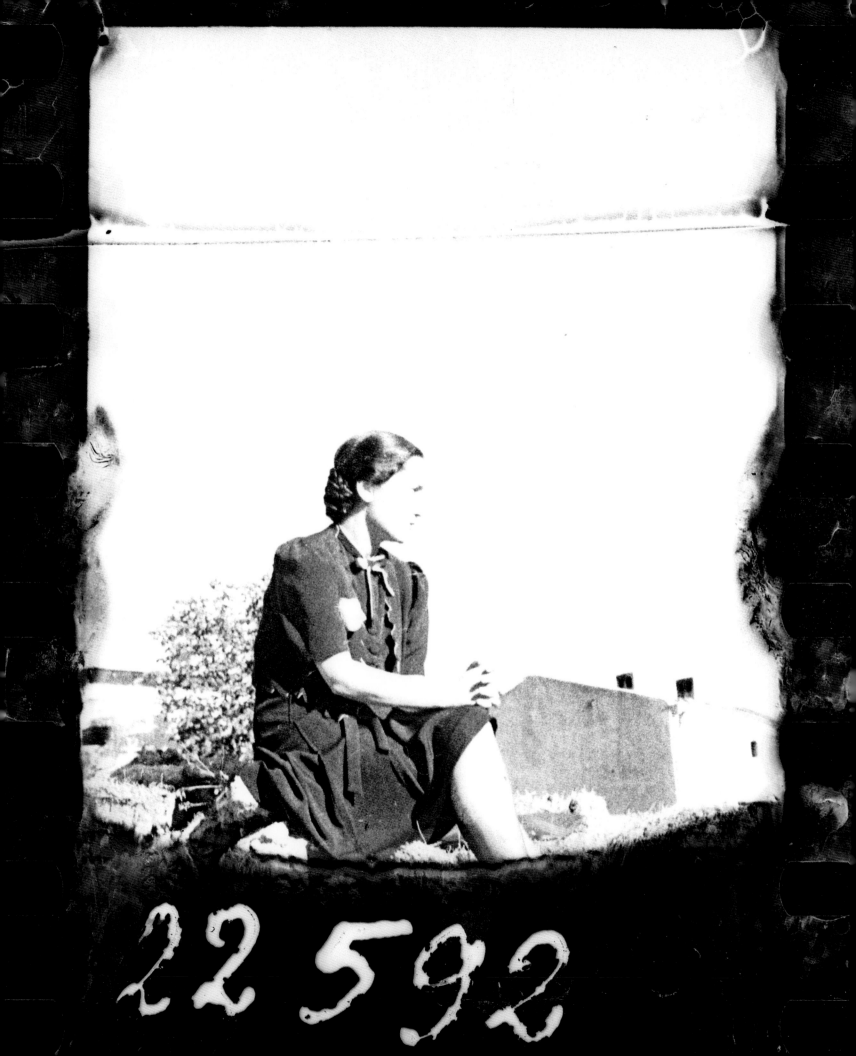

22592

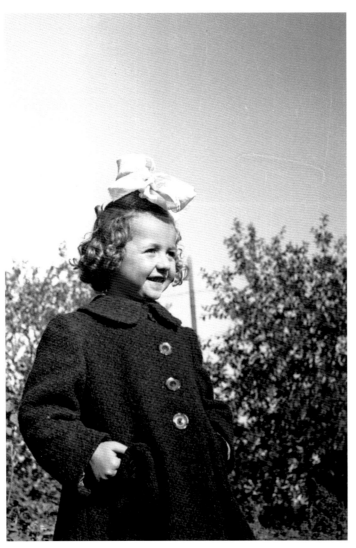 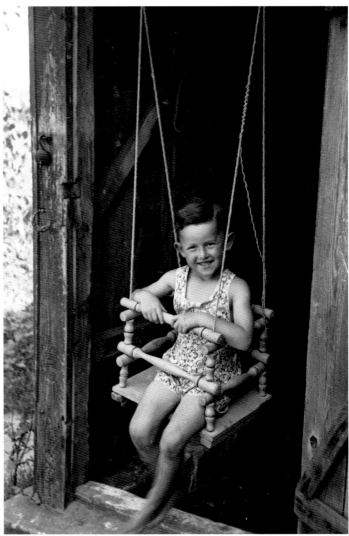

A young girl with a large bow in her hair, before 1942, 2007/1974.20.
A girl in a doorway swing, 1940–1944, 2007/1990.11.

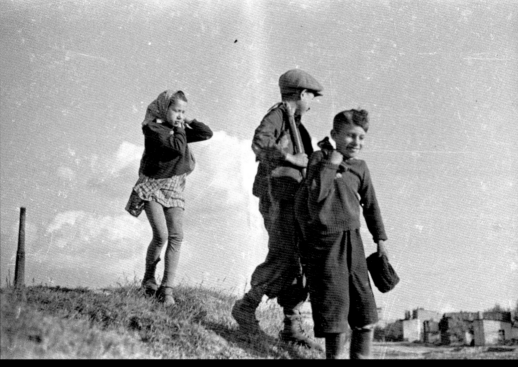

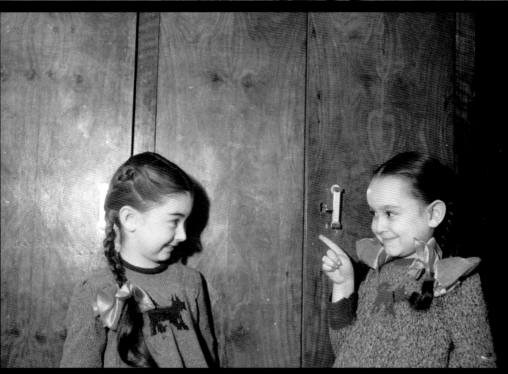

Children strolling in the outskirts of Lodz, 1940–1944, 2007/2022.133.
Girls at play, before 1942, 2007/1987.14.

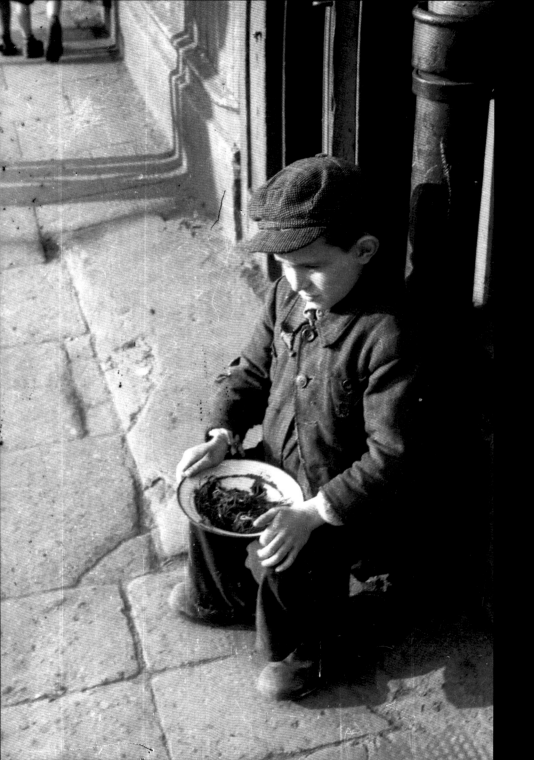

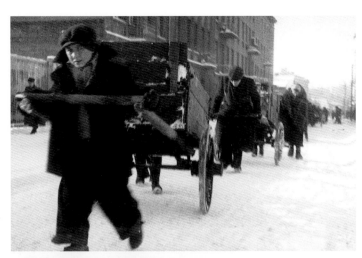
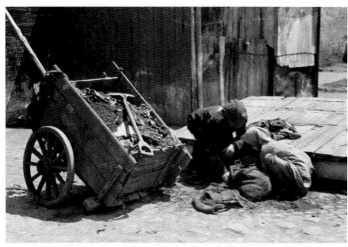
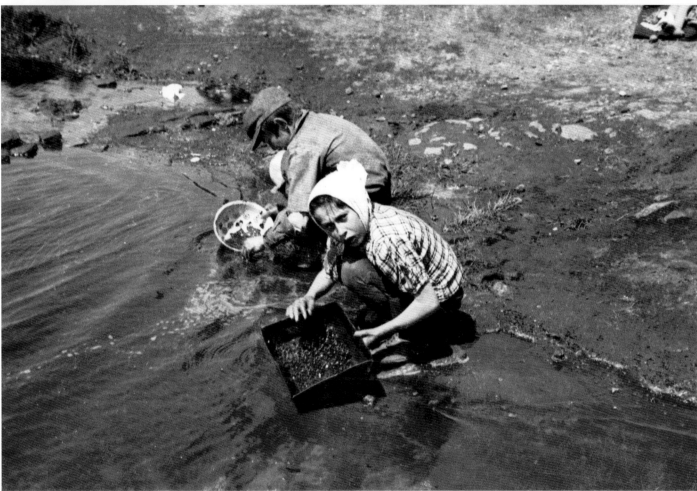

A young boy pulling a cart with belongings into the ghetto in winter, 1940–1944, 2007/2021.6.
Children working on a ghetto street with salvage cart, 1940–1944, 2007/2021.127.
Children in a pond searching for items to salvage, 1940–1944, 2007/2022.148.

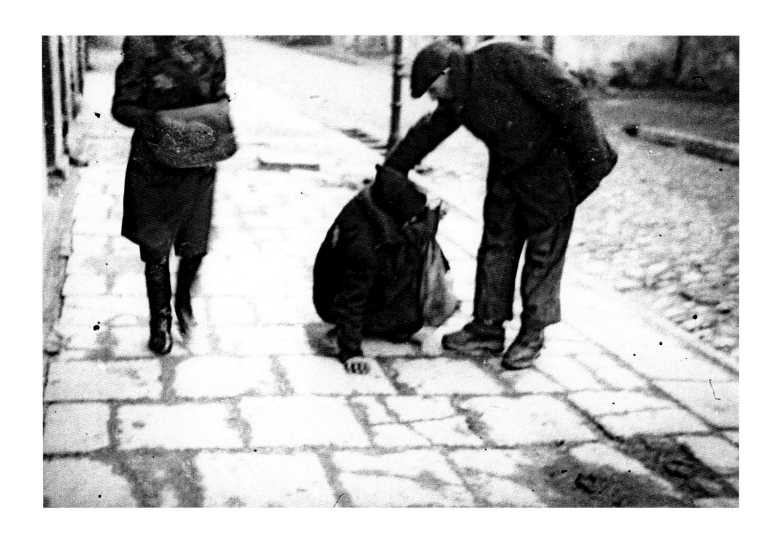

Giving a helping hand to a person fallen on the street, 1940–1944, 2007/1956.26.
OPPOSITE Ghetto kitchen workers, 1940–1944, 2007/1969.7.

יומן נערה בגיטו

התצלומים, של הנריק רוס, נעשו בגיטו לודז ומתפרסמים כאן לראשונה

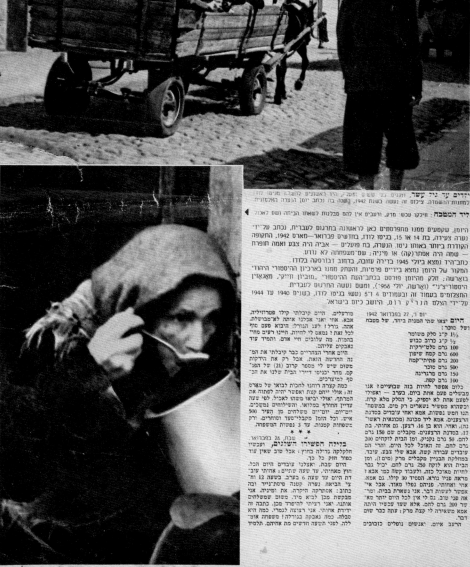

ילדים עד גיל עשר, וזקנים בני ששש חמשה חמשים ראשונים להובלה, מהווים בני-אדם
למחנות ההשמדה. צילום זה נעשה בשנת 1942, כשנה בה נכתב יומן הנערה האלמונית.

◄ ליד המטבח: חילקו טשאַו מרק, ורעבים אין להם סבלנות לשאת הביתה שש צאוּל

היומן, שקטעים ממנו מתפרסמים כאן לראשונה בתרגום לעברית, נכתב על-ידי
נערה צעירה, בת 14 או 15, בגיטו לודז, בחדשים פברואר—מארס 1942, התקופה
הקודרת ביותר באותו ניטו. הנערה, בת פועלים, אביה היה צבע ואמה תופרת
— שמה היה אסתר(קה) או מינירה; שם-משפחתה לא נודע.
כתב-היד נמצא ביולי 1945 בדירה עזובה, ברחוב דלוברסקה בלודז.
הקשר של היומן נמצא בירכין פרסיות, והעתק ממנו בארכיון ההיסטורי היהודי
בוארשה. חלק מהיומן פורסם בכתב-העת ההיסטורי "מזכיין וייקי", מאגאזין
היסטוריצ'ני" (וארשה, יולי 1958). וכמש נעשה הרגום לעברית.
התצלומים בעמוד זה ובעמודים 4 ו-5 נעשו בניטו לודז, בשנים 1940 ו-1944
על-ידי הצלם הנריק רוס, היושב כיום בישראל.

יום ו, 27 בפברואר 1942

היום יצאו שתי המנות ביחד, של מטבח
ושל סובר:
1½ ק"ג סלק משומר
½ ק"ג כרוב כבוש
100 גרם סלט-ירקות
600 גרם קמח שיפון
200 גרם פתיתי-קמחה
500 גרם סוכר
150 גרם מרגרינה
100 גרם קמחה.

כלום אפשר לחיות בזה שבועיים? אני
מבשלים פעם אחת ביום, בערב — ראשוני
לפעם אחת לא יספיק, כי הסלק מלא קרח.
וכשבהו נא נשמים, אבא ואני עובדים בסדר
הרצינים, אבא ליד מכונה (מכונאות ראשוני
נה), ואחי הוא בן 16, דצעו. גם אותי. בת
17. בסדרה הרצינים. מקבלים שם 150 גרם
לחם. 50 גרם נקניק. ומן הבית לוקחים 200
גרם לחם. הרי שיש האוכל לכל היום. עובד
עובדים עבודה קשה, אבא שלי צבע, עובד
במלוכלחם הבניין מקבלים מרק (מים!). ומן
הבית הוא לקח 250 גרם לחם. יכיל גבר
לחיית מאיכל כזה, ולעבוד קשה כמו אבא? גם
מראה פניו נורא. הפסיד 30 קילו. גם אמא.
אחי ואחותי, פגיהם נפל מאוד. אבל אי-
אפשר לעשות דבר. אני נשארת בבית, וכבר
אני מצ'ל... נס לי אין לי לכל היום יותר מא...
אמא משאירה לי קצת מרק; צחה כבר שום
דבר.
הרעב איום. אנשים נופלים כזובים

שבת, 28 בפברואר

בנילה המקשורה השלישית, ועכשיו
חלקלקה גדולה בחוץ; אבל טוב שאין עוד
כפור חזק כל כך.
היום שבת, יאצלנו עובדים היום הכל.
רוצ מאחרים; אי שעה שתיים; אחוני ערב
דת היום עד שעה 6 בערב. בשעה 12 אני
צ הביאה נערה קטנה; פיסטרנייר וזה
כתבנ; אסתרקה. הינלדת. את מינינה. אני
מבקשתם מכל רוב, בשום משפחותינו
אותנו. אני רוצה לגמר. כמה בהא
סבלה. כמה יהודים בגולה! משפחתם אומ-
ללה. לפני תשעה עשר חדשים מת אחותה, תלמדי

מורדדלים. היום קיבלתי קלי פטרהילה.
אבא. אחי יאני אכלנו אותה לאכ'בכר'ילה.
אהה. גורל! לעז הגרל; הובא פעם סוף
לכל זאת? נמצא לי לחיות. היינו רעבים מהי
בחמת. מה עלובים חיי אדם. ותמיד עוד
נאבקים עליהם.
היום אחרי הצהרים כבר קיבלתי את הם
נה, התחדקת הואת, אבל רק את הדלקת
משם שיש לי מספר קרוב (21) של הם'
קם. מחר יכניסו לי דיירי הבית שלנו את הם-
סף המצטברים.
כמה קצה ריחני לחכות לבואו של מאריו
זה; אולי יום קצת נלאים ואפשר יהיה לפתוה את
המרתף, ואולי ירא משהו טוב לאכל. למי שעה
עדיין החזרים במילוא. והשלוחים נתשכים.
היום הזמן היספיק לי מלקבלי-עד העיר 500
איש. וכל הזמן מקבללי שד ושרות. ורק
משפחות קטנות. עד 3 נפשות המשפחות.

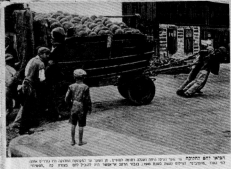

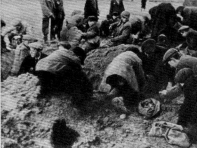

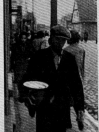

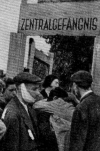
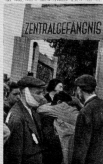

ABOVE AND OPPOSITE "Diary of a youth in the ghetto, Lodz 1942." A photo essay featuring
excerpts from the diary of a young person imprisoned in the Lodz Ghetto, alongside
photos taken by Henryk Ross in the ghetto between 1940 and 1944, published in Israel after 1958.

5

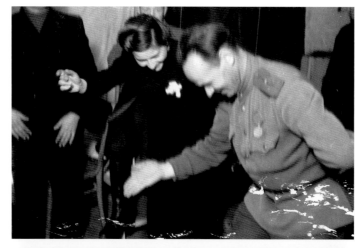

Ghetto liberated by the Red Army, January 1945, 2007/1962.18; 2007/1962.14; 2007/1962.3.

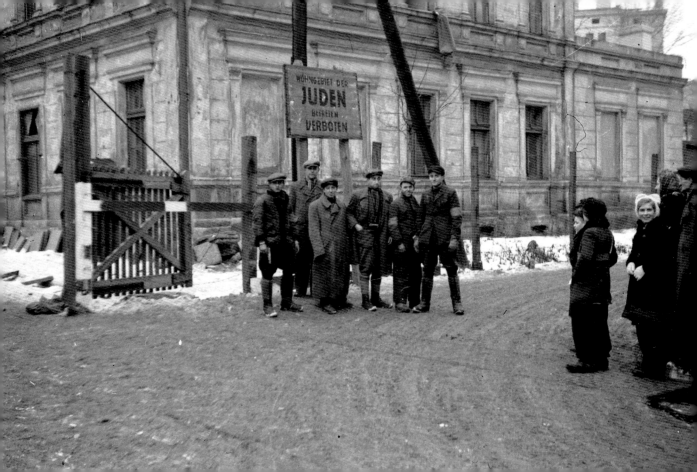

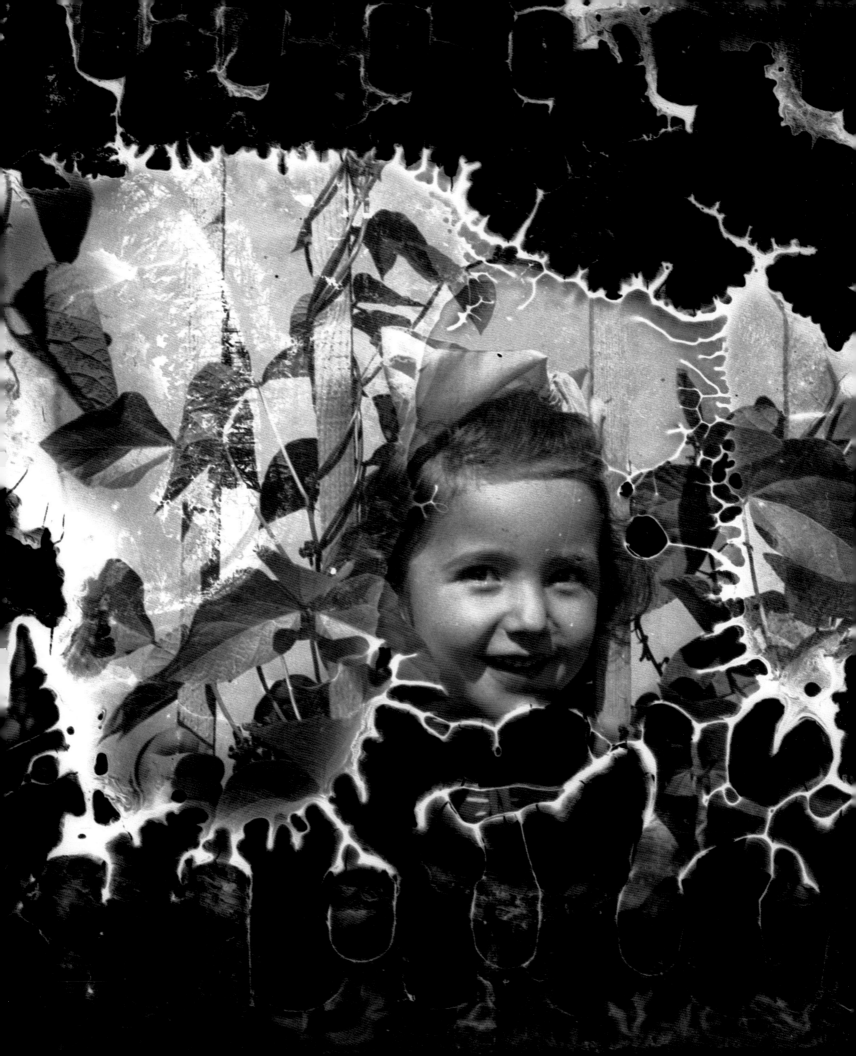

Fatal Edit

Michael Mitchell

BY CHOOSING A MOMENT IN TIME, the photographer is rejecting all other moments, whether past or future. Photography is an editing medium. When a photographer frames up an image, he is editing reality—excluding everything below the frame line, everything above it and all to the right and the left. Significance is ascribed only to what is bounded by the four edges of the frame. It's like pointing, but more precise and permanent. And it has more authority.

This is just the initial editorial step. When photographers return home, they select from these edits. Many exposures on contact sheets or digital files are mere warm-ups, tentative sketches, missed opportunities. Reviewing them in tranquility, photographers find themselves discovering their subjects. They recognize themes, build on familiar tropes and inform themselves. It can be like taking one's own temperature.

Photographers review their exposures, make "selects" and file them for further editing. It can be difficult and intense work, work inflected by what they already know and recognize, work that may even be revised years later in the light of accumulated experience and evolved concerns. They are not always right the first time. The possibilities can be legion.

Once the photographer has achieved a final edit, he can enhance the image to help it better communicate its message. He may do this by altering contrast to change the picture's tonality. Burning and dodging (lightening or obscuring individual elements within the frame) further tune the image. The scale at which the print is output is also part of the message. Photographs that impress when presented at large, painting-sized scales may look very ordinary within the confines of a printed page. Scale shouts. It can take some time to see through it.

All of these steps are essentially editorial. And they are all the photographer has in his toolbox. A painter can seduce with a glistening brush stroke; a photographer has only form, content and time. Photography has an apparent facility, but doing it brilliantly—being original and telling a story well—is a major challenge. Most of the millions of photographs made daily are mere records and as mute as stones. Photography can be a very tough medium. A photographer who can't edit

his own material is little more than a photocopier. He's as dumb as a traffic camera. Editing is everything.

The photography of Henryk Ross is a special case. Before the outbreak of war, Ross was a photojournalist, a practitioner of an often artless profession devoted to recording facts and basic storytelling rather than to producing images with aesthetic ambition. After the outbreak of war and the establishment of the Lodz Ghetto in 1940, Ross found employment within the ghetto, taking photographs for the Statistics Department of the *Judenrat* (Jewish Council), an elite group that administered the ghetto under the watchful eyes of the Germans. His physical survival was possible only if he produced pictures useful to his overseers. However, his spiritual and psychic survival was dependent upon his personal work—his ambition to be witness and memory for his fellow Jews.

These "unofficial" pictures—which Ross shot through cracks in doors or by quickly flicking his overcoat—were made without the benefit of a viewfinder or the luxury of time. They roughly record the rail-borne traffic in human souls, forced labour, disease and executions of unbearable bleakness. The Lodz Ghetto statistics are horrific: tens of thousands of people, mostly Jews and some Roma and Sinti, were confined behind barbed wire in just 2.4 square kilometres. More than 45,000 were to die of starvation and disease. By May 1942, some 55,000 Lodz Ghetto residents had already been deported to the death camp at Chełmno nad Nerem (renamed Kulmhof). When the Red Army liberated Lodz in January 1945, 877 Jews remained there of the 204,000 that had passed through during the five-year life of the ghetto. Eight hundred were forced to dig their own graves. Ross's photography practice was one *in extremis*.

He documented these things, and also the mundane aspects of ghetto life. The ghetto had more than fifty schools and daycares, a hospital and at least 100 factories. Ross shot them all, paying attention to the poorest and sickest as well as to the relatively comfortable lives of the ghetto's Jewish elite.

Toward the end of the war, Ross and his wife, Stefania, sealed his negatives in

iron jars that were in turn secured in a wooden box lined with tar. Film, iron, tar and wood—all were buried in the ghetto earth. Digging was hard work.

Lodz was liberated by the Red Army in January 1945. In the spring of that year, a small group met at 12 Jagielonska Street and exhumed Ross's box. The jars were now free to speak. Ross moved his negatives to Israel after the war. He and Stefania immigrated there in 1956, and he then had the time and the resources to begin to edit and print his material.

In a sense, two edits had already been completed. The first was by circumstance: all the constraints that had been put on his photography—by the Germans, by the *Judenrat*, by spies and gossips. Shooting from the hip through a gap in your overcoat or a crack in a door seriously inflects the image. It can't be more than an artless grab at a fact. But it's immediate; it's urgent.

The second edit was executed by the very earth of the ghetto itself. Groundwater and contaminates slowly invaded the entombed film. Emulsions began to peel from the flammable nitrate bases of the rolls. In the darkroom, light shone unimpeded through the damaged nitrate bases, occasionally creating an accidental but visually and emotionally effective proscenium arch framing the subject. Those were the lucky accidents, as great numbers of negatives were terminally edited into silence. The burial that had preserved had also destroyed.

When, very late in his life, Ross began to cut up his contact sheets, he reassembled them into sequential rows that he pasted into a notebook with pages slightly larger than standard letter-sized paper (pp. 184–201). These pages look like conventional contact sheets, except they are bigger and contain more images—often slightly more than forty. A standard roll of 35mm film cut into strips and contacted usually yields six rows of six images, for a total of three dozen exposures. A contact sheet begins on the upper left with the first exposure made on the roll. It ends six rows down on the bottom right with the last. It has a fixed internal chronology that is marked by sequential latent edge numbers. In the case of Ross's Leica photography, these numbers go from one to thirty-six on each roll of film.

The bound pages of Ross's paste-up—there are seventeen of them—initially look like a narrative. He has added his own set of numbers in ink to the rebate (edge) of the rolls. If this sequence, which begins with his numeral one on the upper left of his page one, is a storyboard, it is a most opaque and hermetic one. What was he trying to tell us, and himself, as he tried to assert control over his material after two significant edits had already been executed by the fates? Is this notebook of contact prints a narrative sequence? Or are these pages, so often filled with mysterious miscellany, merely an inventory, a catalogue, a source book?

The initial frame on page one shows an old man being helped by the ghetto's Jewish police to board a tram at the Radogoszcz train station in Lodz. We deduce that the tram is bound for an extermination camp. There are no dates or captions anywhere in Ross's paste-up, but presumably this represents the deportations of nearly 16,000 "non-productive" elderly people and children that took place in 1942. Then several more conjoined tram photographs are followed by images of ghetto inmates talking through a boundary fence and crowding through the entrance to the prison at Czarnecki Street within the ghetto. This was the staging point for deportations and death. Next, we see two men; one, in a lab coat, reclines on the floor, gazing at the cover of a very large book celebrating Marysin, a garden-filled neighbourhood in the northeast of the ghetto that housed the Jewish elite. This is followed by a heavily damaged frame of a small outdoor gathering of Jews, which is attached to an adjacent frame of people marching to deportation transport with their bags. Next are three similar frames showing people standing around a horse-drawn hearse. By 1942 there were eighty to 100 deaths caused by starvation or disease per day.

In the next frame, we see a pair of well-dressed men inspecting excavations in an open field with the wooden framing for a large new building in the background. Then Ross shows us a trio—two ghetto police flanking a well-dressed man in an overcoat—standing before a small building whose only window comprises four narrow panes in its central entry door. It looks like a little jail. We now return to the excavations, where the same three men pose. The small building turns up

again, with a man, smartly dressed in a fedora, jacket and tie, posing in front of it. Suddenly we jump to three frames shot inside a bakery. The staff mug for the camera. We then leave the bakery for city streets, where sacks, presumably of Chełmno victims' clothing, are piled in rows along the curb and in a churchyard. People stroll by them. Cut to a narrow, muddy alley where a crowd jostles outside a soup kitchen. Next, there are three pictures of a ruined synagogue. Finally, we are presented with eight different Litzmannstadt (Lodz) Ghetto *Judenpost* stamps, for which Ross did the artwork. Most feature a portrait of the chairman of the ghetto's *Judenälteste* (Elder of the Jews), the infamous Mordechai Chaim Rumkowski. Page one ends with two similar images, in which a small group of people in a fenced yard stand with their backs to the camera. They seem to be mostly women, and the yellow stars on their backs tell us they're Jews. What are they witnessing? We aren't shown. What has this whole page and its forty-three pictures been telling us? We don't know. We're confused despite this being a carefully numbered sequence. This is only the first of seventeen pages and the viewer is already puzzled.

The hand-lettered numbers march on. The second page begins with a sequence showing civilians taking coal from a railcar under the supervision of the ghetto police. This is followed by several deportation images in which long rows of ghetto "inmates" lug their possessions through a bleak wintry landscape. The sequence jumps back into town to record a cart being loaded with bread. We then see a street person being comforted, followed by a few frames of ghetto residents carrying loaves on the street or consuming soup in the rail yards or riding a tram. After this tram ride, we are suddenly witnessing Ross's marriage. A half dozen festive wedding photographs of Ross and Stefania are followed by what appear to be more deportations by foot or rail and then a single frame of outdoor food distribution. Six cryptic frames that show a cheerful crowd supervised by the Jewish police are followed by a visit to the hospital, including the X-ray department. The seven-frame hospital sequence is interrupted by a gardening episode featuring a scarecrow ironically adorned with the familiar yellow star. The remaining hospital frames seem to record medical

staff conducting surgery on a prone patient. (These were all "show" pictures of services provided in the ghetto, intended to reassure and flatter the German invaders. All is well: there are no horrors.) As the second page concludes with a sombre portrait of some ghetto administration staff, the viewer can be excused for thinking she has just experienced an image sequence as irrational and random as a shuffled deck of cards.

The third page of Ross's assembly appears to focus on the ghetto's elite. Various officials, well dressed or in uniform, present themselves to the camera in small groups. After depicting people posing in an elegant horse-drawn carriage, Ross shows us a humbler crowd digging for coal, tending a cabbage patch and scrubbing a floor, as well as men posing with poles and a pile of earth. A portrait of two blowtorches resting on a curb is followed by pallets and crates stacked in a warehouse under an elegant chandelier. We then jump to a soup-kitchen series followed by dapper people smiling from a tram. The page ends with workers sorting through sacks piled on the street, followed by a meeting, a lumberyard, an emaciated man with an empty plate and platoons of Jewish police marching past the camera. The final two images record more deportations.

What are we to make of all this? This jumble of images reminds us that editing and sequencing are necessary to tell stories in photographs. The medium can be incredibly mute when shorn of words. It can show hunger and suffering, describe work and suggest social hierarchy, but it needs the support of text to convey more complex ideas. Moreover, some conventions bonded to the act of making a photograph are so strong they dilute meaning. We know that the photographer's subjects are living *in extremis*, yet, when confronted with a camera, almost everyone smiles.

And so Ross's album unfolds. Some pages are coherent. Page four is devoted exclusively to the deportations. Some of its frames are tragically disarming, as deportees grin for the camera; they clearly don't understand that the Chełmno death camp lies in wait. Pages eight and nine are largely devoted to showcasing ghetto industries. Rumkowski believed the best survival strategy was to make the ghetto so productive

that the Germans couldn't afford to shut it down and carry out the Final Solution, so there were at least 100 factories within the ghetto walls. These so-called *ressorts* produced everything from military supplies and uniforms to high-fashion ladies' hats for Berlin department stores. Ross shows us mattress factories, bakeries, millenaries and garment workshops. As the workers were paid largely in food—only 800 calories daily by 1942—the Lodz Ghetto was a very productive operation that yielded a profit of some 350 million Reichsmark. The Lodz Ghetto did operate longer than any other, but in the end there were only about 800 survivors out of a population of more than 200,000. Even Rumkowski, the "King of Lodz," was sent to die at Auschwitz-Birkenau.

While page ten focuses on the deployment of ghetto residents as draft animals, most of the remaining pages are a bewildering pastiche of unrelated themes. In a mere thirty-five frames, the eleventh page jumps from a human-draft photograph to soup distribution to fence gossip to a public hanging to weaving and braiding to millinery and then to a bulk potato delivery. A couple of meetings are also tossed into the mix.

The twelfth page opens with several images of a disastrous rail delivery of tons of inedible frozen potatoes, then abruptly shows us an interior, where a man in a suit and tie poses with two women for a couple of frames. Next, we are taken to the street, and the Central Prison's entry gate. We then see some interior portraits of nursing staff before returning to our well-dressed gent posing in front of a stove with a pair of female friends. The balance of the page is a series of street scenes: vendors, small crowds, people going about their business. It is cold. There are piles of snow and everyone is bundled up. In the last two rows, the season has changed—shirtsleeves—as men and women struggle to move heavily laden wagons and toilet-waste carts.

On the following page, we learn what was in those overburdened wagons: the clothes of the Chełmno dead. We witness workers sorting through heaps of victims' clothing. Perhaps Ross is suggesting that this gruesome task was just another ghetto industry, for the balance of the page is a tour through millinery, tailoring, braiding and yarn-spinning workshops, with a few office portraits in the mix. We also visit a construction site.

While page thirteen seems to demonstrate a certain coherence, it also introduces a tendency that confuses all the remaining pages of Ross's assembly: repetition. We've already seen his photographs of braid production—the whole series is on page eleven—and the wintry street scenes near the top of thirteen are also on the previous page. We've already seen the carts of deportees' clothing, too. Why are they here again?

Duplication marks all the remaining pages. The second-row photograph on page fourteen of a woman reaching for a string of feathers destined for high-fashion hats will appear no fewer than four times on pages sixteen and seventeen. The screw press and operator on the fourteenth page reappears on fifteen, as do some kitchen scenes. The press operator is also on sixteen, which repeats street-barrier scenes from page twelve. Moreover, the strict numerical sequence distinguishing the first couple of pages collapses. It first begins to slip on the third page, which concludes two shy of the correct count. By the last page, the sequence is so disturbed by misnumberings and repetitions that the entire endeavour becomes a puzzle. What are we to make of a page like fifteen, which begins with a first grade report card but proceeds to present various images of Stefania, soup kitchens, deportations, social gatherings of the ghetto elite, factory production and children in a hospital ward?

What are we to make of this assembly that limps to a conclusion on its last page with a miscellany of images that we have already been shown? In one instance, a four-frame sequence of women working at a long table is repeated a second time on the same page. And we've already seen half of this sequence on the preceding page, as well as on page eight.

The chronology is also off: we encounter what seem to be surviving extermination camp prisoners celebrating their January 1945 liberation on page six, barely a third of the way into the overall assembly. Earlier events are depicted later in Ross's paste-up.

It is clear that this "album" is not a final edit or storyboard, as Ross stopped well short of choosing the definitive exposure from his various takes of a subject.

He repeatedly pasted up contact strips that consist of two, three, even four frames of the same scene, distinguished only by slight changes of perspective and time. He may have thought he would have the will and energy to review the material at a later date. We all leave behind unfinished projects.

Photographers edit, then edit and edit again in order to communicate effectively. The early stages are just raw material. Despite the unfinished and provisional state of Ross's notebook, we can still get a sense of the story he took photographs to tell. By sheer frequency, we can see the themes that resonated with him. For example, he inserts his photographs of human draft animals on page after page. They appear at least sixty times, occupying nearly half the total pages. This seems to be a central metaphor for Ross; presumably these individuals stand for loss of freedom and dignity and even life itself, as those ordered to pull carts carrying barrels of human excrement frequently contracted fatal typhus or other diseases.

Other repeated themes are the line-up, marching columns, food distribution, urgent information exchanges, collective work and even the occasional party. This is not a silent world. Life goes on. People talk. And, just as in peacetime, there are the privileged and well fed—mostly officials and Rumkowski's associates—as well as the poor, exploited and hungry.

 Photographers make pictures in order to understand the world. When they find they have reached their limits in the medium, they stop. Ross lost interest in making photographs after Lodz. Photography and the horrors of life in the Lodz Ghetto were inextricably linked in his mind. He had to move on or face paralysis. He did publish his testimonial book, *The Last Journey of the Jews of Lodz*, in 1962, and testified at the trial of Adolf Eichmann in 1961. He and Stefania only stayed with it for two days: "We didn't have it in us," he said.[1] Sometime in the late 1970s, he made up this inventory of contacts from his wartime shooting. We know he'd done it by 1978, because it appears in David Perlow's 1979 documentary *Memories of the Eichmann Trial*. In that film, Ross shows some of his photographs, jumping in no particular

order from page to page and from image to image. This suggests that while he may have set out to tell a story in pictures, his paste-up soon devolved into an inventory of the best surviving negatives.

As a rough catalogue of salvageable negatives, it is raw evidence, not a strict narrative. It winds down into a kind of entropy: disorder, repeats, restarts, stasis. It ends in confusion.

Why?

Ross had undoubtedly had enough. He'd lived through the events and he'd revisited them when the box was exhumed, once again when printing his material in Israel, again when creating his book and once more at the Eichmann Trial, where he sat face to face with the man with the "eyes of a snake." "I was shaking uncontrollably, everything came back to life," he said. For Stefania, seeing Eichmann again was an encounter with the Angel of Death. Once more, she felt it was her turn next.

When, toward the end of his life, Ross tried to bring order to his material, he couldn't do it. He and Stefania had risked their lives more than once to make sure a great crime would be remembered, and now they deserved some peace. As Ross was no longer a photographer, he was no longer obliged to be an editor. His evidence stood, despite some disorder. One can't tidy up evil. Ross owed us nothing.

With special thanks to Donald Rance, Reference Librarian at the AGO, for research materials and innumerable photocopies, and Martina Oehmsen-Clark for translations of German signage and documents within Ross's scrapbook.

1 All direct quotations are from *Memories of the Eichmann Trial*, directed by David Perlov (Jerusalem: Israeli Broadcasting Authority, Channel 1, 1979).

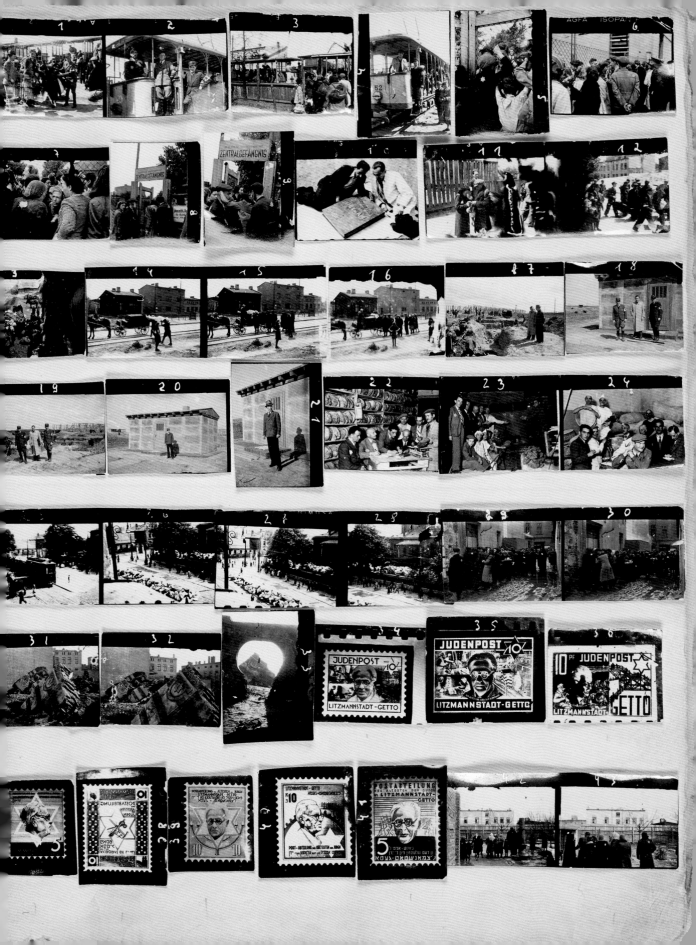

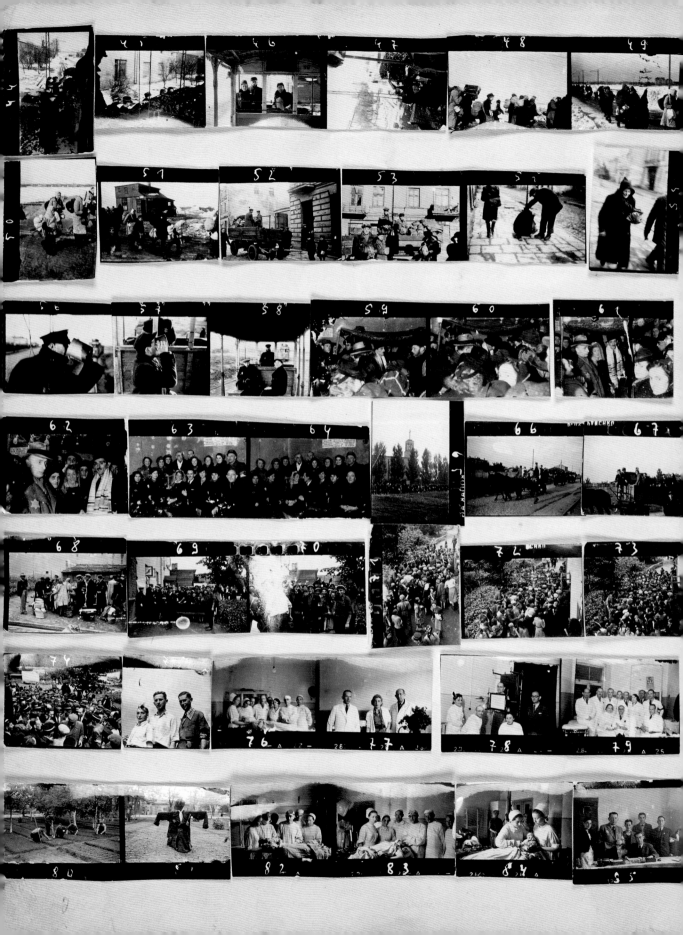

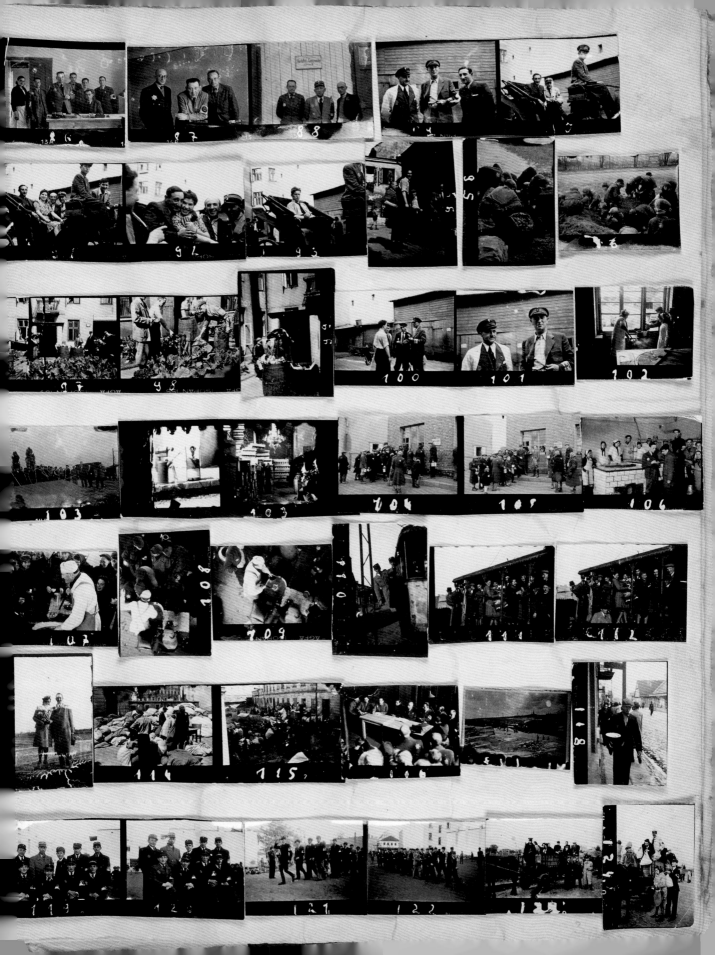

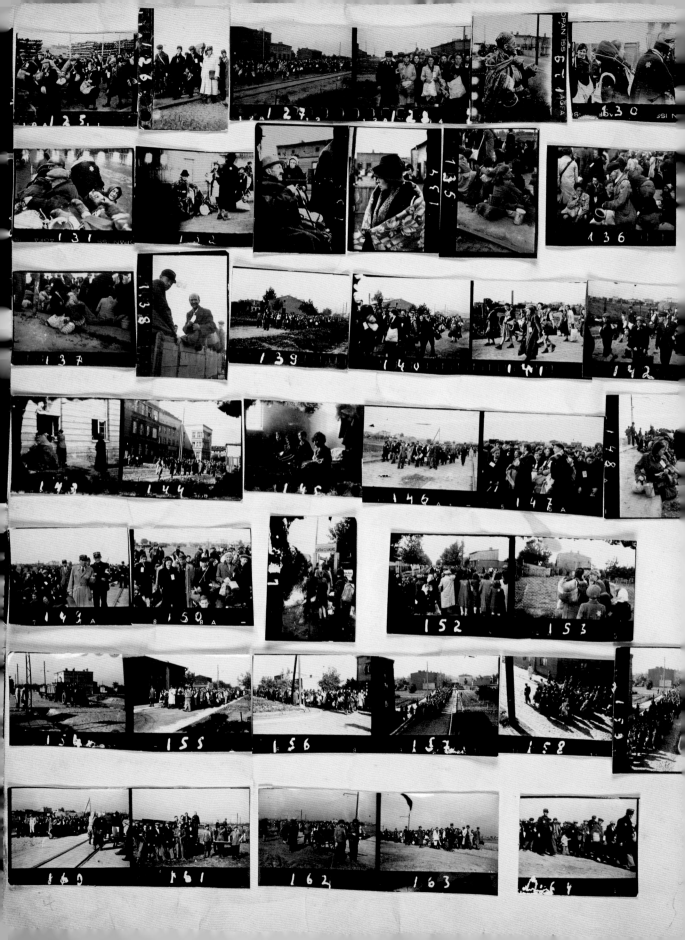

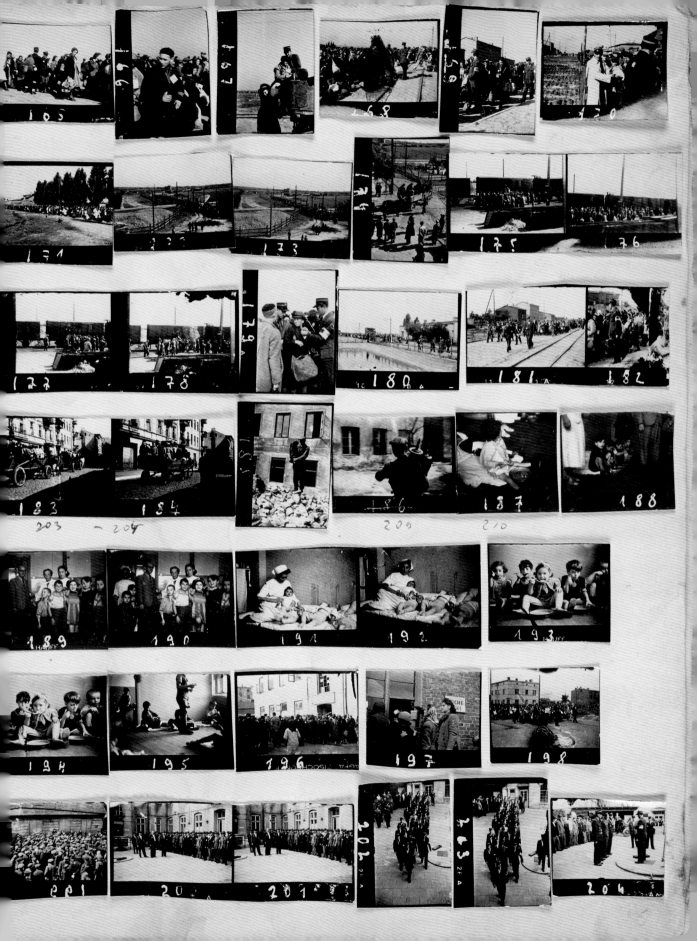

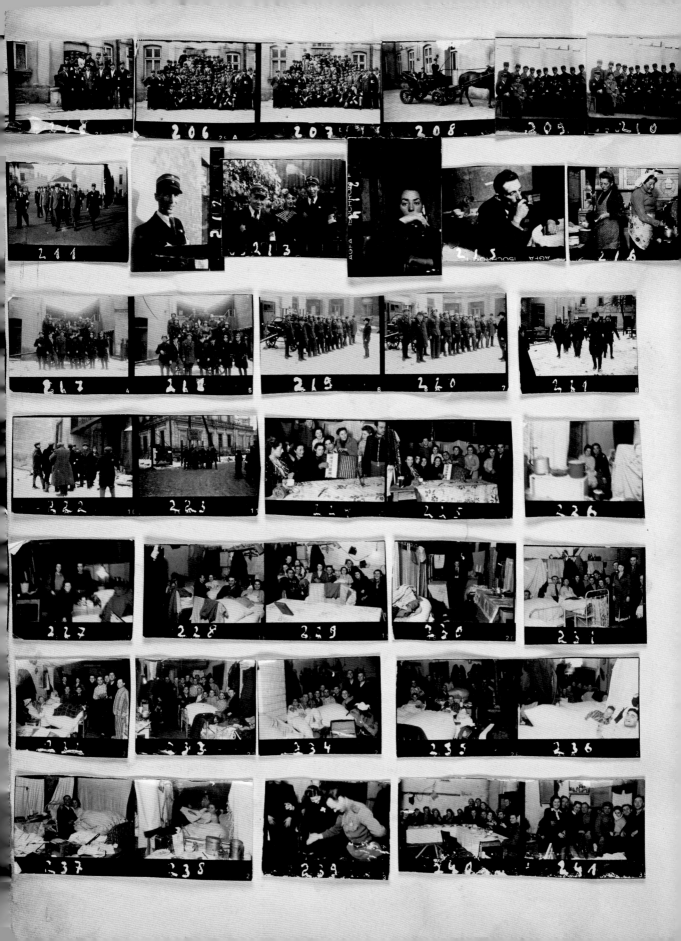

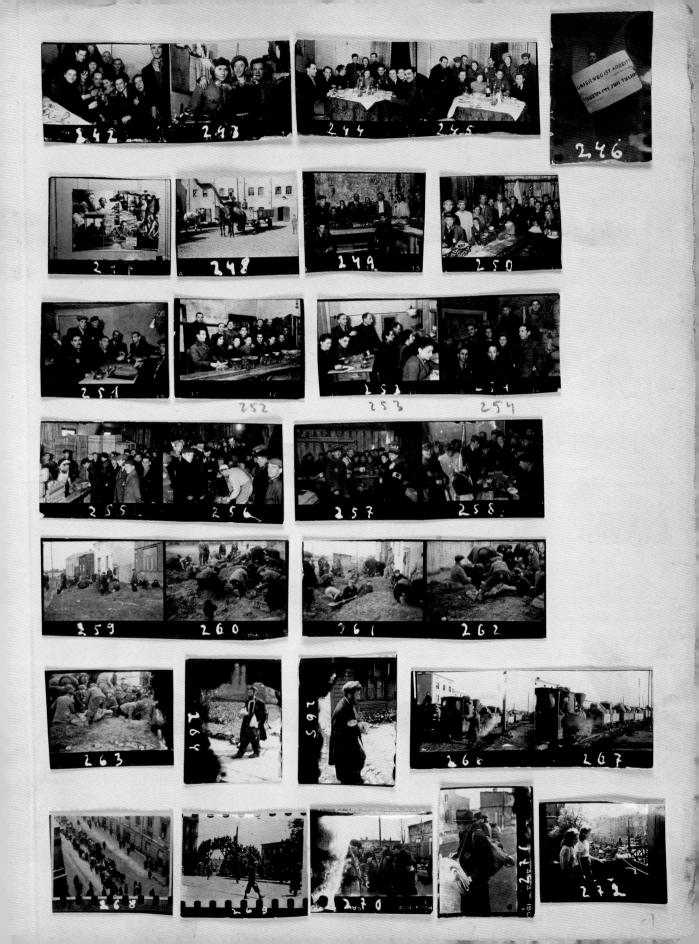

273

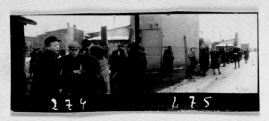

274　275

276

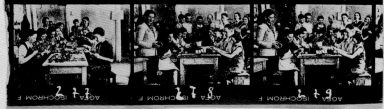

277　278　279

280　281

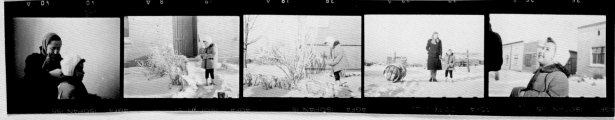

282　283　284　285　286

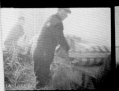
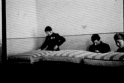
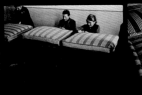

287　289　290　291　292

293　294　295　296　297

BETRIEB 55
HOLZWOLLEFABRIK
GETTOVERWALTUNG

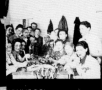
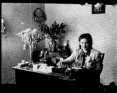

298　299　300　301　302

303 304 305 306 307

308 309 310 311 312

313 314 315 316 317

318 319 320 321 322

323 324 325 326 327

328 329 330 331

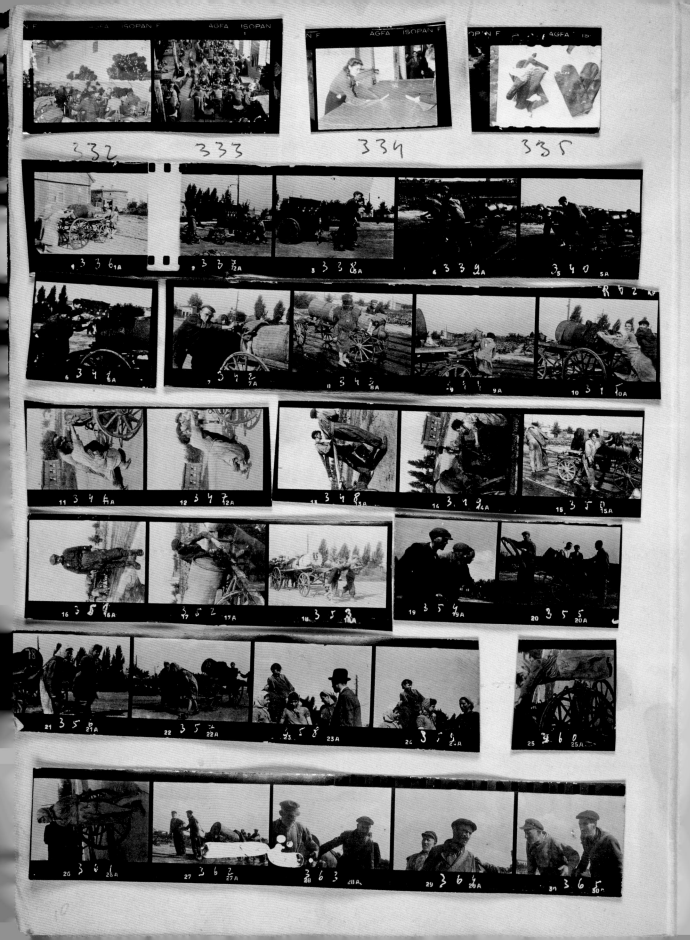

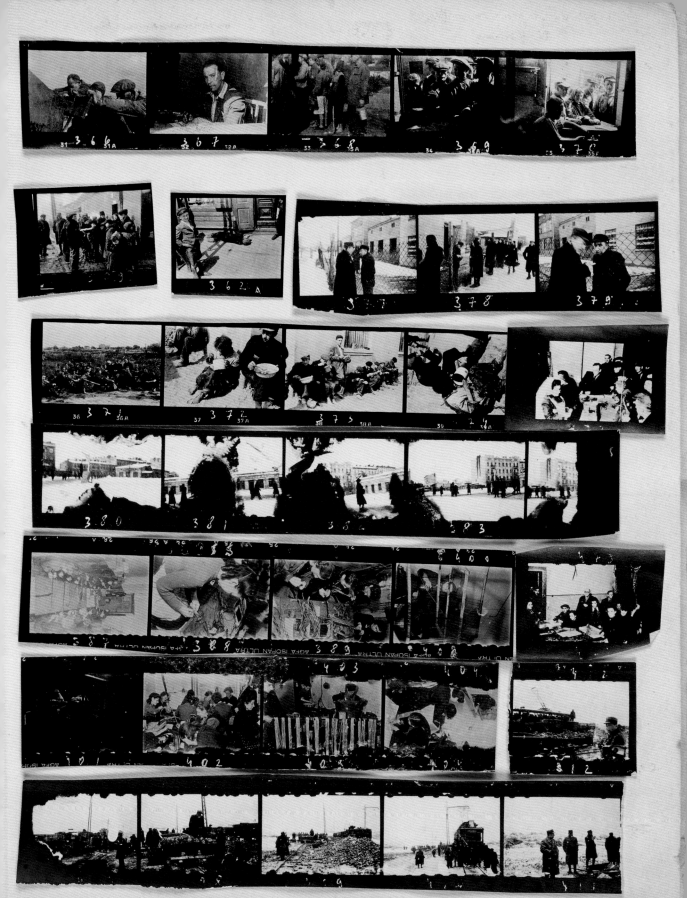

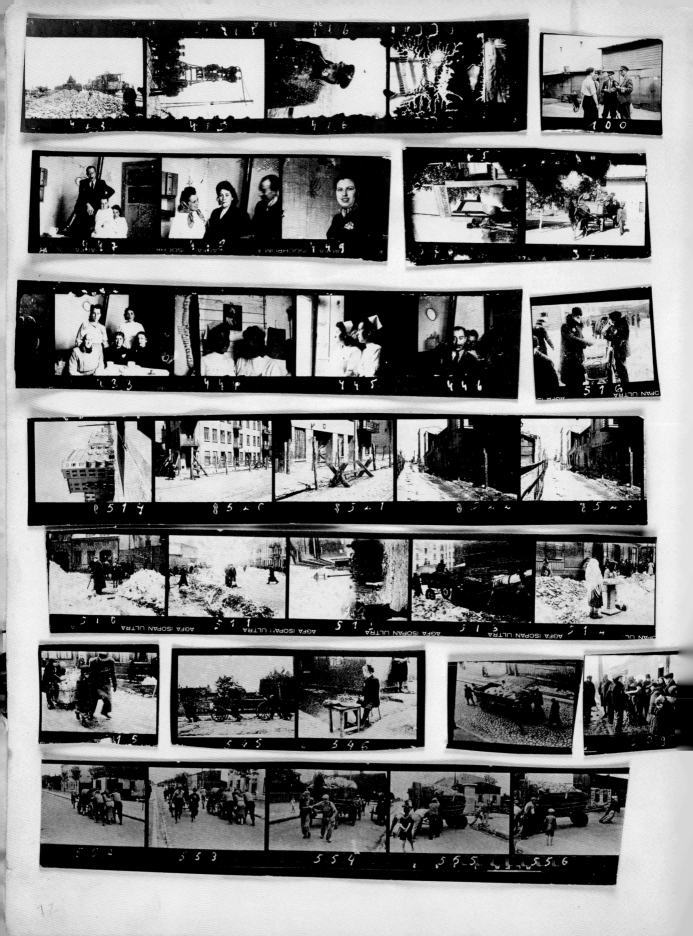

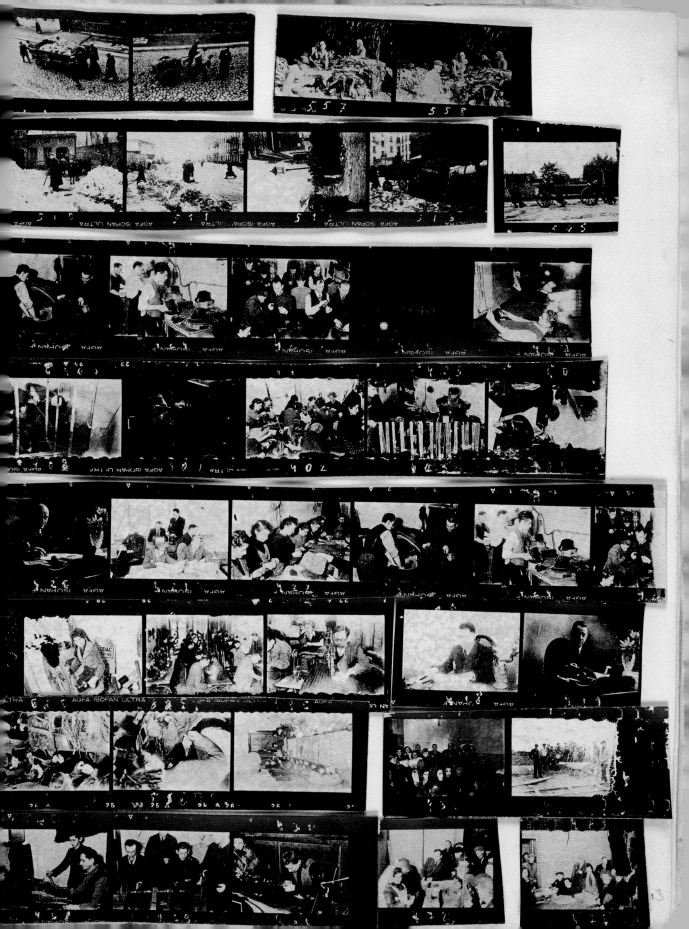

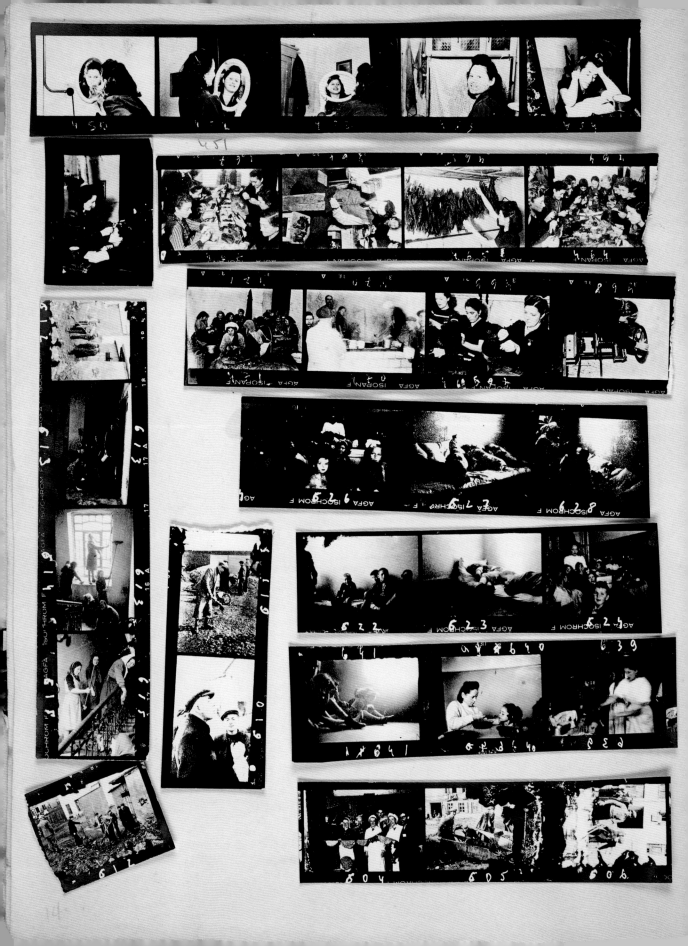

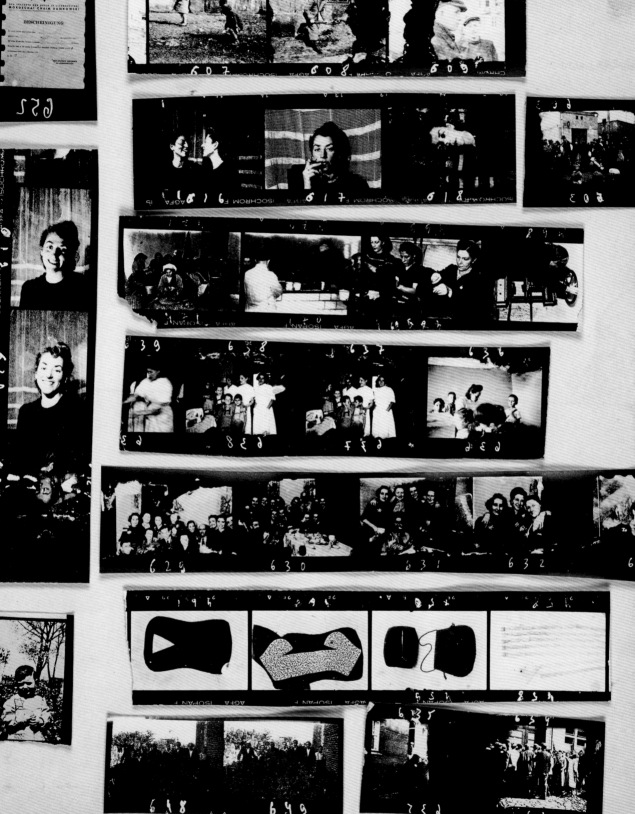

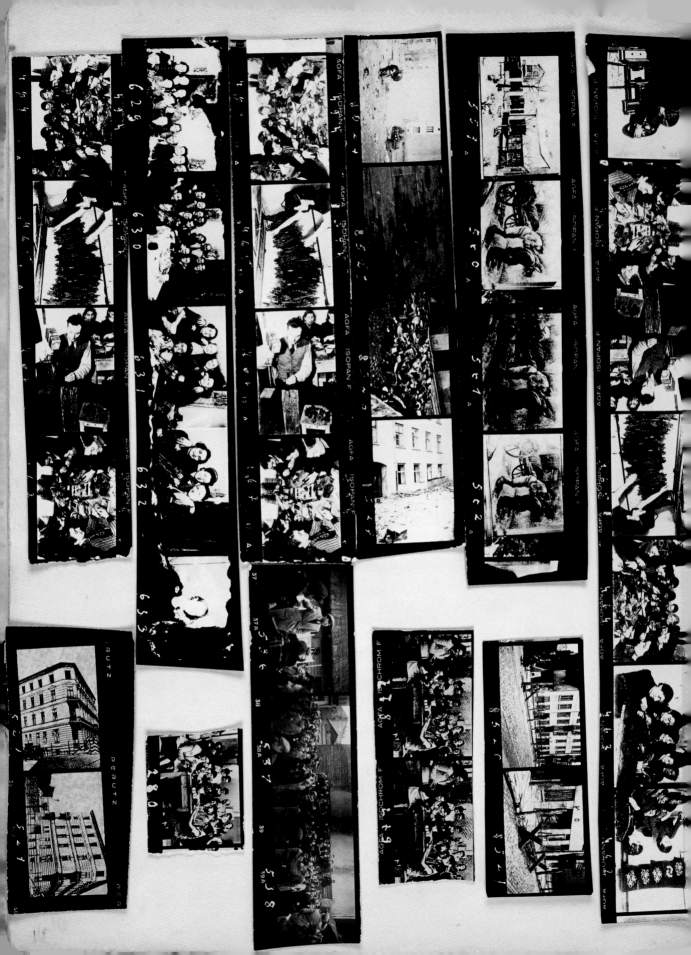

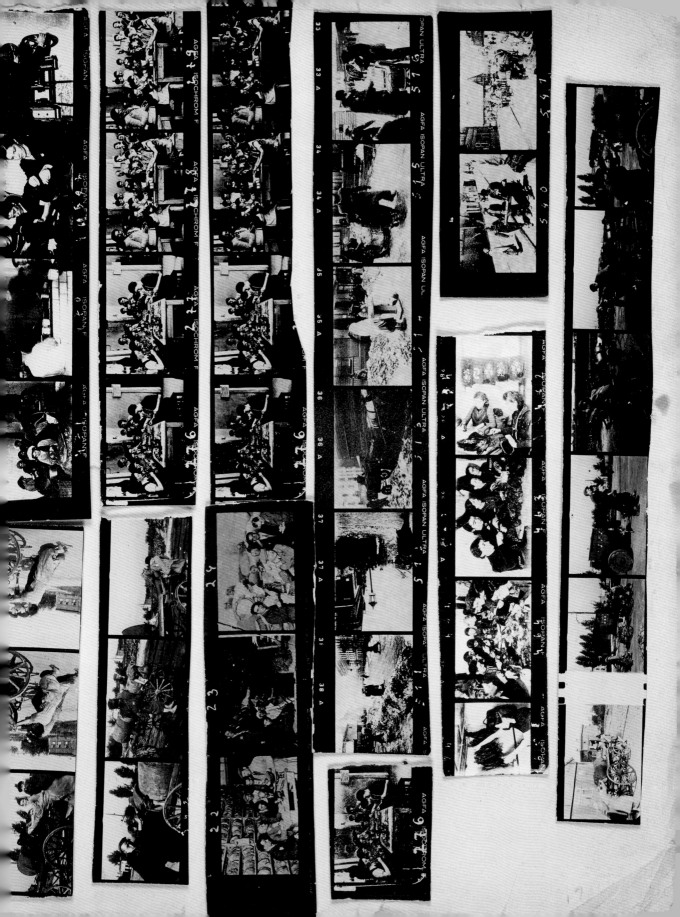

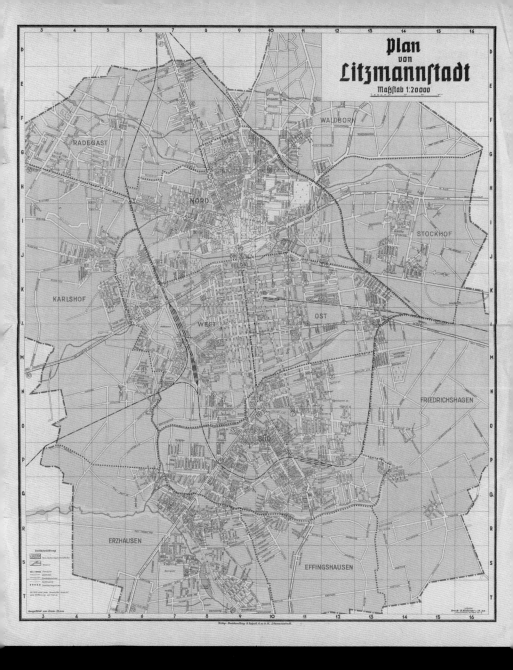

Map of Litzmannstadt (Lodz), Poland, 1942, by Erwin Thiem.
The Lodz Ghetto is indicated in white in the upper centre of the map.

Łódź/Lodz/Lodsch/לאדזש
and Getto Litzmannstadt:
A Historical Introduction

Robert Jan van Pelt

"I'M IN LODZ: FACTORIES, THE WILD WEST, THE STICKS."[1] Thus wrote the German-Jewish physician and author Alfred Döblin in October 1924. Factories: rational determination; the Wild West: lawlessness; the sticks: narrow horizons. Many believe that Döblin caught in these three powerful and clashing images the essence of that most exasperating and also intriguing of cities, which the Poles call "Łódź" (pronounced "woodzh") and which those who speak other languages generally know and spell as "Lodz" (pronounced "lawch"). To make matters even more confusing: the one-time German inhabitants often spelled the name of their hometown "Lodsch," while its one-time Yiddish-speaking Jewish inhabitants spelled Lodz in Hebrew letters: "לאדזש." It was a city where, until the fall of 1939, Poles, Germans and Jews rubbed shoulders—a city of occasional ethnic friction, but little ethnic collision.[2] Then Nazi Germany attacked Poland, conquered the western part, incorporated Lodz into the Greater German Reich, renamed it Litzmannstadt and imprisoned the Jews in a ghetto sealed from the world. In the four-year period of the ghetto's existence, a quarter of the inmates died from starvation. The Germans killed the rest in gas vans stationed at the village of Chełmno nad Nerem, which they had renamed Kulmhof, and in the crematoria of the Auschwitz-Birkenau extermination camp.

This essay provides a context for the mostly unauthorized photographs Henryk Rozencwaijg-Ross (1910–1991) made in the Lodz Ghetto. Employed in the ghetto's Statistics Department, Ross and his colleague Mendel Grossman (1913–1945) were charged with taking portraits of ghetto officials, documenting official meetings, producing passport-size photographs of every ghetto inmate for identity cards, making a visual record of unidentified corpses abandoned in the streets, tracking physical changes in the ghetto as buildings were pulled down, and chronicling the efficiency of the ghetto workshops. While explicitly forbidden from early 1942 onward to make any personal or private photographs, both Ross and Grossman regularly ventured out into the ghetto to record ghetto life as lived, at risk of imprisonment and, during the great deportations, at risk of life.[3]

Both Ross and his negatives survived the liquidation of the Lodz Ghetto in August 1944. Ross later moved them to Israel, where they remained in his personal collection. A relatively small and particular selection of these images became easily integrated into the Jewish collective memory of the Holocaust: depictions of people who starved to death on the streets or who slaved in the ghetto workshops on a daily diet of 800 calories. But the images of the few who belonged to the ghetto elite—members of the ghetto administration and the Jewish ghetto police and their families—have baffled many historians and iconographers of the Holocaust: what to do with the visual evidence of these privileged Jews spending merry moments with colleagues, friends and family? This part of the Ross collection remained a no-go area until the publication, in 2004, of a small selection of the more controversial images in the *Łódź Ghetto Album*.[4]

The Lodz Ghetto was the longest-lasting and second-largest ghetto of the more than 1,100 such places of confinement created by the Germans between 1940 and 1945. All these ghettos were located in cities and towns with well-established Jewish communities.[5] The Nazi official who took the initiative to create the Lodz Ghetto, Friedrich Uebelhoer, stressed the importance of this historical continuity: "We have taken the most effective but also the most radical action by expelling the Jews in Litzmannstadt to the district—namely the ghetto—from which they had poured over the city in earlier times," he wrote in 1941. In other words, the Lodz Ghetto was not created *ex nihilo*: it happened in a local context that included a historical ghetto from which the Jews had emerged. Uebelhoer also suggested a larger, somewhat puzzling ideological context: through the establishment of the ghetto, he believed, "the vital nerve of International Jewry [had] been hit in Litzmannstadt."[6]

Mentioned for the first time in the early fourteenth century, Lodz remained a small town until the early nineteenth. Part of Poland (until 1795), Prussia (1795–1807) and the Grand Duchy of Warsaw (1807–1815), Lodz was allocated to Russia during the Congress of Vienna. This brought economic opportunity: by establishing wool and linen mills in Lodz, German entrepreneurs could access the huge Russian

market without being subject to tariffs. From 1823 onward, many German weavers settled in what was known as the New Town.[7] Beginning in 1848, Jewish craftsmen, shopkeepers and merchants also arrived in Lodz, but were initially forced to reside in the Old Town and the adjacent village of Bałuty.[8] Polish peasants began to move to Lodz in the 1860s to work in the textile mills.[9] Between 1823 and 1914, Lodz grew from 1,000 to 500,000 inhabitants. Thanks to the textile mills, it was a place of ferocious opportunity and competition: the city seemed almost American in its promise to transform rags into riches. Key in the growth of the city was the so-called *Lodzermensch* (Lodzian), the optimistic, opportunistic and ruthless entrepreneur.

Germans had triggered the miraculous rise of Lodz, and in 1840 they constituted almost four-fifths of its population. By 1914, Poles made up half of the population, Jews a third and Germans a sixth. Most Jews were poor or almost poor, but wealthy Jewish entrepreneurs controlled 40 per cent of the textile production, and most of the city's commerce and finance. As the city's economy slowly declined, the Germans in Lodz resented what they considered a usurpation of their heritage and rightful inheritance, and many looked with nostalgia to a past when the Jews had been confined to the Old Town and Bałuty.

The German view of the Jewish rise was also influenced by a new and virulent strain of anti-Semitism peddled by the Russian secret police, based on a fiction that Jews were the authors of some secret, nefarious and global scheme to undermine the natural order of things. This fabrication was outlined in the book *The Protocols of the Elders of Zion*, which was a bestseller by 1914.[10]

In August 1914, a war broke out that pitted, among others, Russia against Germany. A few months later, a German army, commanded by General Karl Litzmann, occupied Lodz. Expecting an incorporation of Lodz into the German Reich, many Lodz Germans turned into rabid nationalists. Yet they, like their Polish and Jewish neighbours, went through difficult economic times: the textile barons had closed most of the production lines as Lodz was separated from its market in the east. The German military advance into Russian Poland brought not only Lodz under German control,

but also the large Polish Jewish community, which had been partly devastated by pogroms and deportations between the outbreak of war and the arrival of the German Army. Seeking deliverance, tens of thousands of hungry, filthy Jewish refugees began to move into the German Reich. To the Germans, these *Ostjuden* (eastern Jews) seemed an utterly alien people that could never be integrated.[11] Sadly, the great majority of German Jews shared in the prejudices of their Christian neighbours: they looked at the *Ostjuden* with a measure of contempt and feared their manifest poverty and backwardness might change the attitudes of the Germans against all Jews, including themselves.[12]

In fall 1918, the Germans faced defeat in the west, and in the east, Polish nationalists proclaimed a sovereign Polish state, cobbled together from territories that had been part of the Russian, Austro-Hungarian and German empires. Lodz became its second-largest city. The confidence of the city's Polish population was bolstered: although they had been the largest ethnic group since the late nineteenth century, the Poles never had enjoyed the prestige or wealth of either the Germans or the Jews. Yet pre-war prosperity did not return. The textile industry remained in dire straits: created to serve the huge pre-war Russian market, its capacity was too large for the relatively small Polish market. Both the economic decline and a general unwillingness to adapt to life as a minority in a Polish national state encouraged many Germans to leave for the German Reich. By the end of the 1920s, the relative size of the Polish, Jewish and German populations in the city was eight to four to one.

The memory of the arrival in Germany of the destitute *Ostjuden* during the war, the shock that followed the sudden military and political collapse of November 1918, and the publication of a German translation of *The Protocols of the Elders of Zion*, which provided an explanation for that collapse, constituted the raw material for Nazi anti-Semitism. A political agitator of Austrian birth living in Germany, Adolf Hitler, bought into the idea that *der Jude* (the Jew), a mythical being comprising all Jews from all times, polluted and undermined the human spirit and consequently threatened the very existence of humankind. As it was difficult to fight an invisible

enemy, Hitler became convinced it was crucial to make *der Jude* tangible and comprehensible. Metaphor proved useful: Hitler liked to compare him to a maggot, or a fungus, or tubercle bacillus, clearly suggesting that *der Jude* was both a parasite and the cause of a lethal disease that threatened the life of humankind in general and the German nation in particular. One could make *der Jude* visible by undoing the assimilation of Jews into non-Jewish society and by countering the progressive fragmentation of Jewish society. And this was what Hitler was committed to do when, in January 1933, he acquired control over the German Reich. Within two months, Nazis started "spontaneously" marking Jewish businesses with crudely painted Stars of David, burning books and identifying individuals as Jews by expelling them from civic society and forcing them into metaphorical ghettos embodied by compulsory Jewish associations, compulsory Jewish residences and, ultimately, a compulsory Jewish community.[13]

On September 1, 1939, the German Army crossed the German-Polish frontier. A week later, Lodz came under German occupation, and on September 13, Hitler was driven into the city, receiving from ecstatic Germans a hero's welcome. In his wake, film crews, dispatched by the Propaganda Ministry, worked to exploit the cinematographic potential of the Lodz "ghetto." They focused on the filthy appearance of the crowded Old Town and Bałuty neighbourhoods, on particularly unappetizing examples of the impoverished Jewish population, and on selected aspects of Jewish ritual life such as kosher butchering. When Propaganda Minister Joseph Goebbels saw the first rushes, he wrote in his diary: "One shudders at such barbarism." After a tour through the Old Town, he added, "One cannot describe it. They are no longer human beings, but animals. It is, therefore, also no humanitarian task, but a task for the surgeon. One has to cut here, and one must do so in a most radical manner. Or Europe will vanish one day due to the Jewish disease." On his return to Berlin, Goebbels discussed his observations with Hitler. That evening, he wrote: "Above all my description of the Jewish problem finds his total approval. The Jew is garbage. Rather a clinical than a social matter."[14]

As Goebbels's men collected the material for the movie that was to be issued in 1940 as *Der Ewige Jude* (*The Eternal Jew*), the Polish Campaign continued. On September 17, the Red Army invaded Poland from the east. On October 6, the last remnants of the Polish Army on Polish territory surrendered, and Germany and the Soviet Union conducted the Fourth Partition of Poland. The Germans divided their part in two; the larger one, to the east, was not formally included in the German Reich. Named Generalgouvernement Polen (General Government Poland), it was meant to become a German-ruled "homeland" for the Poles that could serve German needs as a reservoir of Polish labour. The western area of Poland was officially incorporated into the German Reich. The core of this area was the Wartheland, or Warthegau, a new province that included Lodz.

The man in charge of ethnic cleansing of the Wartheland was Reich Governor Arthur Greiser, who was to be aided by the German security apparatus controlled by SS-Chief Heinrich Himmler and Reinhard Heydrich.[15] Greiser faced an enormous task: only one out of fourteen of the five-million-strong population was German. How to achieve a rapid Germanization of a largely Polish territory that also contained 435,000 Jews? The answer was simple: he created an inventory of the Germans present in the Wartheland that distinguished them according to levels of commitment to the German cause and ethnic-racial purity; allowed willing Poles of "racially valuable" appearance and suspected Germanic ancestry to become ethnic German on probation; began to settle ethnic Germans from the Baltic countries in the Wartheland; and decided to expel at the earliest opportunity most Poles and all Jews to the General Government.[16]

Preparations for the liquidation of the Lodz Jewish community, which held half of the Jews in the Wartheland, began with arbitrary harassment, restrictions on the amount of cash Jews could possess and forced labour. On October 13, the Germans ordered the creation of a *Judenrat* (Jewish Council), which was to enforce German policies within the Jewish community, and appointed sixty-two-year-old Mordechai Chaim Rumkowski (1877–1944) as *Judenälteste* (Elder of the Jews). Rumkowski was

a failed industrialist: before the Great War he had owned a small factory making velvet fabrics, but the business had gone bankrupt. He was a classic example of the *Lodzermensch* and believed his new dignity gave him an opportunity to make good after a life in the shadows.

Decree after decree, alternated by bursts of lethal violence, rained on the Lodz Jews. On October 18, they were forbidden to trade in leather and textile. On October 19, a trustee office was established that began to expropriate Jewish-owned factories. On October 31, Jewish shops, workshops and professional offices were marked, which led to systematic pillage by Germans; Jewish employees in all non-Jewish enterprises were fired; Jewish organizations were forbidden; and Jews were subjected to a curfew and forced to wear first yellow armbands on their right arms and then yellow stars on all garments. On November 10, one day after Lodz became an official part of the Greater German Reich, the Germans burned four major synagogues.[17] The next day, Greiser declared at a rally in Lodz: "For us, and this I can assure you, the Jewish Question is no longer a problem, even when it confronts us in massed form, like here. It's only for us to solve, and it will be solved."[18]

Greiser thought he could drive the Wartheland Jews over the nearby border into the General Government, where a Jewish reservation was to be created near Lublin. But Heydrich knew this could not happen overnight, and in a meeting held in Berlin on September 27, 1939, he had discussed the need for an interim solution. Heydrich chose his words carefully when introducing the first step: "Jewry is to be concentrated in the cities in the ghetto [*im Ghetto*] to allow for better means of control and a better means of expulsion at a later time."[19] Heydrich said Jewry was to be concentrated "in the ghetto," rather than "in ghettos"; by forcing Lodz Jews back into their original ghetto, he sought not only to create conditions that allowed the Germans to easily contain, control and deport them, but also to achieve a goal that was central to Nazi anti-Semitism: making individual Jews become visible again as *Der ewige Jude*.

The Germans believed the ghetto should accomplish four objectives: as a hygienic measure, it was to decrease the risk of epidemics created by the concentration of people;

as an ethical measure, it was to allow for containment of the imagined threat emanating from Jewry; as an ethno-political measure, it was to provide a temporary holding pen for Jews until an as-yet-undetermined date when all the Wartheland Jews could be moved to the General Government; and as an economic measure, it offered the Germans the chance to strip Jews of whatever assets they still had.

In December 1939, Uebelhoer drafted a plan for a closed ghetto in Lodz. It was to be located in the Old Town and Bałuty, slums that housed many poor Poles and 60,000 Jews. Some of the 140,000 Jews living in the New Town were to be sent to this ghetto, while the majority were to be put to work in labour camps elsewhere. The ghetto was to be maintained on a simple barter principle: food and fuel would be delivered to the ghetto in exchange for textiles and valuables. "In this manner we will succeed in completely extracting the most concealed material assets hidden by Jews," Uebelhoer predicted.[20] In the months that followed, the plan evolved: all the Jews from the New Town were to be sent to the ghetto, now a fenced- and walled-off area measuring four square kilometres.

In early 1940, a mass movement of people began: small groups of Polish and Germans residents left the designated area with their possessions and with the help of trucks and wagons, and large groups of Jews, almost completely stripped of their belongings, walked in to the ghetto. On April 11, the day that Lodz was renamed Litzmannstadt, in honour of the general who had won the Battle of Lodz a quarter of a century earlier, most of the Jews had been moved.[21] On April 30, the Germans sealed off the Lodz Ghetto. Any Jew trying to leave the ghetto without permission—which was rarely given—was to be shot without warning. Never before had a ghetto functioned as a permanent prison.

Within the ghetto walls, Rumkowski set out to create an effective and totalitarian administration that, supported by a very efficient police force, penetrated into every last corner of the ghetto by fall 1940. While the ghetto may have tried to offer the appearance of a civic community, it lacked the essential precondition of a community: pockets of privacy that allowed people to withdraw from it. Under Rumkowski's

leadership, the Lodz Ghetto had more in common with a concentration camp than with any of the other ghettos created in Nazi-ruled Europe.

The first census, conducted in June, counted 160,320 Jews: fewer than had been expected, but many more than could be accommodated in the Old Town and Bałuty. To make matters worse, the territory assigned to the ghetto was not a single area: the Germans had excluded a major north-south street and also a second east-west street that met this arterial street in the middle of the ghetto area. The only way for the ghetto inhabitants of the three areas to communicate was by means of foot-bridges that spanned over the walled streets. The main connection to the outside world was a goods-loading platform along a railway line located just east of the ghetto, in the Radogoszcz or, as it was now known, Radegast neighbourhood. The expectation was that in October 1940 the Lodz Jews would be deported to the General Government via the Radogoszcz station.

Rumkowski realized the inhabitants of the ghetto faced catastrophe. In April, before the ghetto was sealed off with walls and barbed-wire fences, he tried to convince the Germans to exploit the considerable labour potential of the many skilled craftsmen among the ghetto inmates. The German Army responded with interest: as more and more men were drafted into the armed forces, they needed uniforms and other leather equipment. Traditional suppliers could not keep up with the demand. The Lodz Ghetto, which included many textile and leather workers, might take care of the shortfall.

The conquest of the Low Countries and France in May 1940 led to new speculation on a destination for European Jewry. In late summer 1940, the German Foreign Office formulated a plan to deport all European Jews to Madagascar, expecting that France would cede the island to Germany as part of a peace settlement. Awaiting the deportation of Polish Jewry, the Germans decided to isolate the Jewish population in the General Government by establishing additional closed ghettos that followed the example set in Lodz. Expulsion of the Lodz Jews to the General Government was now off the agenda. Facing the need to maintain the Lodz Ghetto for at least

another year, Greiser began to explore its economic potential, and considered with greater interest Rumkowski's earlier suggestion to launch industrial production in the ghetto.

By this time the situation in the ghetto was desperate. Some 70 per cent of the ghetto inhabitants had nothing left to barter, and by the end of August food supplies to the ghetto came to a halt. The Germans now faced a choice: they could let the ghetto succumb to hunger and disease, they could expend a significant amount of money to feed it, or they could provide an opportunity for the ghetto to make a living.[22] The Germans chose the last option. In October, Uebelhoer agreed to grant the ghetto a credit to help it survive the winter. This marked a turning point: from now on, it was assumed the Lodz Ghetto would exist for a longer time, and that it would be used as a site for production.[23] The ghetto was transformed from a holding pen into a caricature of the industrial city Germans and Jews had created a century earlier in what had been a common effort. Rumkowski's motto—"Our way is work!"—now guided every aspect of life in the ghetto.

The Lodz Ghetto may have seemed to be a community ruled by the Germans, or by Rumkowski, the man often referred to as King Chaim I, but the real ruler of the ghetto was hunger. The Germans insisted that those engaged in production would receive just enough food to work, while those not employed—children, old people, the ill—would receive next to nothing. Those who belonged to the large ghetto administration would be fed. Between May 1940 and August 1944, when the ghetto was liquidated, 43,725 inhabitants of the ghetto died—more than a quarter of the original 160,320 inhabitants. Of these fatalities, 80 per cent were the direct result of starvation.

By early June 1941, all of continental Europe except the remaining neutral countries was under direct or indirect German control. It was not enough for Hitler. On June 22, 1941, the *Wehrmacht* surprised the Soviets with an all-out offensive—an ideological crusade to destroy the Judeo-Bolshevik conspiracy to rule the world. The German invasion of the Soviet Union in June 1941 inaugurated the Holocaust.

Killing squads, conceived and created by Heydrich, followed the advancing *Wehrmacht* to identify, concentrate and execute Communist leaders and Jews, and more than 1.3 million people were shot.[24]

As the taboo of the mass killing of women and children was violated in the east, it became imaginable to consider a genocide of the Jews of Central and Eastern Europe. In early September, the Germans decided to deport German, Austrian and Czech Jews to Lodz, and between October 16 and November 3, almost 20,000 Jews from Greater Germany arrived. In addition, 5,000 Roma and Sinti were sent to the ghetto. Greiser was appalled. From 1939 he had wanted to make the Wartheland *Judenrein* (Jew-free), and it now became a dumping ground for Jews. As the trains with Jewish deportees arrived at the Radogoszcz station, Greiser resolved to murder Polish Jews incarcerated in the Lodz Ghetto who could not work. It proved a decisive step in the history of the Holocaust: it was the first time Jews outside the occupied Soviet territories were included as a matter of principle in the unfolding genocide.

Greiser entrusted the operation to the Higher SS and police leader in the Wartheland, Wilhelm Koppe, who ordered Herbert Lange to set up a killing installation. Lange commanded a roving, gas van–equipped unit that had been killing inmates of mental asylums since early 1941. Now Lange was to make a decisive and historic contribution to the Final Solution of the Jewish Question: he conceived of a three-part extermination facility.[25] The first part was a waiting area. A synagogue in the town of Koło (now known as Warthbrücken), located some seventy kilometres from Lodz, and an abandoned mill near the village of Zawadki would function as holding pens for Jews arriving in Koło by train. The second part, a loading station for gas vans, would be located in the village of Chełmno nad Nerem (renamed Kulmhof), a few kilometres from Koło. In a partly ruined manor house, victims would undress and be tricked to enter gas vans pulled up to a crude loading bay. The victims would be sent down a corridor toward "shower rooms" and would end up in the hold of a van. Once the space was filled, the doors would be closed, and the van would pull

away from the building. Exhaust piped into the hold would do its lethal work. A forest located five kilometres away was the third part of the facility: the site of the mass graves.

On December 8, 1941, Lange engaged in a first trial of the unprecedented facility. The guinea pigs were Jews from the surrounding area. The production of death proved satisfactory. Four days later, Hitler passed a death sentence on all Jews: they had lost their value as hostages now that Japan had pulled the United States into the war on the Allies' side. Hitler believed that by killing the Jews in Europe he would deal a lethal blow to those in America, and, by implication, to the United States as a whole. In a speech to senior Nazis on December 12, he announced "a clean sweep" to solve the "Jewish Question."[26] On December 16, Rumkowski heard that 20,000 Jews—exactly the number that had been brought into the ghetto in October and November—were to leave the ghetto for Chełmno.

Lodz had become a large industrial enterprise, and a source of pride for Rumkowski. "Financially, I am in much better shape than many of Lodz's important pre-war manufacturers,"[27] he boasted in a speech on January 4, 1942. But the profits generated did not help the starving masses in the ghetto, or shield those deemed "useless" from deportation. From January 16 to 29, and from February 22 to April 2, the Germans dispatched fifty-four trains from the Radogoszcz station to Koło, carrying 44,076 people. The first group to be dispatched to Koło was the Roma and Sinti, followed by Polish Jews who were deemed useless as workers.

In April 1942, Hitler decided that all Jews, irrespective of national origin, were to be included in the genocide. and the ban on including German Jews incarcerated in Lodz in the deportations was lifted. From the moment of their arrival, these Jews from the west had found themselves isolated amid the Lodz Jews. Their old prejudice against the *Ostjuden* was only reinforced when the deportees encountered the terrible conditions in the ghetto, and many blamed the Lodz Jews, rather than their German overseers, for the filth, poverty and starvation. In turn, the Lodz Jews remembered with resentment the way the *Ostjuden* had been the object of the

German Jews' fear, contempt and charity a quarter century earlier.[28] Above all, Rumkowski had no time for the deportees: these mostly middle-class arrivals did not have the skills needed for his enterprise; few spoke either Yiddish or Polish; and he feared that their superior education and intellectual sophistication might allow them to undermine his totalitarian administration. He thus kept the German Jews isolated in hastily assembled mass quarters that quickly became dying pens, and welcomed Hitler's decision that allowed for their deportation to a destination unknown even to Rumkowski.[29]

Beginning in May 1942, German Jews—mostly elderly and lacking the necessary skills to make uniforms or army equipment—were forced to board the trains leaving for Koło. With their departure, the Germans crossed the last boundary in the Final Solution of the Jewish Question: if in July 1941 all Jews in the occupied Soviet territories had become outlaws who could be killed as a matter of course, and if in December 1941 Polish Jews had become outlaws, now every Jew in German-controlled Europe was not only in theory but also de facto a target for murder.

The Germans in charge of the Lodz Ghetto blazed the trail: by the end of May, almost 55,000 inmates had been murdered in Chełmno; some 104,500 Jews remained. Over the following summer, the Germans liquidated the remaining Jewish communities in the Wartheland, dispatching the majority of the Jews to Chełmno and deporting 14,400 to the Lodz Ghetto. Rumkowski had not been willing to split up families, but in summer 1942 the food situation in the ghetto worsened, and starvation became ubiquitous. In late August, the Germans decided there was no reason to keep "useless mouths" in the ghetto, and resolved to eradicate those who could not work, with the exception of the families of the ghetto officials and the ghetto police. Rumkowski was informed only at the very last moment. On September 1, 1942, he ordered the Jewish police to surround the hospitals, remove the patients and load them onto trucks leaving for the Radogoszcz station.

Three days later, Rumkowski addressed the ghetto inmates. After many self-pitying words, he informed the Lodz Jews that the Germans had demanded children

under ten, the old and the sick. In essence, Rumkowski faced the nefarious but, to the Germans, logical consequence of his offer to make the Lodz Ghetto into the largest workshop in the history of the city: if it was a *manufaktura*, there was no place for those who could not work. For a week, trains with the young, old and sick left for Koło. And then, after seven days, it was over. "There is little left to talk about: What comes after is only reverberation, echo, a trembling of nerves," one ghetto inmate wrote in the wake of the September deportation. "After this experience, our existence, always on the brink of death, has taken on a very simple form, restriction to the absolute necessary.... In store for us are: rifle, typhoid fever, gallows, death."[30]

By the end of September 1942, some 90,000 Jews remained in the ghetto, which had now lost all the appearance of a community and had become a factory only. If before September much of the production has been artisanal in character, now the Germans sent modern machinery to the existing ghetto workshops and new ones created in now-empty hospitals, old-age homes and orphanages. In fact, this stabilized the situation for the remaining 90,000 inmates, 73,000 of whom were directly involved in production. The return to routine allowed Ross to go around with his camera, photographing the workshops and also the tiny pockets where conditions transcended the barest essentials. The most important of these were found in Marysin, an area to the northwest of the ghetto. The many photographs Ross made in Marysin show people trying to maintain some normality amid the madness. They show the children of the elite celebrating birthday parties in a ghetto without children. They show tables laden with food in a ghetto that hungers. After the war, in Israel, these images were neither exhibited nor published. They did not fit the postwar ideal, projected backward, of a necessary and common Jewish solidarity against Nazism. Yet when we take these photos at face value, we see individual people trying to make the best of a terrible and terrifying situation. Ross's pictures ought to invite not judgment, but compassion.

In spring 1944, as it became clear that the German Army was unable to stop the Red Army's advance into the General Government and beyond, Himmler decided to

liquidate the Lodz Ghetto. Ethnic Germans fleeing the Red Army were streaming into Lodz, and needed food and supplies. In addition, he feared that upon the approach of the Red Army, the remaining 65,000 ghetto inmates would break out of their prison and take revenge on the 140,000-strong German population of Lodz. Even after he had overseen the murder of six million Jews, for Himmler the spectre of the ghetto as a major threat to non-Jews remained alive and well.

Himmler ordered a resumption of deportations to Chełmno, which had been out of commission for a year and a half. Between the end of June and the middle of July, ten transports brought more than 7,000 people to Koło. On July 23, 1944, the Red Army liberated the Majdanek concentration camp near Lublin, and Himmler decided it would be prudent to erase Chełmno from the earth and push ahead with the final liquidation of the Lodz Jews. On August 2, Rumkowski issued the last of his proclamations: "On the instruction of the Mayor of Litzmannstadt, the ghetto will be evacuated. The workshop crews will go as units, together with their families."[31] Having operated as a factory, the Lodz Ghetto was to be liquidated as a factory: plant by plant, workshop by workshop. The Germans promised that the Lodz Jews would be put to work in other plants.

On August 8, 1944, the first trains with workers and their families left the Radogoszcz station. They headed indeed for a massive plant: the death factory at Auschwitz. Many trains followed. The last train, carrying Rumkowski in a separate carriage, left on August 31. It is not exactly clear what happened to him when he got there; what is certain is that neither Rumkowski nor another 40,000 Lodz Jews survived the day they arrived in Auschwitz. The rest were admitted to the camp, or sent on to other camps. Some survived. The Germans held back more than 800 Jews in Lodz, including Ross, to clean the ghetto area in order to make it habitable as temporary shelter for German refugees arriving from the east. Most of these Jews, including Ross, were still alive when, on January 19, 1945, the Red Army reached Lodz.

Thus ended the German history of Lodz—one that had begun so promisingly in 1823 to end so ignobly between 1939 and 1945. The Jewish history of Lodz has been

on life support since 1945. And the memory of the Lodz Ghetto has been fatefully chained to Rumkowski, to the kind of factory-society he created and, most importantly, to the decision he made in September 1942 to sacrifice the children, the sick and the elderly for the sake of the continued existence of the ghetto as a place of efficient production.

Nevertheless, a plethora of other sources—such as diaries, or the semi-official *Chronicle* that recorded ghetto life, or the photos made by Ross and Grossman, or testimonies such as those given by Ross during the trial of Adolf Eichmann—show that the history of the Lodz Ghetto has a human depth and pathos. The philosopher Hannah Arendt attended the Eichmann Trial, and after hearing many witnesses, reflected on the significance of their testimony. Totalitarianism, she argued, aims to create holes of oblivion into which all deeds, good or evil, disappear. But she also pointed out that such holes of oblivion do not exist. "Nothing human is that perfect, and there are simply too many people in the world to make oblivion possible. One man will always be left alive to tell the story."[32] Her judgment is solid: despite the best efforts of the Nazis to make *der Jude* disappear without a trace, and despite their best efforts to erase the traces of their disappearing by burning libraries and documents, levelling Jewish neighbourhoods, dismantling gas chambers, emptying mass graves and scattering ashes, the Holocaust of the Jews is one of the best documented genocides in history. This applies to the murder of six million Jews as a whole, and it applies to major aspects of that genocide, including the German creation and liquidation of the Lodz Ghetto, and the ways Jews imprisoned in that place tried to cope with the daily destitution, humiliation and violence that came their way. This, then, points to the moral meaning of the 3,000 negatives that Ross made between 1940 and 1944, and that in 1945 he was able to recover from the ruins of the Lodz Ghetto.

An extended version of this essay is available on demand; please visit ago.net.

1 Alfred Döblin, *Reise in Polen* (Olten and Freiburg im Breisgau: Walter-Verlag, 1968), 322; Döblin, *Journey to Poland*, trans. Joachim Neugroschel (London and New York: I.B. Tauris, 1991), 247.

2 See Jürgen Hensel, ed., *Polen, Deutsche und Juden in Lodz, 1820–1939: Eine schwierige Nachbarschaft* (Osnabrück: Fibre-Verlag, 1999); Krystyna Radziszewska, ed., *Pod Jednym Dachem: Niemcy oraz ich polscy i żydowscy sąsiedzi w Łodzi w XIX i XX wieku* (Lodz: Literatura, 2000); Jörg Roesler, "Lodz—Die Industriestadt als Schmelztiegel der Ethnien? Probleme des Zusammenlebens von Polen, Juden und Deutschen im 'polnischen Manchester' (1865–1945)," *Jahrbuch für Forschungen zur Geschichte der Arbeiterbewegung* 5, issue 2 (2006): 121–129.

3 Janina Struk, *Photographing the Holocaust: Interpretations of the Evidence* (London: I.B. Taurus, 2004), 86–89.

4 Henryk Ross, *Łódź Ghetto Album*, ed. Thomas Weber, Martin Parr and Timothy Pruss (London: Archive of Modern Conflict, 2004).

5 Guy Miron and Shlomit Shulhani, eds., *The Yad Vashem Encyclopedia of the Ghettos during the Holocaust*, 2 vols. (Jerusalem: Yad Vashem, 2009), vol. 1, xl.

6 Hubert Müller, ed., *Der Osten des Warthelandes* (Stuttgart: Stähle & Friedel, 1941), 241–244.

7 On the history of the Germans in Lodz, see Stefan Dyroff, Krystyna Radziszewska and Isabel Röskau-Rydel, eds., *Lodz jenseits von Fabriken, Wildwest und Provinz: Kulturwissenschaftliche Studien über die Deutschen in und aus den polnischen Gebieten* (Munich: Martin Meidenbauer, 2009); Andrzej Machejek, ed., *Niemcy łódzcy/ Die Lodzer Deutschen* (Lodz: Wydawn, 2010).

8 On the history of the Jews in Lodz, see the special volume of *Polin* devoted to Lodz: Anthony Polansky, ed., *Polin: A Journal of Polish-Jewish Studies* 6 (Oxford: Blackwell, 1991). Also Andrej Machejek, ed., *Żydzi Łodzcy/ Jews of Łódź* (Lodz: Wydawnictwo Hamal, 2004), and Pawel Spodenkiewicz, *The Missing District: People and Places of Jewish Łódź*, trans. Dorota Wiśniewska and John Crust (Lodz: Wydawn, 2007).

9 Oskar Kossmann, *Lodz: Eine historisch-geographische Analyse* (Würzburg: Holzner, 1966); Stanisław Liszewski, "The Origins and Stages of Development of Industrial Łódź and of Łódź Urban Region," in *A Comparative Study of Łódź and Manchester: Geographies of European Cities in Transition*, ed. Stanisław Liszewski and Craig Young (Lodz: Łódź University Press, 1997), 11–33.

10 See Robert Jan van Pelt, "Freemasonry and Judaism," in *Handbook of Freemasonry*, ed. Henrik Bogdan and Jan A.M. Snoek (Leiden: Brill, 2014), 188–232.

11 Jack Wertheimer, *Unwelcome Strangers: East European Jews in Imperial Germany* (New York: Oxford University Press, 1987).

12 Oskar Singer, *"Im Eilschritt durch den Gettotag…": Reportagen und Essays aus dem Getto Lodz*, ed. Sascha Feuchert et al. (Berlin and Vienna: Philo, 2002), 180–181. Also Sandel L. Gilman, *Jewish Self-Hatred* (Baltimore: Johns Hopkins University Press, 1986), and Jakob Wassermann, *Mein Weg als Deutscher und Jude* (Berlin: S. Fischer Verlag, 1921), 107–108.

13 My argument on the critical importance of making *der Jude* visible is inspired and guided by Dan Michman's reflections on this topic. See Dan Michman, "The Jewish Dimension of the Holocaust in Dire Straits? Current Challenges of Interpretation and Scope," in *Jewish Histories of the Holocaust: New Transnational Approaches*, ed. Norman J.W. Goda (New York and Oxford: Berghahn, 2014), 17–38, especially 23–26.

14 Joseph Goebbels, *Die Tägebücher von Joseph Goebbels: Teil I*, ed. Elke Fröhlich, 14 vols. to date (Munich: K.G. Saur, 1998–ongoing), vol. 7, 157, 173, 177, 179–180.

15 Catherine Epstein, *Model Nazi: Arthur Greiser and the Occupation of Western Poland* (Oxford: Oxford University Press, 2010).

16 Robert Lewis Koehl, *RKFDV: German Resettlement and Population Policy, 1939–1945: A History of the Reich Commission for the Strengthening of Germandom* (Cambridge, MA: Harvard University Press, 1957). The standard work on the persecution and Holocaust of the Jews in the Wartheland is Michael Alberti, *Die Vervolgung und Vernichtung der Juden im Reichsgau Wartheland, 1939–1945* (Wiesbaden: Harrassowitz Verlag, 2006).

17 See Isaiah Trunk, *Łódź Ghetto: A History*, trans. Robert Moses Shapiro (Bloomington and Indianapolis: Indiana University Press, 2006).

18 As quoted in Epstein, *Model Nazi*, 167.

19 As quoted in Raphael Gross and Werner Renz, eds., *Der Frankfurter Auschwitz-Prozess (1963–1965)*, 2 vols. (Frankfurt am Main: Campus, 2013), vol. 1, 177–178. Dan Michman's brilliant interpretation of Heydrich's use of language has resulted in an important corrective on our understanding of the origin of the Nazi-imposed ghettos in Poland. See Michman, "The Jewish Ghettos under the Nazis and Their Allies: The Reasons behind Their Emergence," in Miron and Shulhani, eds., *The Yad Vashem Encyclopedia of the Ghettos during the Holocaust*, vol. 1, xxi–xxiii; see also Michman, *The Emergence of Jewish Ghettos during the Holocaust* (Cambridge: Cambridge University Press, 2011).

20 As quoted in Trunk, *Łódź Ghetto*, 20.

21 A useful primer on the history of the Lodz Ghetto is Julian Baranowski, *The Łódź Ghetto, 1940–1944/Łódzkie Getto, 1940–1944: Vademecum* (Lodz: Archiwum Państwowe w Łodzi/Bilbo, 1999); an important interpretation of the history of the Lodz Ghetto in the context of the Germanization of the city is offered in Gordon J. Horwitz, *Ghettostadt: Łódź and the Making of a Nazi City* (Cambridge, MA: Harvard University Press, 2008).

22 Alberti, *Die Verfolgung und Vernichtung der Juden im Reichsgau Wartheland*, 158–159.

23 Ibid., 251.

24 See Henry Friedländer, *The Origins of Nazi Genocide: From Euthanasia to the Final Solution* (Chapel Hill and London: University of North Carolina Press, 1995); Christopher R. Browning with Jürgen Matthäus, *The Origins of the Final Solution: The Evolution of Nazi Jewish Policy, September 1939–March 1942* (Lincoln and Jerusalem: University of Nebraska Press and Yad Vashem, 2004).

25 See Patrick Montague, *Chełmno and the Holocaust: The History of Hitler's First Death Camp* (Chapel Hill: University of North Carolina Press, 2012).

26 Joseph Goebbels, *Die Tagebücher von Joseph Goebbels: Teil II*, ed. Elke Fröhlich, 15 vols. (Munich: Saur, 1996), vol. 2, 498–499.

27 As quoted in Lucjan Dobroszycki, ed., *The Chronicle of the Łódź Ghetto, 1941–1945*, trans. Richard Lourie et al. (New Haven and London: Yale University Press, 1984), 111–112.

28 Singer, *"Im Eilschritt durch den Gettotag . . . ,"* 180–181.

29 Ibid., 188–189.

30 Oskar Rosenfeld, *In the Beginning Was the Ghetto: Notebooks from Łódź*, trans. Brigitte M. Goldstein (Evanston, IL: Northwestern University Press, 2002), 176.

31 As quoted in Alan Adelson and Robert Lapides, eds., *Łódź Ghetto: Inside a Community Under Siege* (New York: Viking, 1989), 440.

32 Hannah Arendt, *Eichmann in Jerusalem: A Report on the Banality of Evil* (New York: Viking, 1963), 211–212.

The Everyday and the Extreme

Eric Beck Rubin

I.

THE QUESTION OF HOW TO REPRESENT HISTORICAL TRAUMA—particularly the trauma of the Holocaust—and the greater question of how best to preserve and transmit memory of the past has elicited a range of contrasting, often moralistic, responses. There are realist approaches, which state the Holocaust is comprehensible and can therefore be analyzed rationally (the dominant scholarly methodology), and anti-realist approaches, which state the Holocaust is overwhelming and unknowable (typical of popular discourses). There are related claims that the Holocaust is unique and requires its own language in order to be portrayed, or that it is universal, part of a continuum that means it must be compared with other genocides. There is a contingent that argues for relaying only information that can be scientifically verified, and regards any authorial interjection, clarification or contextualization as mitigation. And against this position, there are those who suggest that many such facts are noted or recollected by witnesses, and are therefore subject to the minor uncertainties, mistakes and errors of even the most fastidious observers—our senses are fallible, they argue, and therefore so are our testimonies. Having recognized the errors of witnesses, this group then insists that nothing meaningfully separates the purportedly factual from the inevitably fictional, and that rather than resisting artifice, we must embrace it as part of the process of preserving the past. Indeed, the argument goes, works of fiction give us more than evidence of the event—they give us knowledge.[1]

Broadening the field of "acceptable" and effective representations of the Holocaust to include works of fiction does not, however, tell us much about the content of such fictions. Though we consider fiction a realm without governing rules, writers from the Hellenic period to the present (from Aristotle to John Gardner) have expounded on the correct way—and, to their minds, there is a correct way—to approach character, plot, tone and theme. At the same time, others argue we must create art that explicitly contravenes such conventions, which blends well with the

abovementioned approach that regards the Holocaust as unique. This debate is further complicated by scholars like James Young who argue that the Holocaust was absorbed by witnesses in conventional terms[2]—Young uses novels by witnesses to make the point that we are creatures of convention—but this position is opposed by those who argue that one of the defining traits of the trauma of the Holocaust was its unprecedented nature and outcome, which demand that we supersede convention in our attempts to represent it. This is one interpretation of the philosopher Theodor Adorno's statement that art in the aftermath of Auschwitz is a form of cultural barbarism: we cannot blithely tell the same stories the same ways while thinking the same thoughts, because this will lead us to the same actions and the same results.[3]

A different form of consciousness, which is what Adorno advocated, is the subject of Lawrence Langer's scholarship. Langer focuses on witness testimonies to the Holocaust, and he argues that the best form of representation views the Holocaust through what he terms "necrotic consciousness."[4] Langer defines this term using Primo Levi's remark about his survival in the camps—"I had the sensation that I was living without being alive"—and Jorge Semprún's observation that he had not escaped death, but that "it has passed through me."[5] Necrotic consciousness is also present in the work of Polish author Tadeusz Borowski, whose collection of stories about camp life, *This Way to the Gas, Ladies and Gentlemen*, includes a short piece called "The World of Stone." In this story, the recently liberated Borowski (though he might take issue with the word "liberated") describes passing through a lively city plaza:

> In contrast to years gone by, when I observed the world with wide-open, astonished eyes, and walked along every street alert, like a young man in a parapet, I can now push through the liveliest crowd with total indifference Through half-open eyes I see with satisfaction that once again a gust of the cosmic gale has blown the crowd into the air, all the way up to the treetops, sucked the human bodies into a huge whirlpool, twisted their lips open in terror, mingled the children's rosy cheeks with

the hairy chests of the men, entwined the clenched fists with strips of women's dresses, thrown snow-white thighs on top, like foam, with hats and fragments of heads tangled in hair-like seaweed peeping from below.[6]

By referring obliquely to death, Borowski gives a full sense of what necrotic consciousness could be: the permeation of every thought and sensation with the death of the concentration camps. This is a picture of the "inverse baptism" described by Langer, in which the author (and in turn the reader) is "dipped into a pool of violent death to emerge not forever cleansed but forever soiled."[7]

Like Langer, scholar Michael Rothberg offers a nuanced theory of Holocaust representation. In Rothberg's view, a trauma is marked by its combination of the everyday and the extreme: each is necessary to define the other. In his Nobel Prize acceptance speech, the author Imre Kertész illustrated the force of this tandem when he described how, decades after the war, he came upon photographs that depicted the arrival at Auschwitz-Birkenau.[8] He remarked that he always recalled the separation of men and women and the discovery of the gas chambers, but wasn't prepared for what these images revealed: "lovely, smiling women and bright-eyed young men," as Kertész describes them, who made conversation with the SS guards who, in turn, responded politely to their questions. While the camp was the site of the selection process overseen by Josef Mengele, it also included a soccer pitch. And though Kertész does not mention it, we know there were Shakespeare plays and cabaret, painting and sculpture classes, all next to torture chambers and swimming pools, with athletic competitions that began as sport and lasted until death.[9]

Rothberg's argument is that the juxtaposition of the ordinary and the extreme that is inherent to trauma must be reflected in the representation of trauma. The result is "a form of documentation beyond direct reference and coherent narrative," as well as an illustration of an essence of the Nazi genocide,[10] which used plain language ("prison," "showers," "safekeeping," "work") to describe nearly incredible acts (concentration, gas chambers, confiscation, extermination).

II.

This outline of Rothberg's theory leads us to Henryk Ross, whose frail, makeshift contact print album (pp. 184–201) forms the centrepiece of the *Memory Unearthed* exhibition. The album itself is a paper notebook—something a child might use in a classroom. Its pages have been stapled together at the spine, though some have fallen loose. A thin blue border has been drawn on the cover, seemingly as an after-thought, and is interrupted by an oval at the top and a rhombus at the bottom, both shaded in by pink marker. There is no formal title or name, nor is there any differ-ence in quality between the cover page and those that follow. A few numbers and Hebrew letters have been scribbled on the cover's bottom half, as if the album had been used in a pinch to write down a message.

Inside, the notebook's pages are filled with four-by-six-centimetre prints, hand-clipped from a proof sheet. The small rectangles, which do not lie flat on the page and reflect the light in an uneven fashion, are roughly arranged in rows: six prints per row, seven rows per page. Each rectangle has a white number scrawled above or next to the image, in the black frame, and although the numbers are generally con-secutive, there are some exceptions.

To the person encountering Ross's prints for the first time, they are confusing. Some capture activities—people fighting and playing; others show individuals in fearsome or proud poses, often in uniform. The long exposure times make people's active limbs into ghostly trails. Certain symbols are recognizable (for example, a Red Cross emblem), while others are enigmatic: who exactly is "The Elder of the Jews of Litzmannstadt," and where is the city by that name? There are several pictures of crowds gathered at tall chain-link fences—are these scenes of reunion or separa-tion? Some of the photographs of the streets depict well-maintained storefronts, horse-drawn carriages and streetcar tracks, while others, a few rows down, show demolished buildings, piles of rubble and open pits. The Star of David appears in various forms: on clothing, on books covers, on the facades of buildings, on postage

stamps. In a number of pictures, individuals wear trench coats and ties; in others, workers display the tools of their trades: scales, bakers' hats, wooden paddles; in still others, photographs expose the underfed and destitute, clad in fabric that is ill-fitting and torn. Here and there, a corner or a half of a picture is discoloured, poorly exposed or blacked out by what looks like soot from a fire.

Ross's album is a reflection of life and death in the Lodz Ghetto. This is perhaps inevitable, given his role in that life and death: he was one of two official photographers (with Mendel Grossman) employed by the ghetto government's Statistics Department, and his job was to produce propaganda images of the ghetto, which included identity-card photos. Armed with a camera, however, he also recorded the world of the ghetto as it existed for most of its prisoners: squalid, frightening and brutally violent. As such, his album embodies the traumatic juxtaposition between the familiar and the inconceivable. Today, when we picture the Holocaust, it is images of the extreme that fill our imaginations: tall piles of bodies, skin-and-bone *Musselmänner* at barbed-wire fences, and numberless horrific scenes of violence and humiliation. Ross gives us these images as well as their obverse: scenes of family dinners, portraits of assiduous workers and looks of happiness and hope, which are just as much a part of the Nazi genocide. Each side of Ross puts the other into sharper relief, making the whole less comprehensible (and thereby less digestible, and more memorable). As Rothberg would put it, the juxtaposition also disrupts the coherence of the conventional narrative by showing us something more unsettling and complex. These images, unlike more readily understood events of the Holocaust—facts and scenes we already know or have already seen—ask us to start over.

III.

One of the things that confronts us as we start over is a sense of the enormity of the Holocaust. The sociologist David Rousset described the camps, in which he was incarcerated, as "the concentrationary universe."[11] Ross's images give the viewer

the sense that the universe of genocide extended beyond the camps as we currently envision them; like our universe, it encompasses everything. Baking bread, counting receipts and transporting bodies—the minute and the enormous, the prosaic and the unthinkable—were everyday activities. The photographs also reinforce a revelation recently brought to light by researchers at the United States Holocaust Memorial Museum: there were 42,500 concentration camps and ghettos across Europe, tens of thousands more than experts previously believed existed. In Berlin alone there were 3,000; in Hamburg, 1,300.[12] The point is not to stagger with numbers; it is to show how these sites were imbricated in the routines of a city. On your way to work, at work, even at home—the Holocaust's enormous armies of slave labourers and future victims were ubiquitous, which is to say, everyday. This is not part of the conventional story, but it's part of the story Ross's work tells us.

All the theories of representation described above have merits and shortcomings. Today, Rothberg's prescription of traumatic realism, the combination of the everyday and the extreme, may seem most effective. With time, however, the extreme becomes normal and, soon after, unremarkable. This is one way in which history fades. If *Memory Unearthed* renews and increases interest in Ross's album, it can change how we understand the Holocaust. The goal of trauma representation, however, is not to achieve understanding, but to disrupt it, and make us start over again.

1 James E. Young, *Writing and Rewriting the Holocaust: Narrative and the Consequences of Interpretation* (Bloomington: Indiana University Press, 1988), 37.

2 Imre Kertész's novel *Fatelessness*, translated by Tim Wilkinson (New York: Random House, 2004) dramatizes this dilemma in an early scene, when the protagonist's uncle explains that the deportation of Budapest's Jews is part of a two-millennium continuum of Jewish suffering (see p. 39).

3 Adorno's statement, in original form, is *"nach Auschwitz ein Gedicht zu schreiben, ist barbarisch"* ("Kulturkritik und Gesellschaft," *Prismen* [Berlin: Suhrkamp Verlag GmbH, 1955], 26). Adorno founds this notion in a line of thought, developed alongside the playwright Bertolt Brecht, that culture conceals human beings' inherently negative, not to say evil, qualities ("Meditations on Metaphysics," *Negative Dialectics*, trans. E.B. Ashton from 1966 edition [New York: Continuum, 1994], 366). Auschwitz reveals the failure of culture, which is one reason cultural production in its aftermath is illegitimate, or trash. In the same section of "Meditations on Metaphysics," Adorno makes an exception to his earlier dictum; outside the question of legitimacy or good, he says, a victim of the Holocaust has an unalienable right to express himself or herself, "as much right to expression as a tortured man has to scream." From this, Adorno concluded his earlier statement, prohibiting poetry in the wake of Auschwitz, may have been incorrect—although he goes on to make much wider and more stringent prohibitions in the service of his goal to arrange all thought so as to prevent another Holocaust (see p. 35). The abovementioned instances were not the last times Adorno directly examined the subject of representing Auschwitz and the Holocaust, which demonstrates his struggle to mount special and general ethical and moral frameworks around the study of this history.

4 Lawrence L. Langer, *Using and Abusing the Holocaust* (Bloomington: Indiana University Press, 2006), 100.

5 Ibid., xii.

6 Tadeusz Borowski, *This Way to the Gas, Ladies and Gentlemen*, trans. Barbara Vedder and Michael Kandel from posthumous 1967 edition (London: Penguin Books, 1992), 158.

7 Langer, *Using and Abusing the Holocaust*, 101.

8 These images can be seen in *The Auschwitz Album* (Jerusalem: Yad Vashem, 2003).

9 Eugen Kogon, *Theory and Practice of Hell: The German Concentration Camps and the System Behind Them* (New York: Farrar, Straus and Giroux, 2006), 129. David Rousset, *L'Univers concentrationnaire* (Paris: Fayard, 1998), passim. Alec Wilkinson, "Picturing Auschwitz," *New Yorker*, http://www.newyorker.com/online/2008/03/17/slideshow_080317_wilkinson#slide=1.

10 Michael Rothberg, *Traumatic Realism: The Demands of Holocaust Representation* (Minneapolis: University of Minnesota Press, 2000), 100–101, 6.

11 David Rousset, *L'Univers concentrationnaire* (Paris: Editions du Pavois, 1946).

12 Eric Lichtblau, "The Holocaust Just Got More Shocking," *New York Times*, March 1, 2013.

Coda

Bernice Eisenstein

THE PULL OF HISTORY AND THE SOUL OF MEMORY are heard in a Yiddish expression: "*Es hot undz dos lebn gerufn.*" "Life called for us." It is a phrase of the *mamaloshn*, the "mother tongue," that resonates and expands, stemming from its place in the past and reaching forward to the generations to follow, to those who will inherit the knowledge of all that was once done to extinguish its breath. For every occasion on which the memory of the Holocaust is unearthed, Time finds us newly located. We have moved along its linear path, through the measured passage of days and with the accumulation of years, repeatedly to discover that the protective boundaries of our selves have been altered by a ghostly refrain. And it is one that addresses us with a request, accompanied by the awareness of a debt to be paid: "Remember us."

There are age-old practices that prescribe the rituals for burial as well as for the process of mourning that follows. Their purpose is twofold: to show respect for the dead and to comfort the living. When the death of a close relative occurs—a parent, a sibling, a spouse, a child—there is the rending of a garment, a cut of cloth symbolic of the tear in the hearts of the bereaved. At the gravesite, the community of family and friends assists in filling the grave, all with the understanding that it is the last act of kindness one can perform for a loved one. Each individual will pick up the shovel and use its backside to place the earth into the ground: a reversal of natural order to denote the difficulty of the deed and a demonstration of one's reluctance in the face of what needs to be accepted.

It is only a small step of imagination to move back and forth in time, from one ground of burial to another: from the fall of 1944, when Henryk Ross buried his prints and negatives—the sum of his camera's eye up until the closure and liquidation of the Lodz Ghetto—to their disinterment in March 1945 in the presence of a handful of friends. It is impossible not to wish to make complete and fill to the measure the unknown lives of the ghosts who call to us for their remembrance. Yet we have the orienting compass of our hearts to guide our ways through memory. Once more there is a symbolic tearing of our clothing—for another's parents, their siblings, their spouses, their children. Just as Henryk Ross fulfilled a promise to safeguard and

preserve for the future history's ineffable lament, his offerings come to be understood as a gift—an endowment to our humanity—that has grown as it ages through the seven decades since its delivery.

Memory widens and enlarges, not only during the moments in which we place ourselves within its midst, but also as its form broadens to gather in new voices. The survivors of the Holocaust, who were once meticulously recorded into ledgers and indelibly numbered, their names transferred into books of accounting, are now diminished by age and dying. After liberation, they adhered to the community of one another in the shared knowledge of their incalculable loss, and began to reseed life. In the course of their years, they would come together in celebration and in hardship, both extremes layered with hope and trust. The meaning of the words "life force" is illuminated by the paths of their lives. Their witnessing testimonies, their stories, are the continuant expression of all that is borne to be remembered. And what now passes before our eyes is the seat of our consciousness.

Who will dream You?	?װער װעט דיך חלומען
Remember You?	?װער געדענקען
Deny You?	,װער װעט דיך לייקענען
Yearn after You?	?װער װעט דיך בענקען
Who will flee You,	
only to return	,װער װעט צו דיר, אױף אַ פֿאַרבענקטער, בריק
over a bridge of longing?	[1]?אַװעק פֿון דיר, כדי צו קומען צוריק

The world of memory is an ever-present entity in which our moral imaginations are rooted, sown by our hearts' pressing yet fragile wish to understand. Therein lies the all-embracing setting for observation of and reflection on the immutable legacy of our history. The future of remembrance has already been set down and engraved by a legion of historians, philosophers, artists, writers and poets who have responded

from time immemorial. They have steadily mapped the pathway for us to maintain, in the hope that true bearing could be found without faltering, or be directed either to the right or to the left.

The souls of so many are present. And as we are entrusted to hear their voices, and feel their presence, we have performed an act of kindness not only for them, but also for the generations to follow. And in doing so, a debt continues to be fulfilled.

1 Jacob Glatstein, "Without Jews," from *The Penguin Book of Modern Yiddish Verse*, ed. Irving Howe, Ruth R. Wisse and Khone Shmeruk, trans. Cynthia Ozick (New York: Penguin Books, 1988), 436. © 1987 Irving Howe, Ruth R. Wisse, and Khone Shmeruk.

PAGES 236–237

The ruins of a synagogue on Wolborska Street demolished by Germans, 1940, 2007/2022.20.

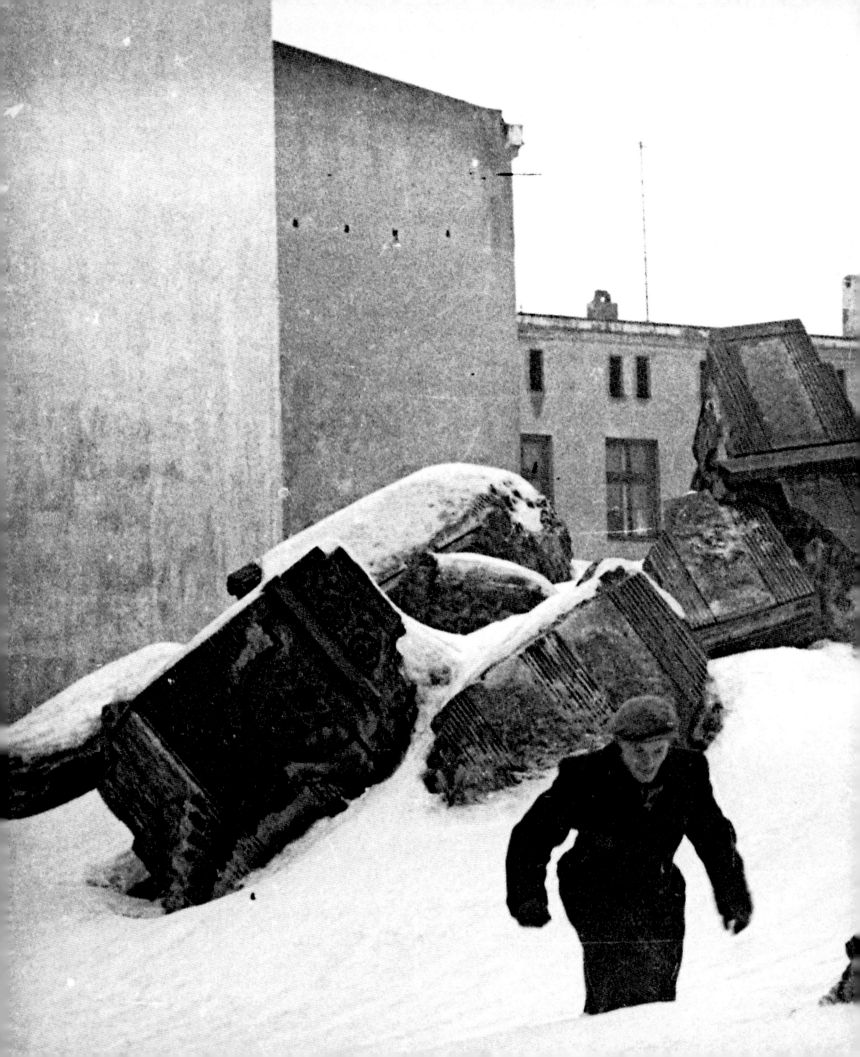

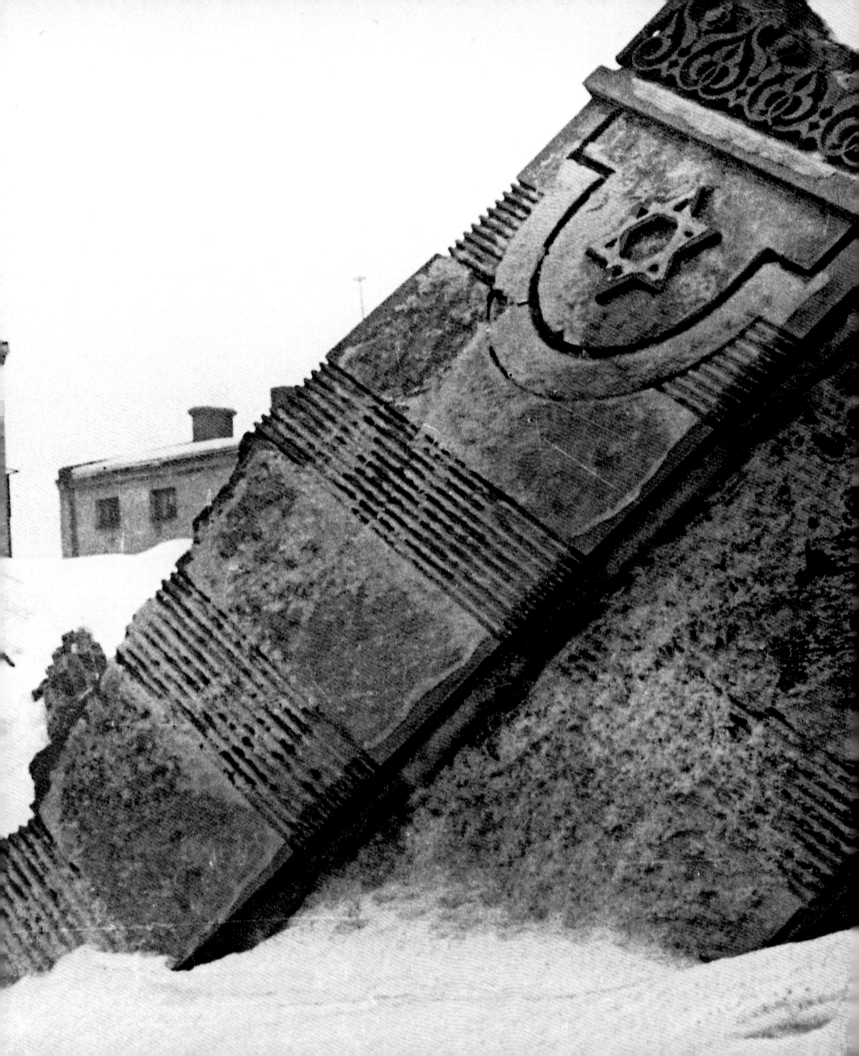

SELECTED BIBLIOGRAPHY

Adelson, Alan and Robert Lapides, eds. *Łódź Ghetto: Inside a Community under Siege*. New York: Penguin Books, 1989.

Adorno, Theodor W. "Meditations on Metaphysic." In *Negative Dialectics*, 361–409. Translated by E.B. Ashton from 1966 edition. New York: Continuum, 1994.

———. *Prismen: Kulturkritik und Gesellschaft*. Berlin: Suhrkamp Verlag GmbH, 1995.

Alberti, Michael. *Die Vervolgung und Vernichtung der Juden im Reichsgau Wartheland, 1939–1945*. Wiesbaden: Harrassowitz Verlag, 2006.

Arendt, Hannah. *Eichmann in Jerusalem: A Report on the Banality of Evil*. New York: Viking, 1963.

Baranowski, Julian. *The Łódź Ghetto, 1940–1944/Łódzkie Getto, 1940–1944: Vademecum*. Lodz: Archiwum Państwowe w Łodzi/Bilbo, 1999.

Berger, John. *Understanding a Photograph*. Edited by Geoffrey Dyer. New York: Aperture, 2013.

Blatman, Daniel, Judith Cohen, Daniel Uziel, Rolf Sachsse and Johan Chaporetet. *Regards sur les ghettos*. Paris: Editions du Memorial de la Shoah, 2013.

Blum, Paul von. *The Art of Social Conscience*. New York: Universe Books, 1976.

Bolanos, Lindsay M. *The Photographic Negative as a Historical Object: An Analysis of the Henryk Ross Lodz Ghetto Collection at the Art Gallery of Ontario*. Toronto: Ryerson University and Art Gallery of Ontario, 2010.

Borowski, Tadeusz. *This Way to the Gas, Ladies and Gentlemen*. Translated by Barbara Vedder and Michael Kandel from posthumous 1967 edition. London: Penguin Books, 1992.

Browning, Christopher R. and Jürgen Matthäus. *The Origins of the Final Solution: The Evolution of Nazi Jewish Policy, September 1939–March 1942*. Lincoln and Jerusalem: University of Nebraska Press and Yad Vashem, 2004.

Bush, Kate and Mark Sladen, eds. *In the Face of History: European Photographers in the 20th Century*. London: Black Dog Publishing and Barbican Art Gallery, 2006.

Döblin, Alfred. *Reise in Polen*. Olten and Freiburg im Breisgau: Walter-Verlag, 1968.

———. *Journey to Poland*. Translated by Joachim Neugroschel. London and New York: I.B. Tauris, 1991.

Dobroszycki, Lucjan, ed. *The Chronicle of the Lodz Ghetto: 1941–44*. Translated by Richard Lourie et al. New Haven: Yale University Press, 1984.

Dyroff, Stefan, Krystyna Radziszewska and Isabel Röskau-Rydel, eds. *Lodz jenseits von Fabriken, Wildwest und Provinz: Kulturwissenschaftliche Studien über die Deutschen in und aus den polnischen Gebieten*. Munich: Martin Meidenbauer, 2009.

Epstein, Catherine. *Model Nazi: Arthur Greiser and the Occupation of Western Poland*. Oxford: Oxford University Press, 2010.

Friedländer, Henry. *The Origins of Nazi Genocide: From Euthanasia to the Final Solution*. Chapel Hill and London: University of North Carolina Press, 1995.

Hogn, Daniel J., ed. *The Holocaust Chronicle: A History in Words and Pictures*. Lincolnwood, Illinois: Publications International, 2000.

Hornstein, Shelly and Florence Jacobowitz, eds. *Image and Remembrance: Representation and the Holocaust*. Bloomington: Indiana University Press, 2003.

Gilman, Sandel L. *Jewish Self-Hatred*. Baltimore: Johns Hopkins University Press, 1986.

Goebbels, Joseph. *Die Tägebücher von Joseph Goebbels: Teil I*. Edited by Elke Fröhlich, 14 vols. to date. Munich: K.G. Saur, 1998–ongoing.

Gross, Raphael and Werner Renz, eds. *Der Frankfurter Auschwitz-Prozess (1963–1965)*. Vols. 1 and 2. Frankfurt am Main: Campus, 2013.

Grossman, Mendel. *With a Camera in the Ghetto*. Edited by Zvi Szner and Alexander Sened. New York: Schocken Books, 1977.

Gutman, Israel. *The Auschwitz Album*. Jerusalem: Yad Vashem, 2003.

Hensel, Jürgen, ed. *Polen, Deutsche und Juden in Lodz, 1820–1939: Eine schwierige Nachbarschaft*. Osnabrück: Fibre-Verlag, 1999.

Horwitz, Gordon J. *Ghettostadt: Łódź and the Making of a Nazi City*. Cambridge, MA: Harvard University Press, 2010.

Koehl, Robert Lewis. *RKFDH: German Resettlement and Population Policy, 1939–1945: A History of the Reich Commission for the Strengthening of Germandom*. Cambridge, MA: Harvard University Press, 1957.

Kogon, Eugen. *Theory and Practice of Hell: The German Concentration Camps and the System behind Them*. New York: Farrar, Straus and Giroux, 2006.

Kossmann, von Oskar. *Lodz: eine historisch-geographische Analyse*. Wursburg: Holzner-Verlag, 1966.

Lagner, Lawrence L. *Using and Abusing the Holocaust*. Bloomington: Indiana University Press, 2006.

Liszewski, Stanisław. "The Origins and Stages of Development of Industrial Łódź and of Łódź Urban Region." In *A Comparative Study of Łódź and Manchester: Geographies of European Cities in Transition*, 11–13. Edited by Stanisław Liszewski and Craig Young. Lodz: Łódź University Press, 1997.

Loos, Ingo, ed. *Das Gesicht des Gettos: Bilder Judischer Photographen aus dem Getto Litzmannstadt, 1940–1944*. Berlin: Stiftung Topographie des Terrors, 2010.

Machejek, Andrzej, ed., *Żydzi Łodzcy/Jews of Łódź* . Lodz: Wydawnictwo Hamal, 2004.

———. *Niemcy łódzcy/Die Lodzer Deutschen*. Lodz: Wydawn, 2010.

Megaree, Geoffrey P. and Martin Dean. *The Encyclopedia of Camps and Ghettos, 1933–1945*. Vols. 1 and 2. Bloomington and Indianapolis: United States Holocaust Memorial Museum and Indiana University Press, 2012.

Memories of the Eichmann Trial. Directed by David Perlov. Jerusalem: Israeli Broadcasting Authority, Channel 1, 1979.

Michman, Dan. "The Jewish Ghettos under the Nazis and Their Allies: The Reasons behind Their Emergence." In *Yad Vashem Encyclopedia of the Ghettos during the Holocaust*, vol. 1, xiii–xxxix. Edited by Guy Miron and Shlomit Shulhani. New York: New York University Press, 2009.

———. *The Emergence of Jewish Ghettos during the Holocaust*. Cambridge, UK: Cambridge University Press, 2011.

———. "The Jewish Dimension of the Holocaust in Dire Straits?: Current Challenges of Interpretation and Scope." In *Jewish Histories of the Holocaust: New Transnational Approaches*, 17–38. Edited by Norman J.W. Goda. New York and Oxford: Berghahn, 2014.

Miron, Guy and Shlomit Shulhani, eds. *The Yad Vashem Encyclopedia of the Ghettos during the Holocaust*. Vols. 1 and 2. Jerusalem: Yad Vashem, 2009.

Montague, Patrick. *Chełmno and the Holocaust: The History of Hitler's First Death Camp*. Chapel Hill: University of North Carolina Press, 2012.

Müller, Hubert. *Der Osten des Warthelandes*. Stuttgart: Stähle & Friedel, 1941.

Parr, Martin, Timothy Prus and Thomas Webber, eds. *Łódź Ghetto Album: Photographs by Henryk Ross*. London: Archive of Modern Conflict and Chris Boot Ltd., 2004.

Polansky, Anthony, ed. *Polin: A Journal of Polish-Jewish Studies* 6. Oxford: Blackwell, 1991.

Radziszewska, Krystyna, ed. *Pod Jednym Dachem: Niemcy oraz ich polscy i żydowscy sąsiedzi w Łodzi w XIX i XX wieku*. Lodz: Literatura, 2000.

Roesler, Jörg. "Lodz—Die Industriestadt als Schmelztiegel der Ethnien? Probleme des Zusammenlebens von Polen, Juden und Deutschen im 'polnischen Manchester' (1865–1945)." *Jahrbuch für Forschungen zur Geschichte der Arbeiterbewegung* 5, issue 2 (2006): 121–129.

Rosenfeld, Oskar. *In the Beginning Was the Ghetto: Notebooks from Łódź*. Translated by Brigitte M. Goldstein. Evanston, IL: Northwestern University Press, 2002.

Ross, Henryk and Alexander Klugman. *Darkam ha-akhronah shel yehudei Lodz (The Last Journey of the Jews of Lodz)*. Tel Aviv: S. Kibel Publishing, 1962.

Rothberg, Michael. *Traumatic Realism: The Demands of Holocaust Representation*. Minneapolis: University of Minnesota Press, 2000.

Rousset, David. *L'Univers concentrationnaire*. Paris: Fayard, 1998.

Singer, Oskar. *"Im Eilschritt dur den Gettotag . . .": Reportagen und Essays aus dem Getto Lodz*, 180–181. Edited by Sascha Feuchert et al. Berlin and Vienna: Philo, 2002.

Smith, Lynn. *Voices of the Holocaust: A New History in the Words of the Men and Women Who Survived*. New York: Carroll & Graf Publishing, 2006.

Sontag, Susan. *On Photography*. New York: Doubleday, 1990.

———. Regarding the Pain of Others. New York: Farrar, Straus and Giroux, 2003.

Spodenkiewicz, Paweł. *The Missing District: People and Places of Jewish Łódź*. Translated by Dorota Wiśniewska and John Crust. Lodz: Wydawn, 2007.

Struk, Janina. *Photographing the Holocaust: Interpretations of the Evidence*. London: I.B. Taurus, 2004.

Trunk, Isiah. *Łódź Ghetto: A History*. Translated by Robert Moses Shapiro. Bloomington and Indianapolis: Indiana University Press, 2006.

van Pelt, Robert Jan. "Freemasonry and Judaism." In *Handbook of Freemasonry*, 188–232. Edited by Henrik Bogdan and Jan A.M. Snoek. Leiden: Brill, 2014.

Wassermann, Jakob. *Mein Weg als Deutscher und Jude*. Berlin: S. Fischer Verlag, 1921.

Wertheimer, Jack. *Unwelcome Strangers: East European Jews in Imperial Germany*. New York: Oxford University Press, 1987.

Young, James E. *Writing and Rewriting the Holocaust: Narrative and the Consequences of Interpretation*. Bloomington: Indiana University Press, 1988.

Publication © 2022 Art Gallery of Ontario.

Unless otherwise noted, all works are by Henryk Ross (born Poland, 1910; died Israel, 1991), *Lodz Ghetto photographs*, 1940–1945. Gelatin silver prints and original 35mm negatives. Collection of the Art Gallery of Ontario, gift from the Archive of Modern Conflict, 2007. © Art Gallery of Ontario.

The Art Gallery of Ontario is partially funded by the Ontario Ministry of Culture. Additional operating support is received from the Volunteers of the Art Gallery of Ontario, the City of Toronto, the Department of Canadian Heritage and the Canada Council for the Arts.

Printed in Belgium

10 9 8 7 6 5 4 3

This catalogue is published in conjunction with the exhibition

Memory Unearthed: The Lodz Ghetto Photographs of Henryk Ross
Art Gallery of Ontario
January 31–June 14, 2015

Contemporary programming at the Art Gallery of Ontario is supported by

Canada Council Conseil des arts
for the Arts du Canada

Art Gallery of Ontario
317 Dundas Street West
Toronto, Ontario
M5T 1G4
Canada
www.ago.ca

Distributed by
Yale University Press
302 Temple Street
P.O. Box 209040
New Haven, CT
06520-9040
www.yalebooks.com/art

Library and Archives Canada
Cataloguing in Publication

Ross, Henryk, 1910–1991
[Photographs. Selections]
 Memory Unearthed: The Lodz Ghetto Photographs of Henryk Ross / edited by Maia-Mari Sutnik.

Catalogue to accompany an exhibition held at the Art Gallery of Ontario, Toronto, Ontario. from January 31 to June 14, 2015.

Reprint. Originally published: 2015.
Includes bibliographical references.
ISBN 978-0-300264-11-1

 1. Ross, Henryk, 1910–1991—Exhibitions.
2. Jews—Poland—Łódź—Pictorial works—Exhibitions.
3. Jews—Persecutions—Poland—Łódź—Pictorial works—Exhibitions. 4. Holocaust, Jewish (1939–1945)—Poland—Łódź—Pictorial works—Exhibitions.
I. Sutnik, Maia-Mari, editor II. Art Gallery of Ontario, issuing body III. Title.

Library of Congress Control Number: 2021950219

Publication

EDITOR
Maia-Mari Sutnik

MANAGING EDITOR
Jim Shedden

PRODUCTION EDITOR
Claire Crighton

DESIGN
Lauren Wickware

PROOFREADER
Judy Phillips

TRANSLATOR
Kalman Weiser

PRODUCTION ASSISTANT
Ebony Jansen

PHOTOGRAPHERS
Craig Boyko
Ian Lefebvre
Dean Tomlinson
Sean Weaver

CATALOGUERS
Liana Radvak
Tracy Mellon-Jensen
Olga Zotova

PRINTING
Type A Print Inc.

Exhibition

CURATOR
Maia-Mari Sutnik

PROJECT COORDINATOR
Tanya Zhilinsky

INTERPRETIVE PLANNER
Gillian McIntyre

EXHIBITION DESIGNER
Flavio Trevisan

GRAPHIC DESIGNER
Marilyn Bouma-Pyper

CONSERVATOR
Katharine Whitman

CURATORIAL
ADMINISTRATIVE ASSISTANTS
Tracy Mallon-Jensen
Jessie Snow

RESEARCH ASSISTANT
Sara Fruchtman*

PRODUCTION COORDINATOR,
DESIGN STUDIO
Malene Hjorngaard

PRODUCTION COORDINATOR,
EXHIBITION SERVICES
Charles Kettle

INSTALLATION COORDINATOR
Brian Groombridge

MEDIA PRODUCER
Danny Winchester

DEVELOPMENT
Lisa Landreth

COMMUNICATIONS
Andrea-Jo Wilson

SOCIAL MEDIA
Meagan Campbell

*Supported by the British Columbia
Arts Council

PAGE 244
Man who saved the Torah from
the rubble of the synagogue in
Wolborska Street, 1939–1940,
2007/1961.18.

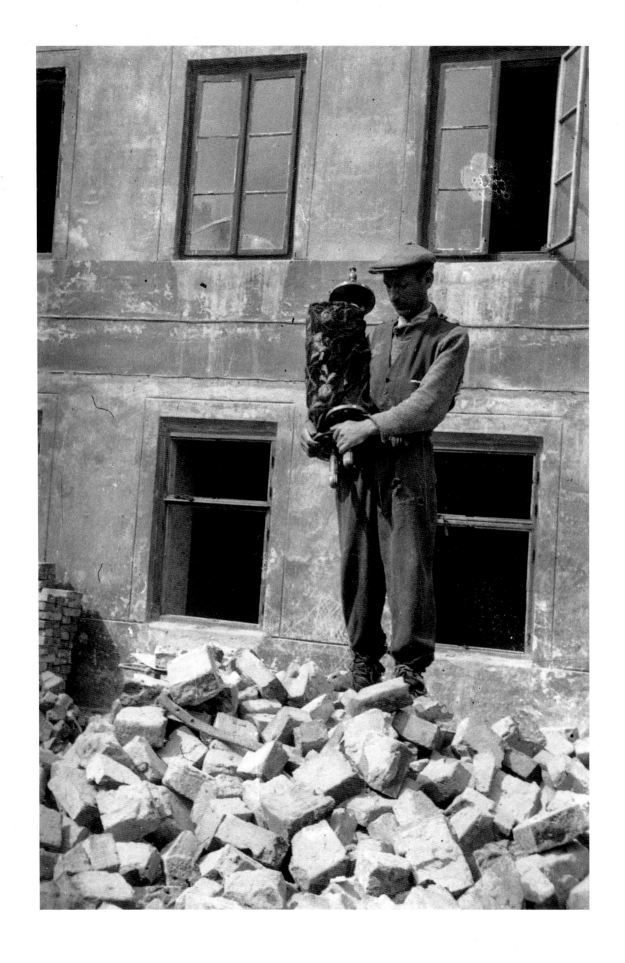